A

D1356179

Rimpa Art

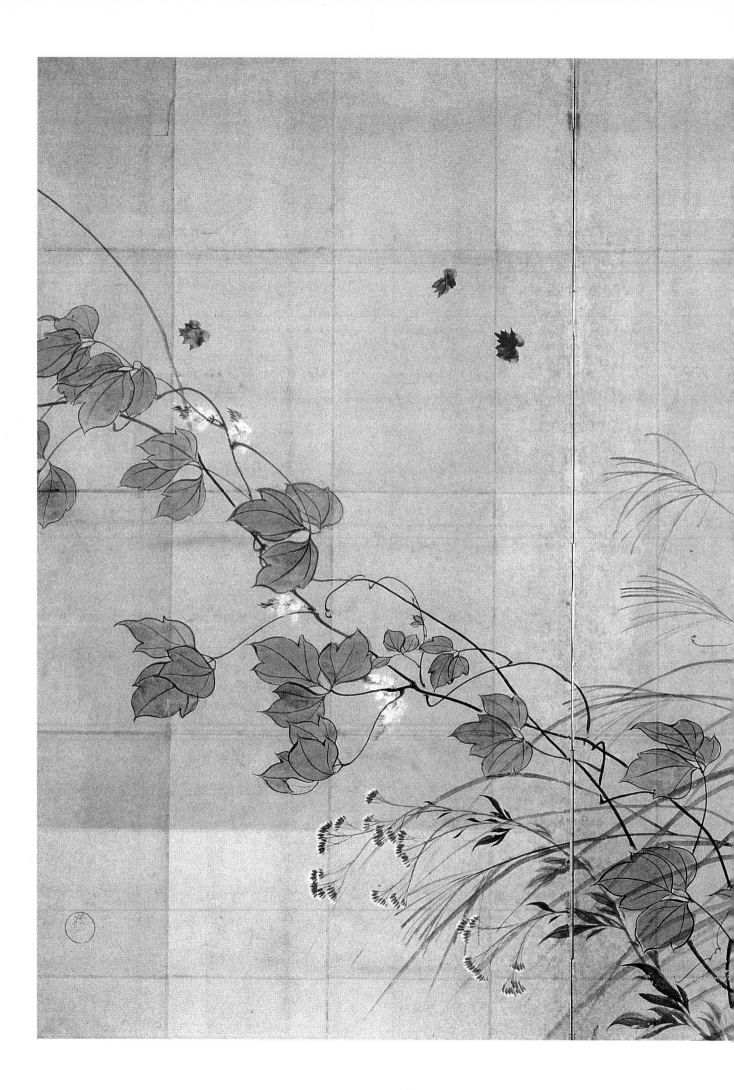

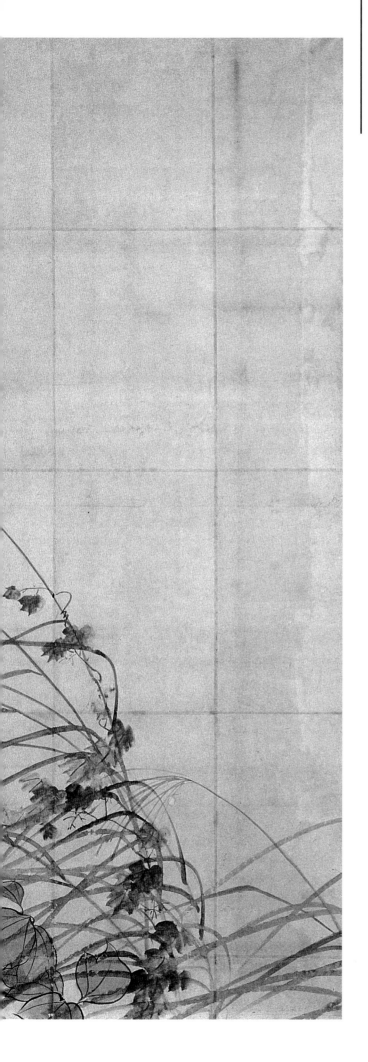

Rimpa Art

From the Idemitsu Collection, Tokyo

Yūzō YAMANE,

Masato NAITŌ

and Timothy CLARK

with contributions by

Masaaki ARAKAWA

Published for The Trustees of

The British Museum by

BRITISH MUSEUM 📛 PRESS

TITLE PAGE: Sakai Hōitsu, Detail from *Summer and autumn grasses* (preparatory study), 1821 (cat. no. 40).

English translations and essay by Timothy CLARK
© 1998 Trustees of the British Museum
Essay by Yūzō YAMANE © 1998 the author
Essay by Masato NAITŌ © 1998 the author
The catalogue entries and artists' biographies were first
published in Japanese in *Rimpa* (The Art of Rimpa from
the Idemitsu Collection), Idemitsu Museum of Arts,
Tokyo, 1993. The essay by Yūzō YAMANE is a revised
and updated version of an essay first published in
Japanese in the catalogue to the exhibition *Rimpa kaiga no
meihin ten,* Nihon Keizai Shimbunsha and Kōbe Sogō
Department Store, 1979.

Colour photographs © Idemitsu Museum of Arts, Tokyo

English translations by Timothy CLARK

Published by British Museum Press
A division of The British Museum Company Ltd
46 Bloomsbury Street, London WC1B 3QQ

First published 1998

British Library Cataloguing in Publication Data
A catalogue record for this book is available from
the British Library

ISBN 0-7141-1486-3

Designed by Harry Green
Typeset in Palatino and Gill by Technical Art Services

Printed in Italy by Grafiche Milani

Contents

4213

B m8 J (YAM)

The Trustees of the British Museum

acknowledge with gratitude generous

sponsorship of the exhibition by

Idemitsu Kōsan Co. Ltd

The Japan Foundation

and additional support from

Japan Airlines

They also wish to record their thanks

for assistance towards the production

of this book from

Klaus F. Naumann

Foreword

by the Director

of the British Museum

It has long been one of the major objectives of the British Museum to bring before its numerous visiting public the various achievements of world material culture. Many of these can be shown from our own permanent collections, but in the last generation of greatly increased international cultural exchange we have been fortunate also to be able to mount exhibitions loaned from many countries of the world. These, naturally, require the co-operation of sister institutions in an age of ever-developing perception, deepening scholarship and archaeological investigation. The latest of these partners is the Idemitsu Museum, to whom I extend our most cordial welcome on this, their first complete loan exhibition to us.

The Idemitsu Museum in central Tokyo is one of the world's leading private museums and has been highly active for more than thirty years not only in building up remarkable collections, but also in research and publication, support for and initiation of archaeological projects, public lectures and information, and loans to other venues both in Japan and abroad. It therefore shares many of the ideals of a publicly funded museum like our own; indeed, the book *The British Museum: Purpose and Politics* (1989) by my predecessor as Director, Sir David Wilson, was translated into Japanese by Mr Nakao, Deputy Director of the Idemitsu Museum. This closeness has been proved by a generation of scholarly contacts between our curators, beginning with studies of Chinese, Japanese and Islamic ceramics and embracing Chinese bronzes and Japanese art of the Ukiyo-e school. The exhibition of Rimpa art is the latest and most ambitious of those projects.

As is noted by Mr Idemitsu in his Foreword, the arts of Rimpa have never been seen in a major exhibition in Europe. There are easily explained reasons for that. Rimpa is a historically recurring Japanese artistic style – some would say *the* Japanese style – but its representative artists and craftsmen have never been prolific, and their clients since the early seventeenth century were predominantly townspeople. This led to a relatively low rate of survival of their works until they began to be fully understood for what they were and treasured by the academic and museum world in the later nineteenth century. Rimpa masterpieces are today in Japan rare and carefully preserved, and very few institutions hold them in numbers sufficient to mount a representative exhibition. There is an understandable reluctance to risk sending these delicate pieces abroad. We are therefore especially grateful to the Idemitsu Museum for allowing these paintings, ceramics and lacquerwares to come to London and to entrust them to the care of the British Museum.

When our Japanese Galleries opened in the spring of 1990, it was always our intention that they should display not only our own collections, but also loans in those outstanding fields of historical Japanese art and craftsmanship which cannot be seen in quantity outside their country of origin. Such exhibitions have already included *Swords of the Samurai*, *Kamakura: The Renaissance of Japanese Sculpture* and *Nihonga: Japanese Traditional Painting 1900–1940*. To this distinguished series we are now proud to add *Rimpa Art from the Idemitsu Collection, Tokyo*, and I trust that it will prove, like its predecessors, a new revelation of the artistic fertility of Japanese culture.

I wish to record my sincere thanks to those who have made this exhibition and catalogue possible. Firstly, of course, our gratitude goes to Mr Shōsuke Idemitsu, Director of the Idemitsu Museum, whose far-sighted agreement to lend these pieces to the British Museum made the whole project possible. Mr Tarō Nakao, Deputy Director, has used his considerable administrative skills to bring us through the many practical difficulties, and the long experience of the Chief Curator, Mr Tadanori Yuba, has also been of the greatest help to us. I also acknowledge the close co-operation on a day-to-day basis of the curator Masato Naitō with our own curatorial staff. International exhibitions are inevitably expensive, and so we are most grateful to Idemitsu Kōsan Co. Ltd for their substantial contribution to the costs of both the exhibition and related conference at the School of Oriental and African Studies, University of London. Despite the many demands upon its resources, the Japan Foundation has nonetheless lent much valued support with a contribution towards transport costs: Japan Airlines has shown similar generosity, as so often in the past, with respect to the travel of personnel involved in the project. At numerous stages in the planning we have benefited from the advice of His Excellency Mr Sadayuki Hayashi and his staff at the Embassy of Japan in London, in particular Minister Masatoshi Mutō.

The inspiration for building up the Rimpa collection of the Idemitsu Museum has been the advice and enthusiasm of the eminent scholar Professor Yūzō Yamane, who has cordially supported this exhibition since its first conception. Professor Yamane has honoured us by contributing an essay to the catalogue. Mr Naitō has also contributed an essay, and the commentaries on the paintings have been provided by him and those on the ceramics and lacquer by his colleague Mr Masaaki Arakawa. The Naumann Art Foundation has generously contributed to the costs of the catalogue; its founder, Mr Klaus Naumann, has also contributed to the exhibition from its inception with much practical assistance and encouragement. I believe that *Rimpa Art* will be another memorable chapter in the history of the Japanese Galleries at the British Museum.

DR R.G.W. ANDERSON
Director, British Museum

Foreword

by the Director

of the Idemitsu Museum of Arts, Tokyo

This is the first occasion on which works of 'Rimpa' art from the collection of the Idemitsu Museum of Arts, Tokyo, have been exhibited abroad. Our partner in this project, which has also kindly provided the venue for the exhibition, is the British Museum, a museum with a history of more than 240 years and well known throughout the world for the openness with which it makes its collections available to ordinary people. It is with the very greatest of pleasure that we show works of art from the Idemitsu Museum of Arts in a setting with such a brilliant history and present an exhibition of one special genre of traditional Japanese arts, works of the so-called Rimpa school.

Rimpa is the name given to an art form full of decorative splendour that first flowered and developed in the seventeenth and eighteenth centuries, corresponding to the Edo period (1600–1868) in Japanese history. The term, coined only in recent years, derives from the name of the painter Ogata Kōrin (Rimpa means 'School of Kōrin'), who had himself further developed the style of the earlier Tawaraya Sōtatsu, regarded as the founder of the school. Considered a uniquely Japanese art form, Rimpa has today in many ways become the most representative art form of our country, a name now known throughout the world. Following on from Sōtatsu and Kōrin, the school continued for over 250 years until the middle of the nineteenth century, producing many great artists in the same lineage, such as Sakai Hōitsu and Suzuki Kiitsu, who in turn have left us many great works of art.

Japanese painting before that time had been under the strong influence of China. In the Edo period, however, material and spiritual richness had their impact on the sense of beauty, and artistic expression began to pursue an independent development. A world of beauty unique to Japan was born, characterised by brilliant colouring and a strongly decorative quality. We are highly delighted to be able to introduce these aspects of traditional Japanese culture to London by means of this exhibition.

In 1993 an exhibition was held at the Idemitsu Museum of Arts, Tokyo, of works of Rimpa art from our collections. After the catalogue of this exhibition had been sent to the British Museum, Mr Lawrence Smith, then Keeper of Japanese Antiquities, came to Tokyo and said that he would very much like to stage a similar Rimpa exhibition in London. Mr Smith made the point that, surprisingly, there had never been a large-scale exhibition of Rimpa art in Europe, and the impact of such a show would therefore be felt not just in London, but across Europe as a whole. I remember how struck we were by the persuasive force of his request to hold the exhibition, and we were very pleased to agree.

We hope of course that this exhibition can make a contribution, no matter how humble, to amicable relations between the United Kingdom and Japan. And if, in addition, it can serve to link Europe in this wider sense in cultural exchange with Japan, then we shall be additionally gratified.

In making this exhibition a reality we have received unstinting support from Mr Graham Greene, Chairman of the Trustees of the British Museum, Dr Robert Anderson, Director, Mr Victor Harris, Keeper of Japanese Antiquities, and Lawrence Smith, Emeritus Keeper of Japanese Antiquities. In addition, Timothy Clark, as the specialist curator with responsibility for Japanese painting at the British Museum, has contributed greatly towards all aspects of the exhibition, from the selection of the exhibits and arranging the display, to writing an essay for the catalogue and translating the contributions of Japanese scholars.

Were it not for the warm support of all these individuals and organisations, this exhibition would certainly not have been possible. We thank you all most sincerely.

SHŌSUKE IDEMITSU
Director, Idemitsu Museum of Arts

Acknowledgements

In addition to those named by Dr Anderson and Mr Idemitsu in the preceding Forewords, the authors would like to record their special thanks to certain other individuals who have generously contributed their time and efforts towards the production of this catalogue. Yu-Ying Brown, Rupert Faulkner, Mavis Pilbeam and Toshio Watanabe all read particular sections of the text and suggested numerous helpful corrections. The book has been designed by Harry Green with customary sensitivity to the works of art included, and skilfully guided through the many stages of editing and production by Teresa Francis, Colin Grant and Julie Young at British Museum Press. Yuka Yoshikawa of the Hosomi Art Foundation kindly provided much advice and support in the matter of illustrative material for the essays and Kevin Lovelock of the British Museum Photographic Service responded at short notice to supplementary photographic requirements. Many thanks are due to the various museums and individuals concerned for their permission to reproduce works of Rimpa art from their collections. We are also most grateful to Misako Takeuchi for her permission to reuse a bibliography originally compiled by her for the catalogue of the Rimpa exhibition held at the Nagoya City Museum in 1994.

Notes on the Text

The Edo period (1600–1868)

The date given for the beginning of the Edo period in this catalogue is 1600, when Tokugawa Ieyasu (1542–1616) secured victory over his military rivals at the battle of Sekigahara. Readers should be aware, however, that the standard practice in the study of art history in Japan is to regard the preceding Momoyama period (began 1568) as having continued until 1615, the end of the Keichō (1596–1615) era, which saw the fall of Osaka castle and the destruction of the Toyotomi clan by the newly established Tokugawa Shogunate.

Traditional Japanese calendar and people's ages

References to months are given according to the Japanese pre-modern lunar calendar, so the tenth month, for instance, does not correspond to October of the solar calendar. Ages are given according to the traditional method of calculation which adds one year to what would be an individual's corresponding age in the West.

Japanese names

Apart from the names of the authors of this book, where they appear on the jacket, title page and headings to their essays, and those of individuals mentioned in the Forewords and Acknowledgements, all Japanese names from both the modern and pre-modern periods appear in the customary Japanese form, i.e. the family name precedes the given name.

References to illustrations

Where works of art are mentioned in the text and not illustrated, or only illustrated with small black and white figures, references are given in square brackets – e.g. [1:25] – to the volume and page number where they are illustrated in colour in the recent authoritative series *Rimpa* (ed. Murashige Yasushi and Kobayashi Tadashi, 5 vols, Kyoto, Shikōsha, 1989–92).

Tarashikomi technique

Numerous references will be found in the text to a painting technique highly characteristic of the Rimpa school known as *tarashikomi* (literally, 'dripping in'). Frequently used in the depiction of plants, trees and rocks, this consists of dripping one colour onto another area of colour that is still wet (typically, green onto black), so as to create a somewhat arbitrary spreading and pooling of the two colours within the confines of these localised areas of the design.

The Formation and Development of Rimpa Art

Yūzō YAMANE

EMERITUS PROFESSOR OF JAPANESE ART HISTORY, TOKYO UNIVERSITY

The name 'Rimpa'

Among the artists of the Edo period (1600–1868) in Japan, those who most fully express Japanese sensibility and emotion are Kōetsu, Sōtatsu, Kōrin, Kenzan and Hōitsu. This group of artists has in the past been known variously as the 'Kōrin school', the 'Kōetsu school' and the 'Sōtatsu-Kōrin school', but in recent years the name 'Rimpa' has come to be most widely accepted. Although the works of the Rimpa school consist mainly of paintings, they also include lacquerware and ceramics, so when wishing specifically to indicate painted works it is customary to use the term 'Rimpa painting'.

Why has the name of the school changed so often? More traditional schools such as Kanō and Tosa were based on family lineages, which continued to pass on their teachings from generation to generation over three centuries or more. The Rimpa school, on the other hand, was unique in that its essence was simply a shared appreciation of a particular style, a style which was transmitted only intermittently, being periodically revived and reborn about every hundred years or so. Its frequent changes of name reflect this unique character.

The first person to give the school a name was Sakai Hōitsu (1761–1828), who had made a personal study of the works of Ogata Kōrin (1658–1716). In 1815, to mark the hundredth anniversary of Kōrin's death, Hōitsu published the woodblock-illustrated catalogue *Kōrin hyakuzu* (One hundred works by Kōrin), which was also intended to bring about a revival of Kōrin's painting style. Learning that the original sources for Kōrin were Hon'ami Kōetsu (1558–1637) and Tawaraya Sōtatsu (worked *c.* 1600–40), Hōitsu collected together signatures and seals of this lineage of artists and published them under the title *Ogata-ryū ryaku impu* (Concise collection of seals of the Ogata lineage, 1815). He called the school the 'Ogata lineage' and regarded himself as belonging to it. Kōrin's name was in fact already widely known through his designs for lacquerware and textiles. Hōitsu's choice of the name Ogata lineage had the effect of making Kōrin even more famous, and before long the whole school became known as the 'Kōrin school'.

During the Meiji (1868–1912) era, too, the name most commonly used was 'Kōrin school'. Among certain intellectuals, however, there was an increasing veneration of Kōetsu. As the famous American art-historian Ernest Fenollosa (1853–1908) wrote in his posthumously published *Epochs of Chinese and Japanese Art* (1912), it was perfectly reasonable to regard Kōetsu as Kōrin's teacher – 'I refer to the school commonly spoken of as the "Korin", but which should be headed more properly with the name of Kōrin's teacher, Koyetsu'[1] – and so

opinion strengthened in favour of the name 'Kōetsu school'. In effect, Kōrin was merely someone who revived the Kōetsu school almost a century after that artist's death. In the Taishō (1912–26) era Kōetsu came to be widely celebrated as a 'many-talented genius'.

Then, from about the end of the Taishō era, scholars began to realise that, although Kōetsu certainly played the leading role in the movement to revive the arts of the courtly classical past and was himself highly skilled at calligraphy and ceramics, he had little competence in the field of pictorial art: in the works on which they collaborated it was in fact Sōtatsu who executed the paintings. Suddenly the works of Sōtatsu began to attract attention after a long period of neglect in the shadow of the reputation of Kōetsu. In the early Shōwa (1926–89) era this tendency became more pronounced and Kōetsu's name was even expunged from the name of the school, which came to be known as the 'Sōtatsu-Kōrin school'. Even before the war Sōtatsu's reputation as an artist seemed likely to surpass that of Kōrin. The only reason the name 'Sōtatsu school' was not adopted must have been that Kōrin was simply too famous to ignore.

In 1951 a large-scale exhibition of Rimpa works was held at the Tokyo National Museum with the aim of restoring a certain degree of self-confidence in Japan's culture after the trauma of defeat in the Pacific War. The name chosen on this occasion was 'Exhibition of the Sōtatsu-Kōrin school'. This triggered renewed progress in the study of the various artists of the school, and there was even a fragmentation of names into 'Sōtatsu school', 'Kōrin school' and 'Hōitsu school', on the grounds that Kōrin and Hōitsu were more than mere revivalists. On the other hand, the reputation of Kōetsu as 'many-talented genius' has persisted to this day. So the term 'Sōtatsu-Kōrin school' may be justified in the context of the history of painting, but since Sōtatsu was certainly influenced in some way by the artistic vision of Kōetsu, and there is also the need to include Kōetsu's ceramics and lacquerware, Kōrin's lacquer and Kenzan's ceramics, the realisation has dawned that this is simply not an appropriate name.

Outside Japan there have been several general exhibitions with the title 'Rimpa', undoubtedly reflecting the continuing high regard in which Kōrin is held abroad (Rimpa, literally 'Rin school', incorporates the second character of Kōrin's name). It could be said that the name Rimpa has come to be used to denote an art which is most quintessentially Japanese.

It was to reflect all these various circumstances that the name 'Rimpa' was chosen for an exhibition staged at the Tokyo National Museum in 1972, followed by the publication of a substantial catalogue with the same title, and this is the name that has come to be most widely accepted today.

I still think that the name 'Sōtatsu-Kōrin school' is most appropriate when discussing painting. For the time being, however, I use 'Rimpa' as a general term to cover not only the Sōtatsu, Kōrin and Hōitsu schools of painting but also the applied arts of the same style and lineage. Among historians of painting there are those who dislike the name Rimpa, arguing instead for the name 'Decorative painting school of the Edo period' (*Kinsei sōshoku gaha*), which reflects the style; but this has not yet found general acceptance.

Kōetsu, and Sōtatsu of the Tawaraya

Kōetsu was born into a branch of the illustrious Hon'ami family, who were hereditary appraisers and polishers of swords. The family belonged to the upper echelons of the so-called *machishū* (wealthy merchant) society of Kyoto, and Kōetsu was an individual of considerable cultivation and discernment. He has always been celebrated as a calligrapher, one of the 'three great brushes of

Fig. 1 Attributed to Tawaraya Sōtatsu (underpainting), and Hon'ami Kōetsu (calligraphy), *Waka poems over paintings of flowers and grasses of the four seasons.* Album, *c.* 1610. Museum für Ostasiatische Kunst, Berlin.

the Kan'ei (1624–44) era': the teabowls he made originally as an amateur are now hailed as the very greatest examples of such wares, and the lacquerware for which he provided designs was almost immediately awarded its own designation as 'Kōetsu lacquer' (*Kōetsu maki-e*). In the past it was argued that since Kōetsu was such a versatile genius, it was inconceivable that he did not also paint, and so the underpaintings beneath his elegant calligraphy on fans, *shikishi* (square poem-papers) and handscrolls were also thought to be from his brush.

About the life of Sōtatsu, on the other hand, nothing was known throughout the Edo period. Then, in the Taishō (1912–26) era, the *Sugawara-shi Matsuda Hon'ami-ke zu* (one of several extant genealogies of the Hon'ami family) was discovered; this was first introduced by Morita Seinosuke in his *Kōetsu* of 1916, published by Unsōdō, Kyoto. There was a note in this genealogy to the effect that Kōetsu's niece, from the main branch of the Hon'ami family, was the wife of Tawaraya Sōtatsu, which, if true, means that Kōetsu and Sōtatsu were closely related by marriage. However, it has unfortunately not been possible to verify this from other sources: there are no similar statements in other genealogies of the Hon'ami family, and this record was composed over a hundred years after the period. Nevertheless, research based on materials discovered since the war has so far revealed the following meagre information concerning Sōtatsu's life:

(1) Sōtatsu had the business name Tawaraya and was from the rich merchant class of Kyoto. He was a friend of the tea master Sen Shōan (1546–1614) and was

Fig. 2 Attributed to Tawaraya
Sōtatsu (underpainting), and
Hon'ami Kōetsu (calligraphy),
Waka poems over paintings of deer
(detail). Handscroll, *c.* 1615.
Seattle Art Museum; gift of Mrs
Donald E. Frederick [3:157].

Fig. 3 Attributed to Tawaraya
Sōtatsu (underpainting), and
Hon'ami Kōetsu (calligraphy),
Waka poems over paintings of cranes
(detail). Handscroll, *c.* 1610.
Important Cultural Property,
Kyoto National Museum [3:101].

also acquainted through the tea ceremony with Kōetsu, Iseki Myōji (dates unknown), a prominent manufacturer of Kyoto Nishijin brocade, and others.

(2) The Tawaraya was the name of a business relating to paintings (a 'painting shop', *eya*), and Sōtatsu is thought to have been its proprietor. Already by the Genna (1615–24) era, the products of the Tawaraya workshop – 'Tawaraya pictures' (*Tawaraya-e*) and 'folding fans from the Tawaraya' (*Tawaraya no ōgi*) – had gained a reputation in Kyoto.

(3) By 1630 he had been awarded the title *Hokkyō* ('bridge of the law') and was producing work for the Imperial court. The name 'Sōtatsu' was well known in court circles and he had a particularly close relationship with the courtier Karasumaru Mitsuhiro (1579–1638).

Although Sōtatsu's birth and death dates are not yet known, certain other facts can be deduced from a study of his works: he began his activities as a painter around 1600; he continued to produce works until about 1638 or 1639; he died several years later at a fairly advanced age. The characteristics of Sōtatsu's painting style and its development can be summarised as follows.

During the Keichō (1596–1615) era, Sōtatsu worked with Kōetsu towards a revival of the artistic combination of calligraphy and decorated paper, a practice that originated in the Heian period (794–1185). Kōetsu must have possessed a good grounding in the calligraphic styles of the Heian court and it seems that it was he who approached Sōtatsu for his cooperation, not only to enhance his own calligraphy but also, more ambitiously, to create a new beauty.

In addition to his natural artistic ability, Sōtatsu was strongly influenced by the gorgeous gold and silver decoration of the *Heike nōkyō* scrolls (thirty-three decorated handscrolls of the Lotus and other sutras donated to the Itsukushima Shrine by the Taira clan in 1164, National Treasure; fig. 38). He repaired the twelfth-century originals in 1602, and must also have gleaned much from study of the *Sanjūroku-nin kashū* (Anthology of the Thirty-six Poets, twelfth century, National Treasure belonging to the Nishi Hongan-ji Temple), the most glorious example of courtly decorated papers.

After this he seems to have devised the printing of under-designs in gold and silver (cat. no. 14), a development of traditional techniques of printing patterned papers with mica, and also to have painted under-designs in gold and silver on fans, *shikishi* (fig. 1) and handscrolls (cat. no. 12). These were then given over to Kōetsu. Nearly all the subjects were common flowers and grasses, but Sōtatsu also favoured creatures such as butterflies, plovers, cranes and deer. Sōtatsu's distinctive approach was to capture the motifs not by means of outlines but with expanses of flat colour, and so he applied the gold and silver paint thickly. At first he seems to have respected the fact that his works were supposed to be under-designs for calligraphy, and many of the motifs were relatively modest in scale (for example, the *shikishi* pasted onto the screen of *Cherry blossom and kerria flowers*, Tokyo National Museum [5:5]). However, they later came to be rendered in ever-increasing close-up, completely filling even small formats. In response to such under-designs, Kōetsu soon developed a novel style of calligraphy characterised by thick, swelling strokes. In contrast to the ancient elegant aesthetic of the Heian court, whereby the calligraphy and under-drawing had acted together in harmony, Kōetsu's calligraphy and Sōtatsu's gold and silver paintings seemed to be pitted against one another as well-matched opponents in an extravagant display of beauty typical of the Momoyama (1568–1600) period. The new combination was widely acclaimed and it is fair to say that it produced masterpieces of a type that had not existed before. Examples include *Waka poems over paintings of Deer* (fig. 2), *Cranes* (fig. 3), *Flowers and grasses of the four*

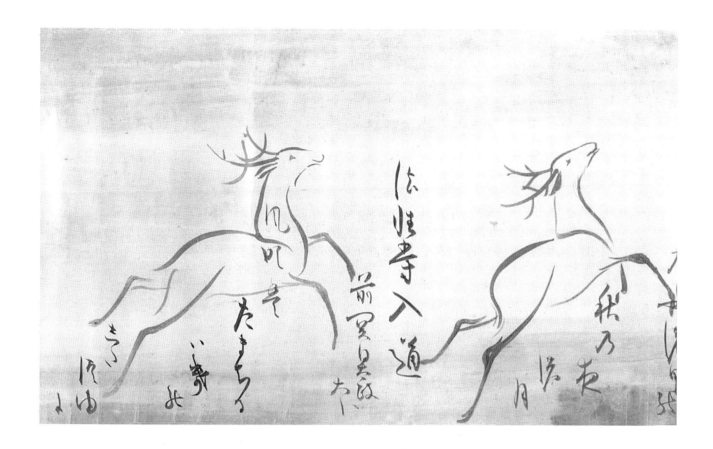

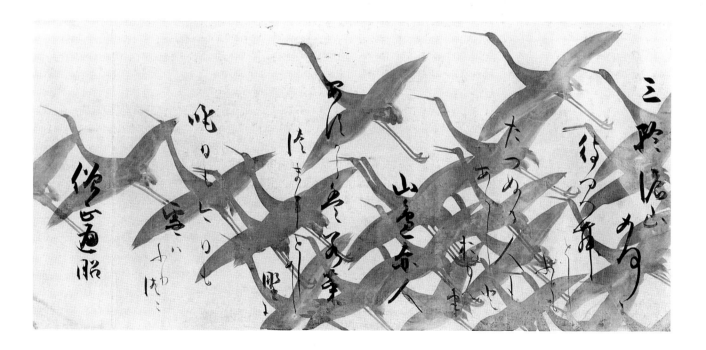

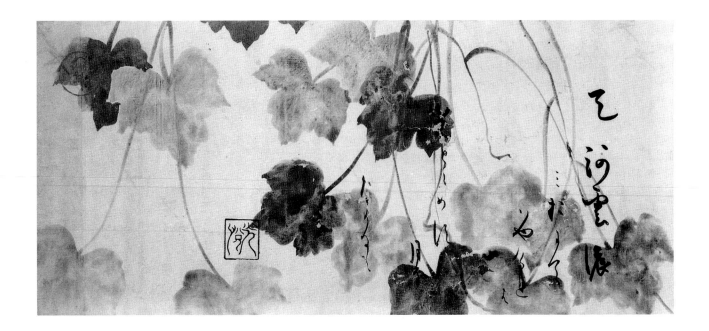

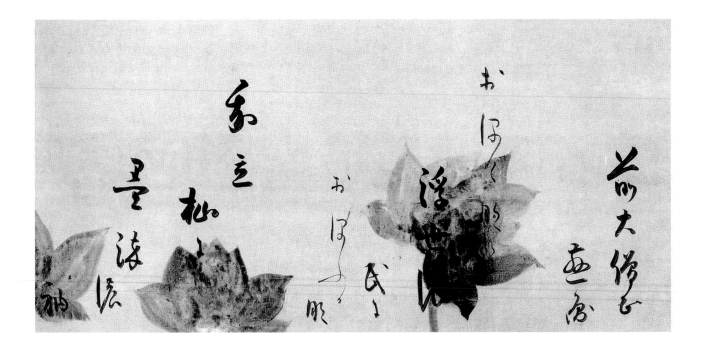

Fig. 4 Attributed to Tawaraya
Sōtatsu (underpainting), and
Hon'ami Kōetsu (calligraphy),
*Waka poems over paintings of flowers
and grasses of the four seasons*
(detail). Handscroll, *c.* 1610.
Important Cultural Property,
Hatakeyama Memorial Museum,
Tokyo [1:1].

Fig. 5 Attributed to Tawaraya
Sōtatsu (underpainting), and
Hon'ami Kōetsu (calligraphy),
Waka poems over paintings of lotuses
(detail). Handscroll, *c.* 1620. Tokyo
National Museum [2:84].

seasons (fig. 4) and *Lotuses* (fig. 5 and cat. no. 12). However, Sōtatsu's gold- and silver-painted designs did have a tendency to exceed the limits of under-drawings for decorated papers (because the silver tarnished, there are even examples in which Kōetsu's calligraphy becomes hard to read: e.g. fig. 1). Although Sōtatsu's and Kōetsu's competing performances have a unique appeal, the two were nonetheless fated to part company at some point. In fact the peak of joint production was reached around 1610. The last example was the handscroll of *Waka poems over paintings of lotuses* mentioned above, thought to date from the early Genna (1615–24) era; after this Sōtatsu broke away from Kōetsu to relaunch his career as an independent artist. The fact that Sōtatsu's name does not appear on the map of the so-called 'Kōetsu village' established in 1615 on land granted by the Tokugawa shogunate at Takagamine doubtless reflects these circumstances.

There are still many mysteries concerning Kōetsu's and Sōtatsu's artistic activities during the Genna (1615–24) era, but Kōetsu certainly seems to have been busily occupied with the running of the Takagamine artistic colony. It was not until 1626 that he again began to produce a large number of handscrolls with calligraphy – this time with under-designs painted by Sōtatsu's pupils. The newly independent Sōtatsu, having explored the expressive potential of gold and silver paintings to their limits, now pursued his technical investigations in two other directions: first, seeking to harmonise the tonalities of ink painting, and second, studying the distribution of colour in full-colour painting. In terms of subject matter, he appears to have turned to classical themes in addition to flowers and grasses. During the Genna (1615–24) era, Sōtatsu also devoted himself to the Tawaraya workshop, supplying his pupils with fan paintings to copy on such themes as *Tale of Genji* (*Genji monogatari*) and *Tales of the Hōgen and Heiji disturbances* (*Hōgen Heiji monogatari*). In this way 'painted fans of the Tawaraya' seem to have achieved a certain reputation.

Sōtatsu's screen paintings

In 1622 Sōtatsu was commissioned to execute wall and sliding-door paintings with gold-leaf backgrounds at Yōgen-in Temple in Kyoto, which was rebuilt at that time by Sūgen-in, the wife of Shogun Tokugawa Hidetada, in memory of her father Asai Nagamasa (1545–73). This was a vital turning point. Up to that time Sōtatsu, although leader of the Tawaraya picture workshop, was really no more than one of many urban professional painters (*machi-eshi*). During the heyday of Kanō sliding-door and screen painting on gold-leaf backgrounds, he had previously limited himself entirely to small compositions which had the character of craftwork. It is unclear why Sōtatsu should have obtained the commission to paint at Yōgen-in (perhaps it may have been on the recommendation of Kōrin's grandfather, Ogata Sōhaku (1570–1631), who had close links with the Asai family, Sūgen-in and Sūgen-in's daughter Tōfukumon-in). At any rate, Sōtatsu was granted the honorary rank of *Hokkyō* to mark his successful completion of the paintings at Yōgen-in, and I would argue that this took place at the end of the Genna (1615–24) or beginning of the Kan'ei (1624–44) era.

If we list the screen paintings that can be attributed to Sōtatsu with certainty, the total comes to six works: (1) *Pine-islands* [*Matsushima*] (fig. 6); (2) *Dragons in clouds* (pair of six-fold screens, Freer Gallery of Art, Smithsonian Institution, Washington, D.C. [3:185]); (3) *Black pines and Japanese cypress* (six-fold screen, Ishikawa Prefectural Art Museum [3:90]); (4) *Bugaku dancers* (pair of two-fold screens, Important Cultural Property, Daigo-ji Temple [4:231]); (5) *Scenes from 'Tale of Genji' – the 'Gatehouse' and 'Channel Buoys' chapters* (fig. 7); (6) *Wind God*

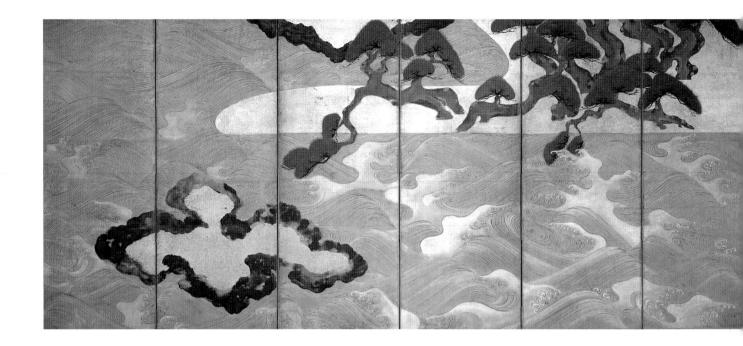

Fig. 6 (top) Tawaraya Sōtatsu, *Pine-islands* [*Matsushima*]. Pair of six-fold screens, *c*. 1625. Freer Gallery of Art, Smithsonian Institution, Washington D.C., 06.231-232 [3:1].

Fig. 7 Tawaraya Sōtatsu, *Scenes from 'Tale of Genji' – the 'Gatehouse'* (right) *and 'Channel Buoys'* (left) *chapters*. Pair of six-fold screens, *c*. 1637. National Treasure, Seikadō Bunko Art Museum, Tokyo [4:43].

and Thunder God (fig. 8). Of these, nos 1–5 all bear the signature 'Sōtatsu of Hokkyō rank' (*Hokkyō Sōtatsu*) and so can be dated to the Kan'ei (1624–44) era. There is apparently no signature on no. 6, the *Wind God and Thunder God* screens, but these are widely acclaimed as Sōtatsu's greatest masterpiece and I would place the date of their production in his final years, that is, the second half of the Kan'ei (1624–44) era. Nos 1–6 should be regarded as Sōtatsu's most representative works and thus surely demonstrate that during the Kan'ei era his main focus of interest was the production of large-scale screen paintings.

In his highly important commission for the paintings at Yōgen-in, Sōtatsu had been seeking to establish a new style for sliding-door and screen painting on gold leaf that differed from that of the Kanō school. These sliding-door paintings of *Pines and rocks* [3:83] originally comprised twenty panels. Sōtatsu took a subject commonly found in Yamato-e painting of the Muromachi period

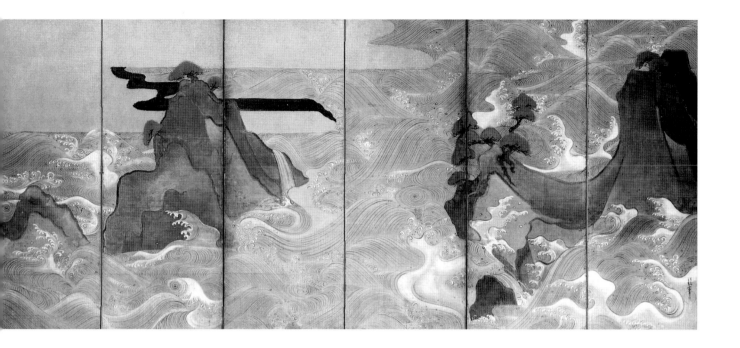

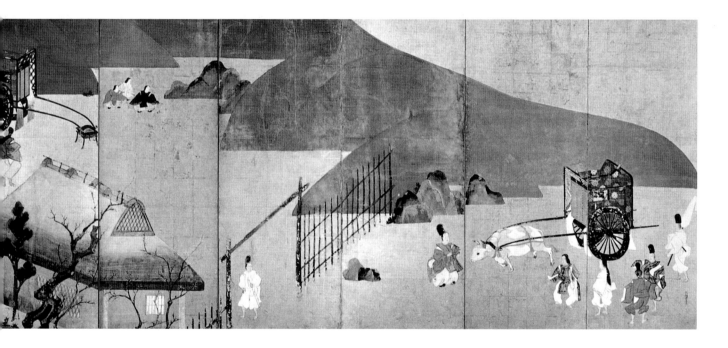

(1333–1568), and by applying the rhythmic compositional techniques of the gold and silver paintings on handscrolls that he had mastered during the Keichō (1596–1615) era, was able to create new large-scale paintings. Perhaps because he was trying so hard to oppose the Kanō style, however, Sōtatsu tends to exaggerate the size of his motifs. Although there are passages in which he succeeds in expressing a sense of solidity previously absent from his work, nevertheless, taken as a whole, the progression of the composition lacks a sense of rhythm (this may partly be explained by Sōtatsu's inexperience in large-scale screen painting). Nor does the overall gold-leaf background, so insistent in its presence, give a feeling of living space. Realising these shortcomings, Sōtatsu next set himself the difficult task of using the constituents of form and colour to turn the wide planes of gold into rich space that extended deep into the painting. I see each of the six works in screen format listed above – particularly nos 1, 4, 5

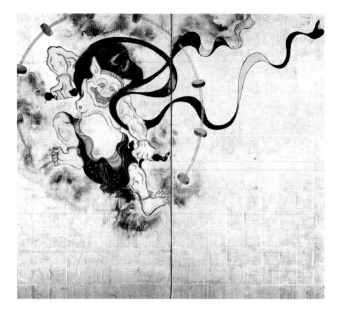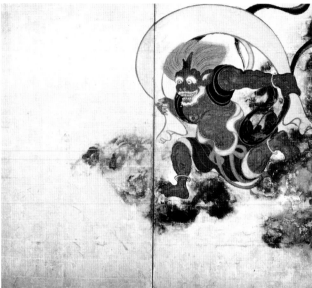

Fig. 8 Tawaraya Sōtatsu, *Wind God and Thunder God*. Pair of two-fold screens, *c.* 1640. National Treasure, Kennin-ji Temple, Kyoto [4:130].

and 6 with their gold-leaf backgrounds – as demonstrative of Sōtatsu's efforts to overcome these problems.

There is not adequate space here to discuss the order in which these six works from the *Hokkyō* period were produced, nor to describe how Sōtatsu succeeded in surmounting the difficult compositional problems he set himself. Suffice it to say that he gave brilliant new life to Yamato-e painting, reviving magnificently a tradition that had been in decline. Nos 2 and 3, the screens which use the technique of just ink on paper, also represent a high point in the tradition of Japanese adaptations of continental ink painting modes. It was these paintings, too, that later so excited Kōrin and made it possible for him to achieve such great heights in his art. In the words of the art-historian Yashiro Yukio, a scholar deeply knowledgeable in the arts of both East and West: 'When we consider Japanese art in comparison to the great masterpieces of European art we see abroad, I feel that the decorative, large-scale paintings by Sōtatsu and Kōrin should be singled out as truly symbolising our country and exhibiting Japanese sensibility to the full. What is more, they are also capable of standing their ground against the large-scale compositions of the West.'[2]

Fan paintings and ink paintings by Sōtatsu

Screens pasted with fans

The type of painting most commonly associated with Sōtatsu is fan painting. Irrespective of whether they were actually used as fans or not, all his fan paintings were preserved by being pasted onto folding screens (those presently mounted as hanging scrolls have been taken off screens and remounted). There are eight works of this type – known as 'screens pasted with fans' (*semmen haritsuke byōbu*, cat. no. 1) – and the total number of fans pasted onto them exceeds 220. The most famous of these has always been the pair of eight-fold *Screens pasted with fans* [5:13] in the Imperial Collection, which has long been attributed to Sōtatsu himself. Its forty-eight fans can be divided by subject as follows: scenes from *Hōgen monogatari* (twenty fans), scenes from *Heiji monogatari* (sixteen fans), scenes from either *Hōgen* or *Heiji* (two fans), a scene from either *Hōgen* or *Saigyō monogatari* (one fan), flowers and grasses (five fans). Six of the eight examples of screens pasted with fans have been discovered since the war and these can be broadly divided into three categories: flowers and grasses, figure subjects from the classics, and other subjects. Among them are many fans

depicting *Hōgen monogatari* and *Heiji monogatari*, similar to those in the Imperial Collection. However, the quality of execution varies widely and the opinion evolved that not all could be by Sōtatsu himself. At that point various new factors – the discovery of an account in the popular novel *Chikusai* by Isoda Dōya (published *c.* early Kan'ei [1624–44] era) to the effect that the 'painted fans of the Tawaraya' (*Tawaraya no e-ōgi*) had become popular in Kyoto, and the subsequent discovery of three types of seal on many of the fans, two reading 'Inen' and 'Taitō' and one unread – quickly led scholars to the conclusion that these fan paintings were the product of a 'Tawaraya workshop' with Sōtatsu at its centre.

Even allowing for a certain range in the quality of execution, the 'Sōtatsu' fans do display superior characteristics, completely different from those of Kanō, Tosa and other fan paintings: they treat the motifs on an unusually large scale; they show great skill in adapting scenes from medieval handscrolls and other sources; and they create compositions with a wonderful sense of *mise en page*, exploiting to great effect the unusual shape of the paper used for a folding fan. In any case, it is thought to have been Sōtatsu who provided the models for his pupils to copy, and it is highly likely that in the near future we shall be able to differentiate individual artists working within the Sōtatsu workshop as pupils A, B, C, D and so on.

The problem, surely, is whether or not there are any genuine works by Sōtatsu himself among these fan paintings. Some of those depicting flowers and grasses are technically very similar to the paintings in gold and silver in the *shikishi* format of the Keichō (1596–1615) era (fig. 1). These are fan paintings in Sōtatsu style and comparatively early in date, and I would suggest that they were probably done by Sōtatsu himself during the Keichō era. In the case of the fan paintings with scenes from classical tales that appear in greater numbers from the Genna (1615–24) era onwards, it is quite difficult to detect works attributable to Sōtatsu himself: so far, probable candidates seem to be the eleven fan paintings pasted onto the pair of two-fold screens belonging to Daigo-ji Temple (Important Cultural Property [5:14]), unusual examples of works by Sōtatsu dating from *c.* 1630. The production of fan paintings by the Tawaraya workshop continued during the Kan'ei (1624–44) era, even after Sōtatsu was elevated to *Hokkyō* rank.

In some cases the screens were not decorated with existing fan paintings; instead, fan-shaped outlines were painted directly onto the screen and then filled with various motifs. These are known as 'screens with scattered fans' (*semmen chirashi-zu byōbu*, cat. no. 2) or 'screens with fans on flowing water' (*semmen nagashi-zu byōbu*). In effect, patterns of scattered fans were being employed to decorate screens that were then used as interior furnishings. A number of such works are in the Sōtatsu manner. All bear the 'Inen' seal and on stylistic grounds should be regarded as Tawaraya workshop pieces dating from the Kan'ei (1624–44) era.

Ink paintings

The second type of work most commonly attributed to Sōtatsu is ink painting. Like fan paintings, ink paintings were most often originally pasted onto folding screens. It is true that Sōtatsu painted large-scale works in ink directly onto screens, such as the *Dragons in clouds* and *Black pines and Japanese cypress* (nos 2 and 3 in the list given on pp. 19–20), and produced ink paintings that were intended from the start to be hanging scrolls (cat. no. 21), but these are few in number. It is fair to assume that most ink paintings were intended to be pasted onto screens (though the custom of remounting them as hanging scrolls appears

already to have begun in the late Edo period [1600–1868]). Almost all the surviving ink paintings have the signatures 'Hokkyō Sōtatsu' or 'Sōtatsu Hokkyō' and the seals 'Taisei' or 'Taiseiken'. There are some examples where the signature is thought to have been added when the painting was remounted as a hanging scroll, but even in such cases the seals are either 'Taisei' or 'Taiseiken' – both well known to have been used during Sōtatsu's *Hokkyō* period – and we can assume that they were painted after Sōtatsu was awarded the *Hokkyō* rank, that is, during the Kan'ei (1624–44) era. This means that very few of the ink paintings date from before this time. In the case of gold and silver paintings and full-colour paintings, too, Sōtatsu only began to add a signature to his works after receiving the *Hokkyō* title: there is not a single instance of his signing just 'Sōtatsu'. It is thought that before this date he only used the 'Inen' seal, and then only in special cases, such as at the end of the handscroll of *Waka poems over paintings of Deer* (fig. 2), his masterpiece in the genre of gold and silver painting from the second half of the Keichō (1596–1615) era. One of Sōtatsu's most representative works in the ink painting genre is the *Lotuses and waterbirds* hanging scroll (fig. 9). This bears the 'Inen' seal and is one of the earliest ink paintings by Sōtatsu, probably executed at the beginning of the Genna (1615–24) era.

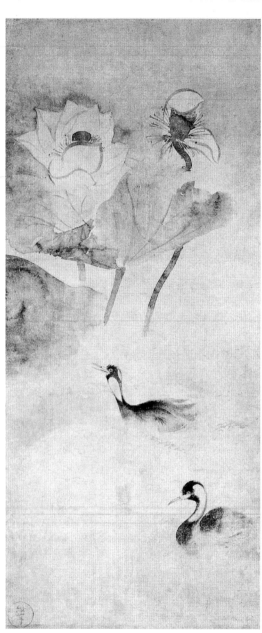

If we categorise by subject the many ink paintings dating from the period when Sōtatsu used the *Hokkyō* signature, the majority are of common animals and birds, including dogs, rabbits, ducks, herons and domestic fowl, and we find very similar compositions repeated many times. If we compare these, we find, as with the fan paintings, quite marked differences in the level of technical skill, and it is readily apparent that they cannot possibly all be by Sōtatsu himself. Obviously in the case of ink paintings, too, we must allow for the existence of Tawaraya workshop pieces. In other words, the 'Hokkyō Sōtatsu' and 'Sōtatsu Hokkyō' signatures and the 'Taisei' and 'Taiseiken' seals are kinds of trademark indicating that these are products of the Tawaraya workshop. On the other hand, there are both fan paintings and screens painted with scattered fans which have the 'Inen' seal, and so this latter seal should also be regarded as a trademark of the Tawaraya workshop. Indeed, we may conjecture that during Sōtatsu's *Hokkyō* period he was surrounded by two groups, one which used the 'Inen' seal and painted mainly full-colour works, and another which used the 'Taiseiken' seal and painted mainly monochrome ink works. Of course, since these two groups both belonged to what can be called the 'Tawaraya workshop' (or the 'Sōtatsu workshop'), they were certainly closely connected.

Fig. 9 Tawaraya Sōtatsu, *Lotuses and waterbirds*. Hanging scroll, *c.* 1615. National Treasure, Kyoto National Museum [2:85].

By the late Edo (1600–1868) period, Sōtatsu's ink paintings were described as 'things drawn as shadow pictures' (*kage-bōshi o utsushita mono*, a phrase used by Konoe Iehiro in his printed memoir *Kaiki*, preface dated 1724). We might paraphrase this as 'painting the subject using flat planes instead of outlines'. Sōtatsu's other favoured compositional technique of painting the subject large within the format is obviously also appropriate for 'shadow pictures'. It seems likely that, right from the beginning, ink paintings by the Tawaraya workshop had a broad popular appeal based on their familiar subjects – unlike those of the

Kanō and other schools – coupled with their unusual compositions and the 'shadow painting' technique. This must surely be the reason why so many ink paintings in Sōtatsu style have survived to the present day. Looked at one by one, the subtle differences between them in the quality of expression are indeed as fleeting as 'shadows' and would have required a connoisseur of some experience to appreciate them fully. Nevertheless, ordinary people must have been captivated by the excellence of this new style which, in comparison with the stiffness and formalism of Kanō school ink painting, must have seemed so fresh and yet so familiar at the same time.

Sōtatsu's followers

Sōsetsu

The only follower of Sōtatsu whose name is known is Sōsetsu. Various accounts describe him as Sōtatsu's younger brother or son, or even as one of his pupils, but in any case he was using the name Tawaraya Sōsetsu by 1639. By 1642 he had already been elevated to *Hokkyō* rank, and in that year he is known to have executed a painting of *Flowers and grasses* for Retired Emperor Gomizuno'o (1596–1680). It seems likely that from the early Kan'ei (1624–44) era, when Sōtatsu received the *Hokkyō* rank, Sōsetsu took over control of the Tawaraya workshop and, following in Sōtatsu's footsteps, was himself later awarded the *Hokkyō* rank. It may be that Sōsetsu's assumption of the *Hokkyō* rank meant that Sōtatsu was already dead. In 1642 Sōsetsu painted wall and sliding-door paintings in the palace built by Prince Hachijō Tomotada (1619–62) for his new wife, Princess Tomi, fourth daughter of Lord Maeda Toshitsune of the Kaga fief. In about 1644 he went to Kanazawa in Kaga and became a painter in the service of the Maeda clan. In 1650 he is said to have painted sliding-door and screen paintings of flowers and plants with gold-leaf backgrounds, in collaboration with Kanō Tan'yū, at the Edo residence built by Maeda Toshiharu. His most representative work is *Autumn grasses* (pair of six-fold screens, Important Cultural Property, Tokyo National Museum [2:193]), which has a composition somewhat reminiscent of the famous *Narrow Ivy Path* (pair of six-fold screens, Manno Art Museum [4:9]) that bears an 'Inen' seal (see p. 26); however, the Sōsetsu work is far less novel in terms of its design. All in all, Sōsetsu seems to have been most celebrated as a painter of flowers and grasses.

Sōsetsu*

The artist who succeeded Sōsetsu was also called Sōsetsu (written with different characters and so here designated Sōsetsu*). He painted many screens of *Flowers and grasses*, including one example signed 'Painted by Kitagawa Sōsetsu* of *Hokkyō* rank, aged seventy-two years' (*Kitagawa Hokkyō Sōsetsu nanajū-ni sai hitsu*; pair of six-fold screens, Kurobe City [1:103]). In comparison with Sōsetsu's screens of flowers and grasses, which still retained the large scale of landscape paintings across the whole screen, most of Sōsetsu*'s works are in the format of screens with a separate composition pasted onto each of the leaves (*oshie-bari*) (fig. 10). Each of these individual compositions is characterised by its skilful arrangement of only one or two kinds of flower or plant. The luxuriance and the large scale of paintings by Sōtatsu have been completely lost, but there are nonetheless certain elements worthy of appreciation, such as the increase in the variety of flowers depicted, the manner in which their individual characteristics have been faithfully captured, and the fresh new way in which the colours and ink have been harmonised. Even after Sōsetsu*, there appear to have been painters in the Kanazawa area who specialised in depictions of flowers and grasses.

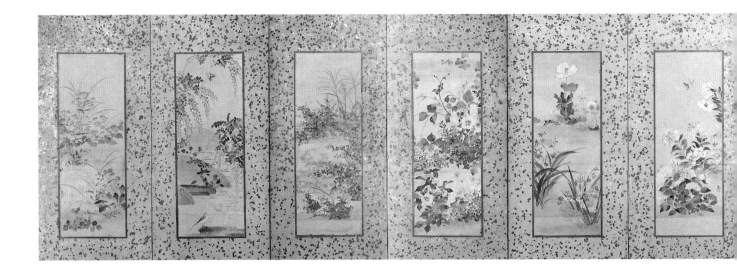

Fig. 10 Kitagawa Sōsetsu*, *Flowers and grasses*. Pair of six-fold screens, *c.* 1645. Idemitsu Museum of Arts, Tokyo.

Anonymous painters

Among the pupils of Sōtatsu in the Tawaraya workshop, there seem to have been two or three anonymous painters who were technically a great deal more proficient than his successor Sōsetsu, even approaching the skill of Sōtatsu himself. The leading pupil was given the 'Inen' seal by Sōtatsu in the early Kan'ei (1624–44) era and is referred to as the 'Painter of the Inen seal' or as 'Painter A'. He was particularly skilled at paintings of flowers and grasses, and around the middle of the 1630s produced a succession of famous works such as *Moon and autumn grasses* (cat. no. 15);[3] *Cherry blossom and poppies* (four sliding-door panels, Private Collection, Japan [2:53]); *Silk tree, flowers and grasses* (four-fold screen, Freer Gallery of Art [2:179]); *Flowers and grasses* (four sliding-door panels, Kyoto National Museum [1:25]), and *Narrow Ivy Path* (pair of six-fold screens, Important Cultural Property, Manno Art Museum [4:9]). The second pupil was given the 'Taiseiken' seal by Sōtatsu in the second half of the Kan'ei (1624–44) era and was also permitted to use the signature 'Sōtatsu Hokkyō'; he is referred to as the 'Painter of the Taiseiken seal' or 'Painter B'. His works include *Black pines and maples* (six-fold screen, Yamatane Art Museum [2:333]), later copied by Kōrin; *Scenes from Tale of Genji* (eight-fold screen, Burke Collection, New York),[4] and *The 'Gatehouse' chapter from Tale of Genji* (six-fold screen, Important Cultural Property, Kyoto National Museum [4:45]).

'Painter A' and 'Painter B' led, respectively, the 'Inen' seal group and the 'Taiseiken' seal group, which produced fan paintings and ink paintings in large quantities and endeavoured to promote the Sōtatsu style. They continued to remain active in Kyoto even after Sōsetsu went to Kanazawa. The painter referred to as 'Mr Nonomura of the Tawaraya' (Tawaraya Nonomura-shi) in *Yōshū fushi* (1682) by Kurokawa Michisuke must have been one of the artists who succeeded to that lineage. However, the level of their skill was not sufficient to lay the foundations for the appearance of Kōrin.

Revival and consolidation by Kōrin

Kōrin's admiration for Kōetsu and Sōtatsu

Kōrin was born in 1658, the second son of Ogata Sōken (1621–87), owner of the prosperous Kariganeya drapery business in Kyoto. His grandfather Sōhaku's mother was Kōetsu's elder sister, so Kōrin was a blood relative of Kōetsu. At first his common name (*tsūshō*) was Ichinojō, but at the age of 34 or 35 he changed this to Kōrin. This must have been in order to follow the example of

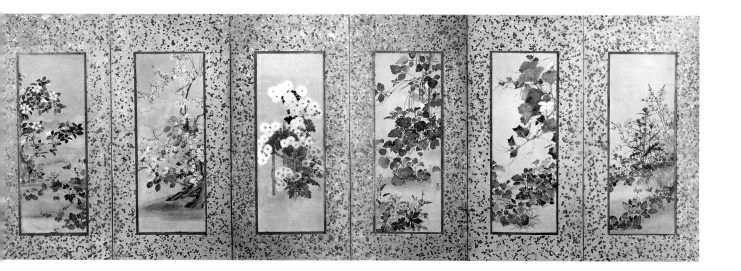

Kōetsu (the two names share the same first character). His formal name (*na*) was Koretomi or Koresuke, which he later changed to Masatoki. His art-names (*gō*) were, first, Sekisui, then Kansei and Dōsū, also Jakumei and Seisei. He also used a seal reading 'Iryō', which imitated Sōtatsu's 'Inen' seal, the second character 'ryō' being an alternative reading of the 'suke' character in Kōrin's name Koresuke. His younger brother, five years his junior, had the common name Gompei and later became famous as a painter, using the name Shinsei, and as a potter, using the name Kenzan (see pp. 36–8). Kōrin was awarded the *Hokkyō* rank in 1701; otherwise his career can be divided into the following five periods:

1. Dependent on his parents (1658–87)
2. Produces study works as a painter (1688–96)
3. Establishes his own style (1697–1704, either side of 1701 when he receives the *Hokkyō* title)
4. Changes occur in his style (resident in Edo, 1704–9)
5. Reaches full maturity of his style (after the return to Kyoto, 1709–16)

All but four or five of the surviving works by Kōrin date from after his assumption of the *Hokkyō* title at the age of 44. Various facts about his early career can be deduced, however, from a study of the many preparatory drawings and sketches that have been passed down through Kōrin's descendants in the Konishi family (Research Materials relating to Kōrin formerly in the collection of the Konishi family, Important Cultural Property, Agency for Cultural Affairs, Tokyo/Osaka City Museum).

Even during period 1, before he was 30, Kōrin was obviously studying the hybrid Kanō-Tosa painting style that was then fashionable among the upper classes of Kyoto. This was due to the influence of his father, Sōken, who pursued many varied cultural activities. The screens *Pine, bamboo and cranes* (six-fold screen and four-fold screen, Metropolitan Museum of Art, New York [5: *shiryō* 1–1]) have been put together from various studies and are a work of Kōrin's twenties. It seems likely that he must have studied with his father under a painter of the Kanō school in Kyoto (the painter Yamamoto Soken [?-1706] has been suggested), and it is significant that Kōrin should have begun his career with Kanō-style works.

During period 2, his thirties, Kōrin and his younger brother were frequent visitors to the mansion of the aristocrat Nijō Tsunahira (1670–1732). Spending his days in such conspicuous socialising, Kōrin quickly used up his inheritance and was soon on the verge of bankruptcy. In this period he continued his study of

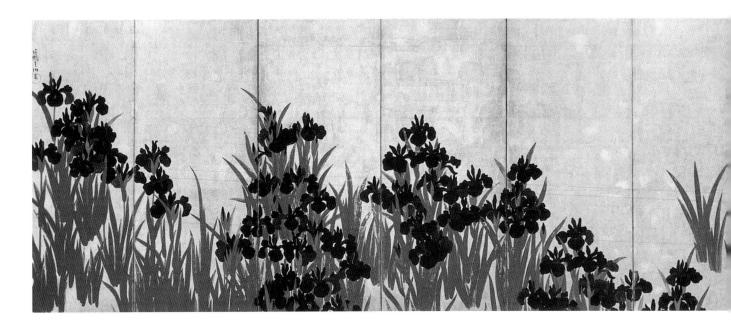

Fig. 11 Ogata Kōrin, *Irises*. Pair of six-fold screens, *c.* 1702. National Treasure, Nezu Art Museum, Tokyo [2:122].

painting, however, and was drawn to the beauty of the works of lacquerware and ceramics by Kōetsu that had been passed down in his family. Assuming the name Kōrin for the first time, he made his first attempts at *maki-e* lacquer pieces. He also discovered the beauty of the paintings by Sōtatsu that had been passed down in the Ogata family – there seem to have been gold and silver paintings, ink paintings, fan paintings and screens – and at first concentrated on trying to learn their special designs and technique by means of copying. It was this personal rediscovery of Sōtatsu's paintings that really represented the birth of Kōrin as an artist. The period was also marked by the first appearance of works bearing the Kōrin signature, such as *Poem-pictures for the twelve months* (pair of six-fold screens [*oshibari*], Kyōtaru Co. Ltd. [1:87]) and the hanging scroll portraits of the *renga* poets Sōgi (cat. no. 22) and Botanka Sōhaku [4:120]. Then, in 1696, at the age of 39, facing imminent financial ruin, Kōrin finally determined to establish himself as a painter. The hanging scroll *Hotei kicking a ball* (cat. no. 23) can be described as a creative representation of that decision, symbolised by the stalwart expression given to the figure of Hotei.

It was in his early forties, period 3, that Kōrin showed remarkable progress as an artist. The two-fold screen *Autumn grasses* (Private Collection, Japan; Yamane Yūzō, *Rimpa meihin hyakusen*, 1996, no. 54), painted when he was about 40 years old, bears just the 'Iryō' seal, reviving the lineage of earlier *Flowers and grasses* screens with the 'Inen' seal (for example, cat. no. 16). The way in which he succeeds in unifying the large composition by repeating the elegant curving lines of the pampas-grass, however, shows us that Kōrin is beginning to display his true abilities. The award of *Hokkyō* rank when he was 44 was a spur to further efforts and, cultivating the powerful support of patrons such as Nakamura Kuranosuke, a high-ranking official (*toshiyori*) at the Kyoto mint known for his lavish lifestyle, Kōrin began to paint screens with gold backgrounds such as the *Morning glory on a fence* (two-fold screen, Idemitsu Museum of Arts). The most representative work of this period is the famous pair of screens of *Irises* (fig. 11). Ink painting of the same period is represented by the hanging scroll *Hanshan and Shide* (*Kanzan and Jittoku*, Private Collection, Japan).[5] Although a small-scale work, the rapid brushwork and the powerful composition linking the two monks (both figures are borrowed from ink paintings by Sōtatsu and recombined) demonstrate Kōrin's vigour at this point in his career.

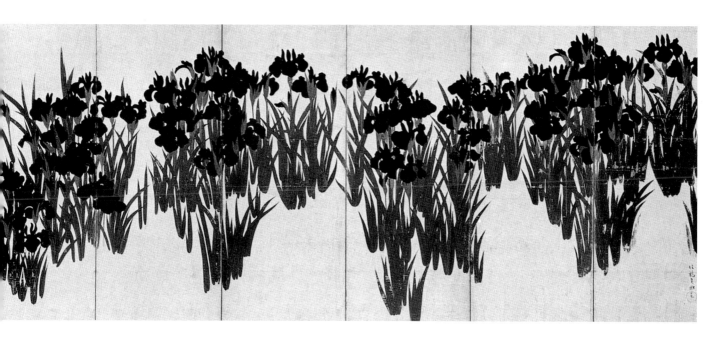

Changes in Kōrin's style and its consolidation

In the tenth month of 1704 Kōrin made his first trip to Edo, relying for help on his patron Nakamura Kuranosuke who was posted there on official service at that time. He wrote in his letters how he expected to escape from his endless cycle of economic difficulties in Kyoto and enjoy 'wonderful happiness' (*kimyō naru shiawase*) in Edo.[6] In the third month of 1705 he returned for a while to

Fig. 12 Ogata Kōrin, *Autumn plants.* Painting on a kimono, *c.* 1707. Important Cultural Property, Tokyo National Museum [2:223].

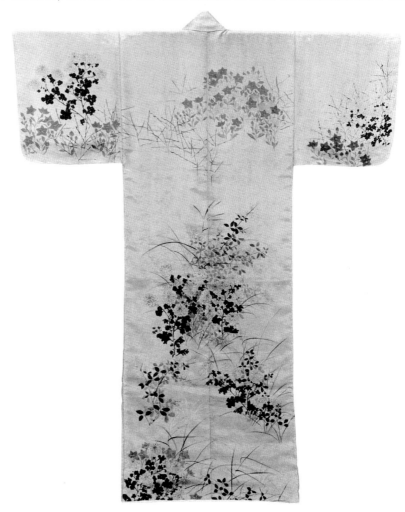

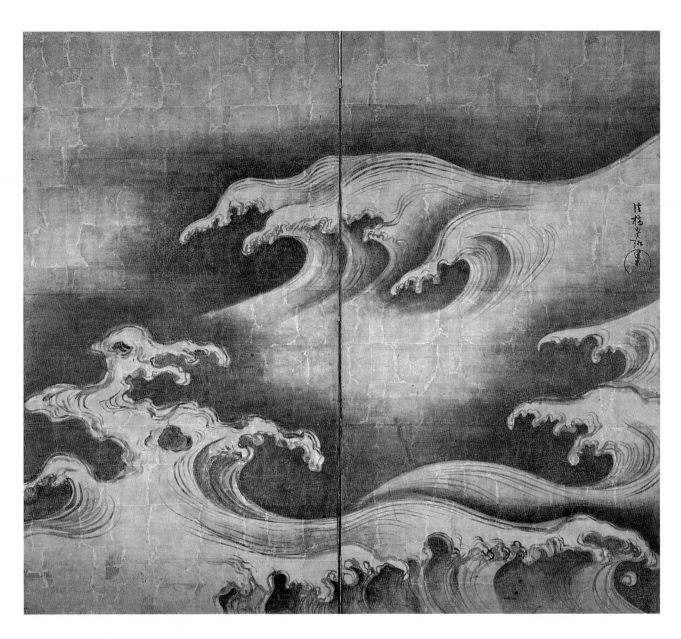

Fig. 13 Ogata Kōrin, *Waves*. Two-fold screen, *c.* 1708. Metropolitan Museum of Art, New York, Fletcher Fund, 26.117 [3:10].

Kyoto to make his preparations and then set out once more for Edo in the seventh month. Whilst it is true that Kōrin painted incense wrappers (fig. 14) and a woman's kimono with short, hanging sleeves (*kosode*) with a design of *Autumn plants* (fig. 12) for the Fuyuki family who were lumber merchants in the Fukagawa district of the city, in general the wealthy Edo merchants were not yet able to understand his art. This meant that Kōrin was obliged – doubtless against his basic inclinations – to paint in the service of feudal lords (*daimyō*), notably those of the Tsugaru and Sakai fiefs. Finally realising (as his letters tell us) that 'I do not wish to spend the ten or more remaining years of my life in this manner', and 'even if I am poor, I want to be content in my heart',[7] in the third month 1709 he returned to take up residence in Kyoto.

During this period, no. 4, the difficulties experienced in an unfamiliar Edo gradually cast a shadow over Kōrin's normally cheerful paintings. The painting that best exemplifies this is *Waves* of *c.* 1708 (fig. 13). Although a screen with gold leaf like the famous *Irises* of period 3, in contrast to the latter's dashing, decorative sense of beauty, *Waves* is weighed down with a weird, almost tragic poignancy. The model is surely the ample, rich expression of the waves in Sōtatsu's *Pine-islands* screens (fig. 6), but it is as if adversity penetrated deep into

the eyes and mind of Kōrin even as he worked from nature and studied Sōtatsu's paintings. Readily apparent, too, are the sense of decorum and spiritual strength Kōrin derived from his assiduous copying at this time of the works of the fifteenth- and sixteenth-century ink painters Sesshū (1420–1506) and Sesson (1504–89?).

Fig. 14 (left) Ogata Kōrin, *Vine*. Incense wrapper, *c*. 1707. Manno Art Museum, Osaka [2:358].

Fig. 15 (below left) Ogata Kōrin, *Daikoku*. Hanging scroll, *c*. 1709. Private Collection, Japan [4:179].

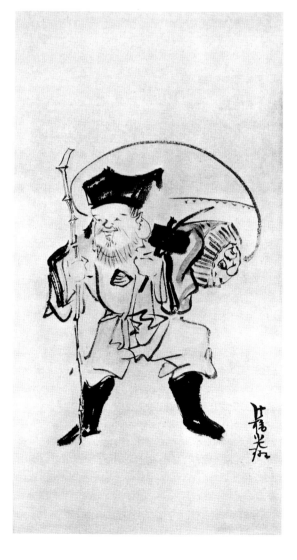

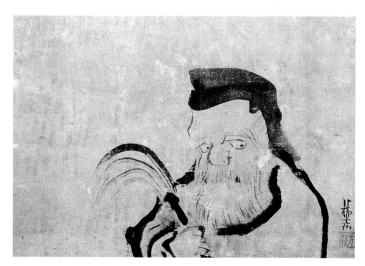

Fig. 16 (top) Ogata Kōrin, *Lucky treasure ship*. Hanging scroll, *c*. 1710. Private Collection, Japan [4:324].

Fig. 17 (above) Ogata Kōrin, *Portrait of Yuima (Vimalakirti)*. Hanging scroll, *c*. 1715. Important Cultural Property, Private Collection, Japan [4:206].

Two incense wrappers, *Vine* (fig. 14) and *Willow* [2:105] are said to have been painted for the Fuyuki family. Adapting Sōtatsu's technique of painting flowers and plants with gold and silver, Kōrin uses ink and colour on a gold ground. The design of ivy in *sumi* ink is most effective and shows that Kōrin's observation of nature has taken on added depth. I would like to interpret the hanging scroll of *Daikoku* (fig. 15), thought to date from the end of period 4, as expressing Kōrin's eager expectation of his long-awaited return to Kyoto, shown in both the springing quality of the fast-moving brush and the very pose of Daikoku himself as he carries both his treasure sack and a bale of rice on his shoulders.

In period 5, after his return to Kyoto, Kōrin had a new house built with a spacious studio on the upstairs floor. Hoping to improve his own fortunes as well as those of his son Juichirō (b. 1700), whom he arranged to have adopted into the Konishi family, the artist concentrated his energies on the production of large-scale screen painting, using the art-names Jakumei and Seisei. An auspicious painting such as *Lucky treasure ship* (fig. 16) may express his own sense of optimism at this new departure. This period is particularly rich in masterpieces: for example, the ink paintings, *Portrait of Yuima (Vimalakirti)* (fig. 17)

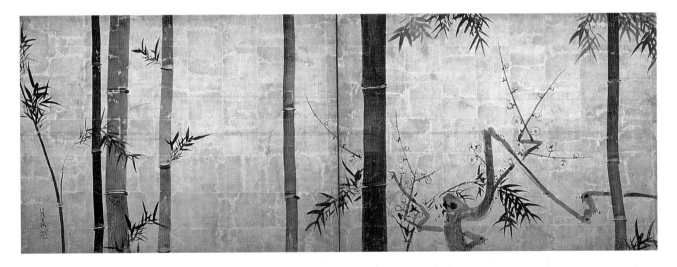

Fig. 18 Ogata Kōrin, *Bamboo and plum*. Two-fold screen, *c*. 1715. Important Cultural Property, Tokyo National Museum [2:34].

and *Bamboo and plum* (fig. 18), and the greatest of all the screen paintings with gold-leaf backgrounds, *Red and white plum trees* (figs 19, 46). But in order to make such progress, Kōrin had first to confront the painting that was the most sublime expression of Sōtatsu's art, namely the *Wind God and Thunder God* screens (figs 8, 36). For Kōrin, Sōtatsu was of course the great teacher whom he himself had discovered. But at the same time he represented a major obstacle that had to be overcome at all costs before Kōrin could establish a unique personal style. To Kōrin the composition of the *Wind God and Thunder God* screens must have seemed bizarre indeed, with the figures of the gods placed so far apart and such a wide stretch of space in the gold-leaf background between. In order to unravel its mysteries, Kōrin diligently set about making his own copy of the original. Through the process of copying, he came to understand his own essential character, distinct from Sōtatsu's. He went on to paint first *Peacocks and hollyhocks* (fig. 20), then *Bamboo and plum* (fig. 18) and, finally, the *Red and white plum trees* (figs 19, 46). In such works Kōrin created his own unique, strict world of contrasting light and darkness – quite different from the ample, generous world of Sōtatsu. He was also able to bring together and combine the brilliance of the *Irises* screens (fig. 11) of period 3 with the melancholy of the

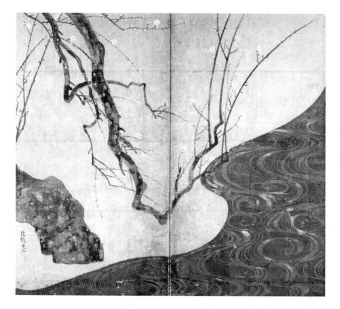
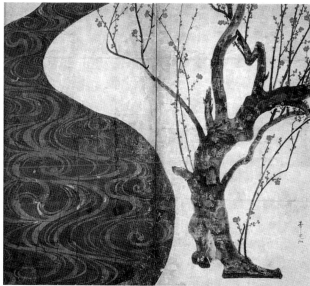
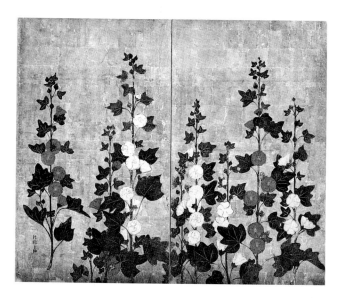
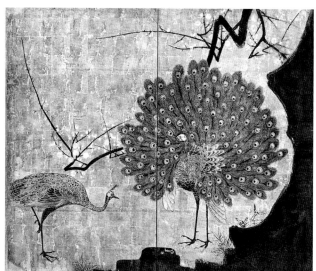

Fig. 19 (top) Ogata Kōrin, *Red and white plum trees*. Pair of two-fold screens, *c.* 1715. National Treasure, MOA Museum of Art, Atami [2:4].

Fig. 20 Ogata Kōrin, *Peacocks and hollyhocks*. Pair of two-fold screens, *c.* 1712. Important Cultural Property, Private Collection, Japan [1:64].

Waves screen (fig. 13) from period 4. Period 5 thus represents the full maturity of Kōrin's painting.

In the period after his return to live in Kyoto, Kōrin also enthusiastically resumed the painting of designs on ceramic pieces to assist his younger brother Kenzan at the Narutaki kiln (cat. nos 60, 61). He also drew studies for Kenzan, suggesting new ideas for ceramic decoration. The handscroll *Designs for tea bowls for Kenzan* (cat. no. 26), though painted with a quick, simplified touch, reveals the true essence of Kōrin's exquisite ink-painting skills during this period. Other objects such as the *Lidded box with a design of pine trees and waves* (cat. no. 55) and *Writing box with a design of Gama Sennin and flowing water* (cat. no. 69) demonstrate that period 5 was also the period of full maturity in Kōrin's works of applied art.

Kōrin's successors

The 'painter of the Seiotsu seal' and others
Until quite recently scholars thought that, unlike Sōtatsu, who headed a large group of pupils producing workshop pieces for sale, Kōrin worked alone. However, the archive of Research Materials relating to Kōrin formerly in the collec-

tion of the Konishi family contains studies thought to be by Kōrin's pupils, and it therefore seems that he did at least have one or two assistants. A letter written by Kōrin in 1704 contains a reference to the fact that when he went to Edo he was accompanied by a pupil called Kōken: Kōrin writes that he is pleased that his pupil is well received there. Some copybook studies (*e-dehon*) also survived at one time that Kōrin apparently prepared for a pupil called Rinsui. It is quite likely that works by pupils such as these are included among works currently attributed to Kōrin.

There is a group of fan paintings bearing a seal provisionally read as 'Seiotsu' (alternatively, Seiitsu or Seishi) that at first glance appear to be in pure Kōrin style (fig. 21). Since the time of Hōitsu's *Ogata-ryū ryaku impu* (Concise collection of seals of the Ogata lineage, 1815), this seal was said to have been used by Kōrin. But pictures bearing this seal have certain distinctive compositional characteristics and generally lack the degree of discipline we associate with Kōrin, so I believe they should be attributed to an anonymous artist working in Kōrin's circle. For convenience he may be referred to as the 'Painter of the Seiotsu seal'. Opinion used to be divided as to whether the screen *Shintō ceremony of purification (Misogi)* (cat. no. 29), which formerly belonged to the famous collector Hara Sankei (1868–1939), should be attributed to Sōtatsu or Kōrin. I have argued elsewhere, however, based on certain characteristics of the composition, that it is probably the most important work to have survived by the painter of the Seiotsu seal.

As with many famous artists, there are difficult issues of authenticity in relation to Kōrin's works, notably instances in which there is an apparently genuine signature and seal on a problematic work, and the opposite case in which the painting appears to be good but the signature and seal are not authentic. These may be explained in the former case by a pupil having assisted Kōrin or even executed the whole piece in his place, and in the latter by a pupil having copied a work which was later mistakenly appraised (if we give the appraiser the benefit of the doubt) as a genuine work by Kōrin. If in future more works of the former type are discovered, we shall have to give serious consideration to the idea that there are workshop pieces associated with Kōrin as well as with Sōtatsu.

When Kōrin was painting impromptu at a party (*sekiga*), he normally added a handwritten seal (*kaō*) after the signature. The only instances in which he applied a seal without also writing his signature seem to have been on the back of fan paintings. In the case of the pairs of screens which have a separate painting pasted to each of the twelve leaves (*oshie-bari byōbu*), it was customary to inscribe the signature only on the first and last panels and just to impress a seal (or to use no seal at all) on the other ten compositions. There is also one other exceptional example from early on in Kōrin's career, before he received the title *Hokkyō* in 1701, where he used just the 'Iryō' seal on the two-fold screen *Autumn grasses* (Private Collection, Japan; see p. 28 above), which appears to be genuine. We might suggest that at this early date he still lacked the confidence to apply a full signature. To sum up, any other screen paintings which only bear seals (such as the 'Hōshuku' seal) should be regarded for the time being as works by the Kōrin

Fig. 21 Painter of the Seiotsu seal, *Vine*. Fan painting, *c*. 1720. Kyoto Mingeikan [2:360].

school. (It should also be mentioned that it was not customary to sign incense wrappers, paintings on clothing and the like.)

Screen paintings by the Kōrin school

As we saw at the beginning of this essay, one hundred years after Kōrin's death Hōitsu compiled a woodblock-illustrated catalogue of his works in two volumes, the *Kōrin hyakuzu* (One hundred works by Kōrin). From that time until the present, the number of paintings attributed to Kōrin illustrated in publications must have reached three or four hundred. I myself have seen more than six hundred paintings said to be by him. But if we limit ourselves to works that are unquestionably genuine – the famous masterpieces among them – the total would be about sixty (including those works designated by the Japanese government as National Treasures and Important Cultural Properties).[8] Obviously such strict connoisseurship is desirable in terms of the scholarly study of Kōrin himself, but how should we then interpret the works other than the basic sixty? In the case of some artists, there can certainly be a big gap between their most successful and least successful works, and sometimes there is the danger that unsuccessful works may be mistakenly declared forgeries. With a highly skilful artist such as Kōrin, however, there cannot be many examples of this kind. So, should we dismiss the large majority of these six hundred works as forgeries?

Because Kōrin is so famous, it is understandable that there will be more forgeries of his works than those of other painters. The problem I would like to raise here, however, concerns works which are thought to have been painted in the century between Kōrin's death and the period of Hōitsu's activity – in particular, the screen paintings which seem to have been done in the fifty or sixty years after Kōrin's very last period of activity during the Shōtoku (1711–16) era. In the woodblock-printed pattern-books for kimonos published during these years there are many examples of 'Kōrin patterns' (*Kōrin moyō*), suggesting a kind of Kōrin 'boom'. Might there not have been a similar phenomenon in the painting world? Certainly, a large number of screen paintings resembling one another seem to have been produced at this time. For example, there are at least four versions of a screen painting type known as 'One hundred flowers in Kōrin style' (*Kōrin hyakka zu byōbu*) which have a splendour and sense of taste very reminiscent of the master, and there are instances, too, of multiple versions of screens with similar compositions, including copies of some of Kōrin's most famous works. Could these perhaps include copies made for study purposes, or at the request of patrons, by anonymous pupils (such as the painter of the Seiotsu seal mentioned above) or else by Watanabe Shikō (1683–1755), Fukae Roshū (1699–1757) and others, who will be discussed below? If there were no signatures and seals on these pieces, they could properly be treated as Kōrin school, but the problem is that they have signatures such as 'Hokkyō Kōrin' and Kōrin seals (be they fake seals or impressions from genuine seals that were still extant). In cases where they bear only seals, it is better simply to describe them as Kōrin school works, as explained above.

If the signature and seals are disputed, the works themselves should normally be dismissed as fakes. And yet some are of a quality such that they deserve consideration as works of the Kōrin school, made after the master's death and before the period of Hōitsu. It may be forcing the point too far, but perhaps we should even regard these interpolated signatures as mistaken attributions by people of a later period. I think these works can then be correctly appreciated in their own right as screen paintings by the Kōrin school dating from the first half of the eighteenth century. The existence of Sōtatsu workshop pieces has become

generally accepted, but so far a similar argument has not yet been advanced with respect to Kōrin. I firmly believe that instead of immediately dismissing works as fakes because they have fake signatures and seals, it is much more useful for the study of Kōrin in a wider context to treat them as works of the Kōrin school. This approach should also lead us back to a better understanding of works by Kōrin himself.

Kenzan

Kenzan (1663–1743) was Kōrin's younger brother, five years his junior. His formal name (*na*) is thought to have been Koremitsu (the reading of the characters is tentative); he also used the names Reikai and Furiku. His common name (*tsūshō*) was Gompei, later changed to Shinsei. His art-names (*gō*) for ceramics were Kenzan, Tōin and Shōkosai; and for painting Shisui, Shūseidō and Tōzen. The best-known of these names are Kenzan and Shinsei.

Kenzan had a more introspective personality than Kōrin's. He enjoyed personal study and Zen, and does not seem to have been naturally skilful with his hands, although he was confident of his abilities as a calligrapher from early on. As an artist, however, he apparently thought himself much inferior to Kōrin, whose paintings he venerated throughout his life. From the end of 1699, assisted in matters of technique by Seiemon, son of the great Kyoto potter Nonomura Ninsei (worked second half of the seventeenth century), he opened a kiln at Narutaki in Kyoto, making ceramics which later came to be known as 'Kenzan wares'. These were celebrated primarily for the beauty of their pictorial decoration, and Kōrin is believed to have painted all the designs at first. Kenzan devised flat, square dishes (cat. no. 59) that were an appropriate shape to take his brother's paintings, and strove to develop a new beauty combining Kōrin's paintings with his own calligraphy. Doubtless he followed the example of Kōetsu, who, as we have seen, produced handscrolls combining gold and silver paintings by Sōtatsu with his own calligraphy and thereby created a new and distinctive sense of beauty in the early years of the Edo period. One might even argue that Kenzan's initial aim was to achieve a similar effect on the surface of the ceramic pieces that he prized so much.

Fig. 22 Ogata Kenzan (ceramic) and Ogata Kōrin (painted design), *Charcoal container painted with a landscape design, c.* 1715. Yamato Bunkakan, Nara.

Having said this, however, among the surviving painted dishes by Kenzan and Kōrin there in fact appear to be very few that date from the earliest period of the Narutaki kiln, around 1700. Judging by the style of Kōrin's paintings and Kenzan's calligraphy, most date from after Kōrin's return to Kyoto in 1709. A key work in supporting this theory is the hexagonal dish with a design of *Pine and crane* (Private Collection, Japan)[9] which is dated 1710. The set of ten square dishes in the Fujita Art Museum [5:44] and the related square dish with a design of *Autumn flowers and grasses* (cat. no. 61) must also date from about this time. The handscroll painted by Kōrin of *Designs for teabowls* (cat. no. 26) must be a work of the late Hōei (1704–11) or early Shōtoku (1711–16) eras, again judging by the style of the painting and calligraphy. It is fascinating to see that at this period Kōrin was not merely painting designs on Kenzan's ceramics, but also painting additional reference material to give his brother for the same purpose.

Fig. 23 (right) Ogata Kenzan, *Eight-fold bridge over the iris pool*. Hanging scroll, *c*. 1736. Private Collection, Japan [4:7].

Fig. 24 (below) Ogata Kenzan, *Flower baskets*. Hanging scroll, *c*. 1736. Fukuoka Art Museum [2:209].

Fig. 25 (below right) Ogata Kenzan, *Third month*, from the series *Birds and flowers of the twelve months, with poems by Teika*. Hanging scroll, 1743. Idemitsu Museum of Arts, Tokyo [1:89].

Fig. 26 (bottom right) Ogata Kenzan, *Pampas-grass/Waves and breakwaters*. Painted wooden lidded box, 1743. Important Cultural Property, Yamato Bunkakan, Nara [2:354].

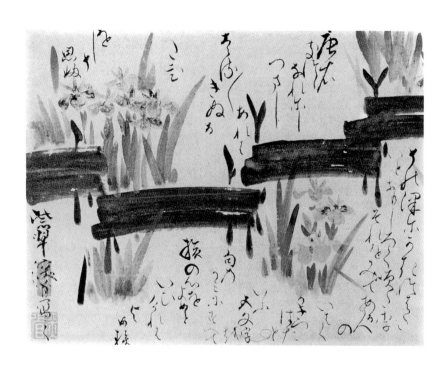

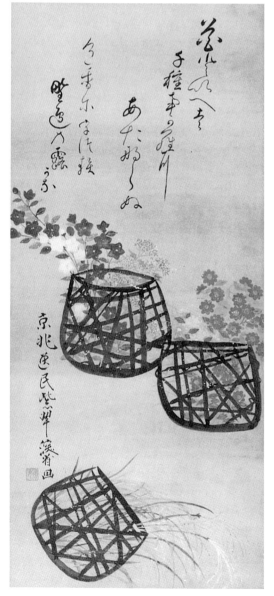

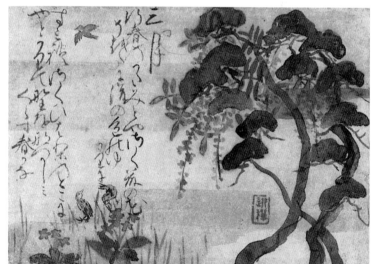

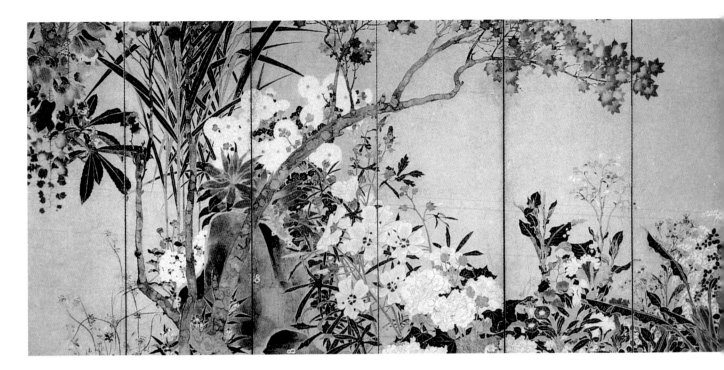

Fig. 27 Watanabe Shikō, *Flowers and grasses of the four seasons.* Pair of six-fold screens, *c.* 1725. Hatakeyama Memorial Museum [1:36].

In 1712 Kenzan abandoned the Narutaki kiln, moved back to Nijō Chōjiya-chō in the centre of the city, and is said to have attempted large-scale production of Kenzan wares by supplying designs to the various kilns of the Awataguchi district. In the collection of the Yamato Bunkakan, Nara, there is a charcoal container with a landscape design painted by Kōrin (fig. 22) which, judging by the form of Kōrin's handwritten seal (*kaō*), should be dated after 1714. We should note therefore that Kōrin must have continued to paint designs on Kenzan's ceramics during the Nijō Chōjiya-chō period as well. In 1731 Kenzan moved to Edo and, under the patronage of prince-priest Kōkan (1697–1738) of Rinnō-ji Temple, established a kiln in the Iriya district. Apart from a sojourn in the town of Sano (in present-day Tochigi Prefecture) in 1737, Kenzan spent the rest of his life in Edo producing ceramics and paintings. A particular development of this period is that, after many years of decorating ceramics, he finally seems to have gained some confidence as a painter, and many of the surviving paintings date from his final years, when he was in his seventies.

In later life, Kenzan obviously had the ambition to transmit Kōrin's painting style to Edo. However, Kōrin's was an art that sought beauty in creating new forms, while Kenzan, in contrast, gave expression to a lyrical world that combined calligraphy and painting into a unique single entity. His most representative paintings are the hanging scrolls *Eight-fold bridge over the iris pool* (fig. 23) and *Flower baskets* (fig. 24), and the set of four small sliding-door paintings *Plum, pinks, bush-clover and snow* (cat. no. 31). In certain works, indeed, Kenzan tries to give pictorial expression to the very essence of classical *waka* poetry or else actually inscribes the paintings with *waka* or other poems in his distinctive hand. Examples are the hanging scrolls *Birds and flowers of the twelve months, with poems by Teika* (fig. 25) and the decorated box with *Pampas-grass/Waves and breakwaters* (fig. 26), both painted at the age of 81, in the year he died. They are imbued with a deep lyrical appeal quite distinct from the brilliant combinations of calligraphy and painting in the handscrolls produced jointly by Kōetsu and Sōtatsu. It is not without reason that Kenzan's paintings are sometimes hailed as a precursor of literati painting (*bunjinga*) in Japan, for it is not technical skill but the expression of cultivation and inner personal values that they represent above all else.

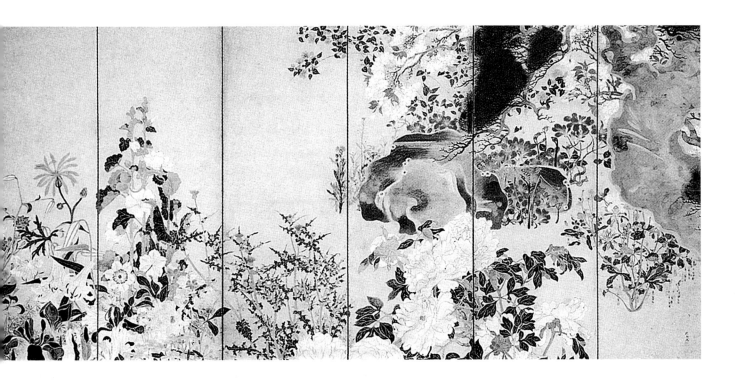

Watanabe Shikō and Fukae Roshū

Watanabe Shikō (1683–1755) was born in Kyoto and his common name was Kyūma. From about 1708 he entered the service of the aristocrat Konoe Iehiro (1667–1736). There has been a suggestion that a certain Watanabe Soshin who decorated Kenzan wares from the Narutaki kiln during the Hōei (1704–11) era may be the same person as Shikō, but this is not yet certain. Shikō first studied with the Kanō school and then fell under the influence of Kōrin, though it is not known whether he was an actual pupil. As demonstrated by his copy of the *Illustrated handscroll of legends of the deity Kasuga Gongen* (*Kasuga Gongen reigen-ki e-maki*, set of twenty handscrolls, Yōmei Bunko [4:55]), datable to 1735, it is clear that Shikō also had a firm grounding in painting in the Yamato-e tradition. Throughout his career he continued to paint in these various distinct styles and was a highly accomplished technician in each. Among his surviving paintings those in Kanō style are most common, and among his large-scale works *Pines and lilies* (four sliding-door panels, Kombu-in Temple, Nara [3:85]) is particularly well known. As for works in Kōrin style, the twelve cedar doors with such titles as *Agricultural scene* [4:278] and the two sets of twelve wooden boards from translucent sliding doors (*shōji no koshi-ita*) depicting *Rabbits* [1:173] and *Birds and flowers of the four seasons* [1:112] (all the above Important Cultural Properties, Daikaku-ji Temple, Kyoto) have long been celebrated. The Kombu-in works are characterised by their cheerful idyllic charm and the Daikaku-ji paintings by an almost childish innocence. However, screen paintings such as *Flowers and grasses of the four seasons* (fig. 27) have much in common with the screens known as *One hundred flowers in Kōrin style* (see p. 35 above), and his delicate ink paintings in Kōrin style are all the more similar to works by Kōrin himself in as much as the styles of both men were based on training in Kanō school techniques. There is therefore the distinct possibility that among the screen paintings of flowers and grasses and the ink paintings attributed to Kōrin there are in fact quite a number of works by Shikō. Shikō also did fan paintings of flowers and grasses in Kōrin style, but with a distinctive way of abstracting the subjects and an intellectual approach to ordering the composition.

Shikō leaves us handscrolls and albums of subjects drawn from life such as *True depictions of types of birds* (handscroll, Private Collection, Japan [3:154]) and

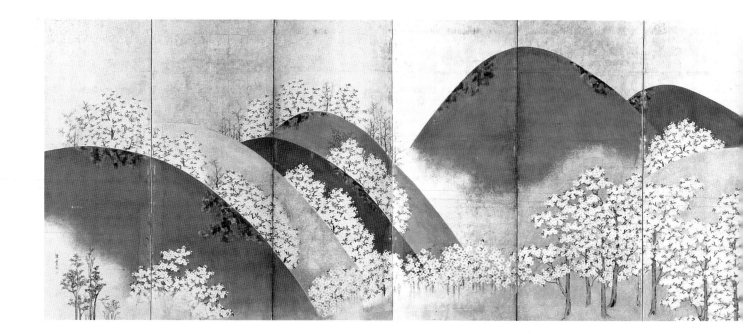

Fig. 28 (above) Watanabe Shikō,
Flowering cherries at Mt Yoshino.
Pair of six-fold screens, *c.* 1735.
Private Collection, Japan [3:51].

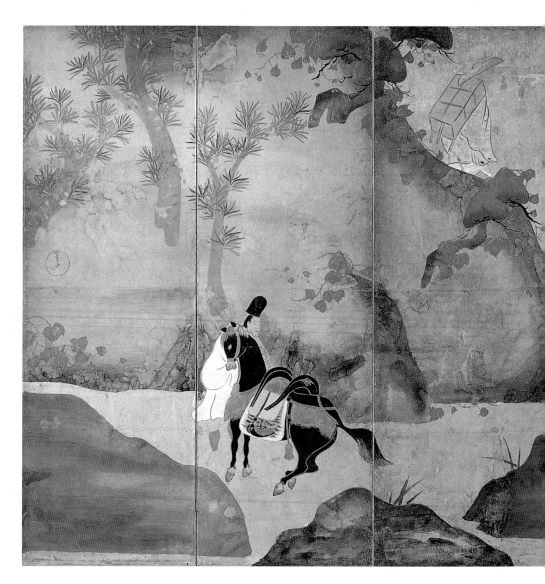

Fig. 29 Fukae Roshū, *The Narrow
Ivy Path.* Six-fold screen, *c.* 1725.
Cleveland Museum of Art, John L.
Severance Fund, 54.127 [4:11].

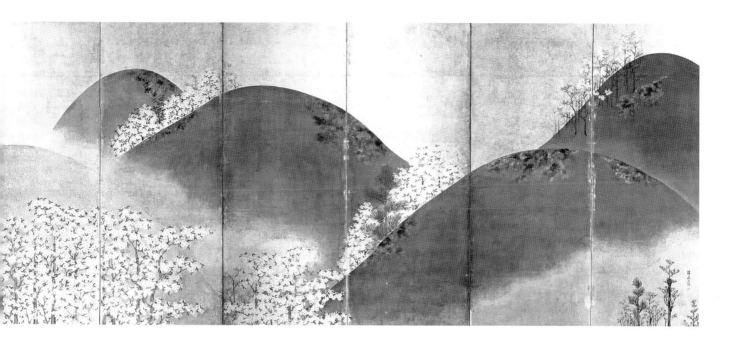

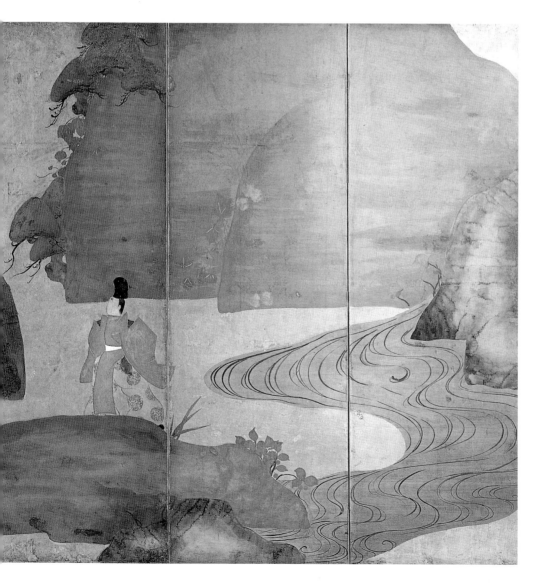

Album of wading birds (cat. no. 36) which are even more objective in their handling than the sketchbooks of birds and animals drawn by Kōrin. Shikō's sketches must in turn have exerted a significant influence on the late eighteenth-century realistic painter Maruyama Ōkyo (1733–95), as shown by the copies that survive in Ōkyo's sketchbooks (Tokyo National Museum). As an artist who stands at the midpoint between Kōrin and Ōkyo in the course of development of Kyoto painting, Shikō is certainly an artist who warrants further study. His most representative work is *Flowering cherries at Mt Yoshino* (fig. 28).

For a long time the artist Fukae Roshū (1699–1757) was only known by a round seal with characters reading 'Roshū' which appeared on several paintings. Subsequent research, however, has revealed that he was one Fukae Shōroku, eldest son of Fukae Shōzaemon, a high-ranking official at the Kyoto mint. A colleague of his father's at the mint was Kōrin's patron Nakamura Kuranosuke, and it is assumed that Roshū came to study with Kōrin as a result of this connection. Since Roshū was only 18 when Kōrin died, however, even if he was a direct pupil it cannot have been for very long. His principal surviving works are three versions of *The Narrow Ivy Path* (six-fold screen, Important Cultural Property, Tokyo National Museum [4:10]; six-fold screen, Cleveland Art Museum [4:11], see fig. 29; and two-fold screen, Asian Art Museum of San Francisco); *Flowers and grasses* (six-fold screen, Important Cultural Property, Manno Art Museum [1:40]), and some hanging scrolls of *Flowers and grasses* that were originally pasted onto a pair of six-fold screens (various collections [1:109]). Stylistically they may lack the polished technique and strict sense of pictorial construction seen in the works of Kōrin, but, conversely, this very lack of sophistication lends them a simple, straightforward appeal. One also detects the influence of the pre-Kōrin screen paintings of flowers and grasses that bear the 'Inen' seal thought to have been used by Sōtatsu's workshop. Furthermore, the recently discovered screens of *Flowers and grasses of the four seasons* (cat. no. 33) are surely Roshū's most ambitious work, executed with the example of Kōrin's famous *Red and white plum tree* screens (figs 19, 46) firmly in mind. It is only regrettable that the silver areas of the abstract background of mixed gold and silver leaf have tarnished black, markedly altering the appearance of these screens.

Tatebayashi Kagei and Tawaraya Sōri

Tatebayashi Kagei used the formal name Rittoku and the art-names Kingyū Dōjin and Kiusai. His life history is very uncertain, and his dates of birth and death are unknown. He is said originally to have been a doctor in the service of the Maeda family, Lords of Kaga, who later went to Edo and changed his name to Shirai Sōken. He also used the name 'Tsurugaoka Hermit' (Tsurugaoka Itsumin), which may suggest that he lived for a time in the vicinity of the Tsurugaoka Hachiman Shrine in Kamakura. At some point he became a pupil of Kenzan, and in 1738 Kenzan gave him a copy made by Kōrin of a fan painting by Sōtatsu. Kenzan also seems to have permitted Kagei to use a seal similar to the 'Hōshuku' seal used by Kōrin, suggesting that Kenzan recognised Kagei as the successor to the Kōrin painting style in Edo. His most representative work is *Oto-goze as if painted on a fan* (hanging scroll [4:319]), dated 1751. Paintings such as *Corn and morning glory* (hanging scroll, Idemitsu Museum of Arts [2:254]) and *Rooster and hen* (cat. no. 37) clearly demonstrate Kagei's adoption of the Kōrin painting style.

Tawaraya Sōri was a native of Edo and first studied the Yamato-e style under Sumiyoshi Hiromori (1705–77), a painter-in-attendance to the Shogunate. Later

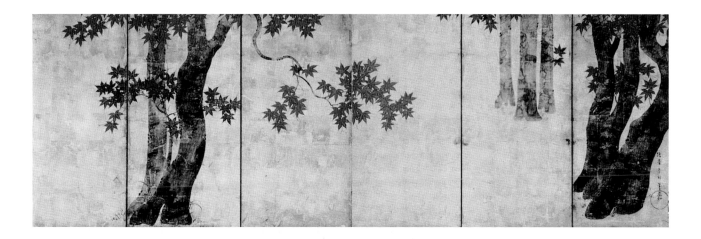

Fig. 30 Tawaraya Sōri, *Maples*.
Six-fold screen, mid-eighteenth
century. Manno Art Museum,
Osaka [2:337].

he developed a passion for the painting styles of Sōtatsu and Kōrin, but how this came about is not known. Nor is it certain at present whether he had any direct contact with either Kenzan or Kagei. He used the art-names Ryūryūkyo Hyakurin and Hyakurinsai as well as the name Tawaraya Sōri, and was active as a so-called 'town painter' (*machi-eshi*) with connections with the literati of Edo. He seems to have been active mainly from the Hōreki (1751–64) to the An'ei (1772–81) eras, and is estimated to have died in 1782. His most important works are *Maples* (fig. 30) and a *Shintō ceremony of purification* (hanging scroll, Hatakeyama Memorial Museum [4:39]). The former work in particular, with its witty sense of colour distribution between the red and green maple leaves, is a masterpiece that has done much to enhance his reputation in recent decades. It is not yet known whether Sōri had any direct connection with Sakai Hōitsu, the next painter we shall consider, but he was certainly a significant precursor of Hōitsu working in the Rimpa style in Edo.

Rebirth and development under Hōitsu (Edo Rimpa)

Sakai Hōitsu

Hōitsu (1761–1828) was born in Edo, the younger brother of Sakai Tadazane, Lord of Himeji. His formal name was Tadanao and his common name Eihachi. Hōitsu was his art-name. His father, grandfather and earlier ancestors had all cultivated refined pursuits to a degree unusual among feudal lords, and Hōitsu followed their example, developing many talents and skills. In 1797, at the age of 37, he used the pretext of ill health to become a pupil of Bunnyo Shōnin at Nishi Hongan-ji Temple, Kyoto, taking the ecclesiastical name Tōgaku-in Monzen Kishin, and was awarded the rank of *Gondai Sōzu*. Almost immediately, however, he retired to the Asakusa district of Edo, then to Negishi in the Shitaya district, where he established a retreat called the Ugean. Using the pen-name Ōson, he led an elegant life practising calligraphy, painting and *haikai* (*haiku*) poetry. Other art-names included Toryō, Teihakushi and Ugean.

Hōitsu first studied painting in the Kanō style, under the painter Kanō Takanobu (1740–94) of the Nakabashi Kanō school, and in the realistic Chinese bird-and-flower style of Shen Nanpin (the so-called Nagasaki school), under Sō Shiseki (1712–86). He also painted in the Ukiyo-e style, studying with Utagawa Toyoharu (1735–1814). Another major influence was the eclectic painter Tani Bunchō (1763–1840), with whom he had much friendly contact, and he then went on to master the techniques of the Tosa and Maruyama schools. In short, Hōitsu did the rounds of all the contemporary painting styles before finally coming to the realisation that it was the style of Ogata Kōrin that most

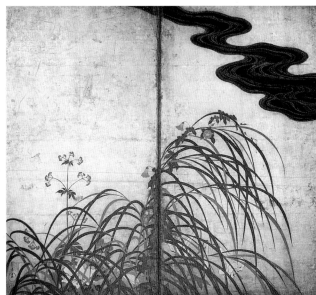

Fig. 31 Sakai Hōitsu, *Summer and autumn grasses*. Pair of two-fold screens, *c.* 1822. Important Cultural Property, Tokyo National Museum [1:71].

impressed him, whereupon he determined to devote his energies to its revival. Sakai Utanokami Tadataka, head of the family five generations before Hōitsu, had employed the services of Kōrin as a painter when he came to Edo and it is thought that there must have been many paintings by Kōrin in the Sakai family collection. However, it took much experimentation in other directions finally to confirm Hōitsu in his devotion to Kōrin's style. Furthermore, as described above, the artist Tawaraya Sōri was already painting Kōrin-style works in Edo and it is certainly plausible that Hōitsu was impressed by his example. Even allowing for any possible influence of Tawaraya Sōri, however, Hōitsu's veneration of Kōrin and his determination to revive his painting style were certainly much stronger and deeper.

In 1807 Hōitsu made enquiries of Kōrin's descendant Konishi Katamori concerning the family lineage and in 1815 held memorials to mark the hundredth anniversary of Kōrin's death. As we have seen, he collected together and exhibited paintings by the great artist and published several volumes of his work: *Kōrin hyakuzu* (One hundred works by Kōrin) and *Ogata-ryū ryaku impu* (Concise collection of seals of the Ogata lineage) in 1815; *Kenzan iboku* (Paintings and calligraphy by the late Kenzan) in 1823; and *Kōrin hyakuzu: kōhen* (One hundred works by Kōrin: Part 2) in 1826. Throughout this period he was studying Kōrin's paintings and, using that style as a basis, went on to establish his own unique vision of the world of plants and flowers, showing a delicate sensitivity towards nature developed from his composition of *haikai* poetry. Though lacking the extravagance and depth seen in works by Kōrin and his predecessor Sōtatsu, Hōitsu nevertheless inherited their distinctively Japanese emotive and decorative qualities. His own special stylistic contribution derived from a sophistication common to many literary and artistic figures active in the mature urban culture of the city of Edo during the Bunka (1804–18) and Bunsei (1818–30) eras, coupled with an acutely developed personal emotional sensitivity.

The masterwork of Hōitsu's last years, the *Summer and autumn grasses* (figs 31, 49) in ink and colours on a silver-leaf background, succeeds in combining sentiment and decoration into a unique form of beauty. It is fascinating to realise that this work was originally painted on the back of Kōrin's version of the *Wind God and Thunder God* (fig. 39). In recent years the preparatory study for *Summer and autumn grasses* has been discovered (cat. no. 40), and from the date inscribed on

it stating when it was shown to the patron – 9th day, 11th month, 1821 – it is virtually certain that the finished work was painted in 1822.

The rediscovery of two other important screen paintings – Hōitsu's version of *Wind God and Thunder God* (cat. no. 39), lost since the Second World War, and *Eight-fold bridge over the iris pool* (cat. no. 41) – and the recent discovery of *Red and white plum trees* (cat. no. 43), painted on a background of silver leaf, has led to an even clearer appreciation of the brilliance of Hōitsu's references to, and borrowings from, paintings by Kōrin. As a further example, the very recently discovered *Green maples and red maples* (Private Collection, Japan)[10] is clearly a version of a screen painting by Kōrin included in *Kōrin hyakuzu*. Yet at the same time it is a work in which Hōitsu's modern sensibility is most obviously displayed, a sensibility which in turn was strongly influential on the work of Nihonga painters of the early Shōwa (1926–89) era, such as Hayami Gyoshū (1894–1935). *Birds and flowers of the twelve months* was a favourite subject of Hōitsu's and the set of twelve hanging scrolls in the Imperial Collection (Museum of the Imperial Collection [1:94]) is well known. Several further similar sets have survived, and a set pasted onto a pair of six-fold screens has recently come to light (cat. no. 42), demonstrating once again just how popular such subjects must have been at the time. It is a cause for celebration that so many works have appeared in recent years to enhance Hōitsu's reputation as an artist.

Suzuki Kiitsu

Kiitsu (1796–1858) was a native of Edo. His common name was Isaburō/Tamesaburō (the correct reading of the first character is uncertain), his formal name Motonaga, and his scholar's name (*azana*) Shien. Kiitsu was his principal art-name. At first he used the combination Kaikai Kiitsu and then changed this

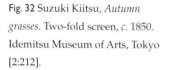

Fig. 32 Suzuki Kiitsu, *Autumn grasses*. Two-fold screen, *c.* 1850. Idemitsu Museum of Arts, Tokyo [2:212].

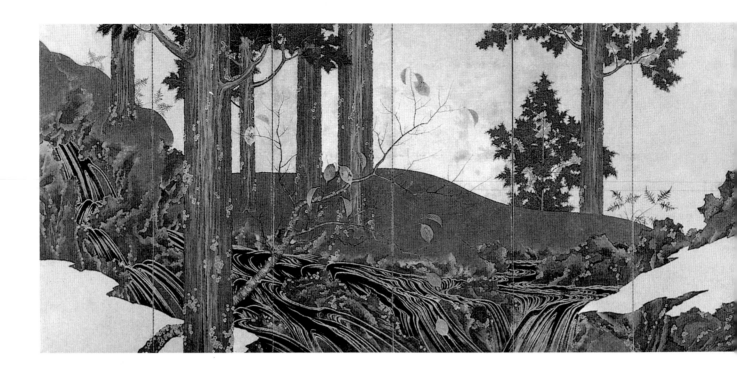

Fig. 33 (above) Suzuki Kiitsu,
Rapids in summer and autumn.
Pair of six-fold screens, *c.* 1835.
Nezu Art Museum, Tokyo [1:78].

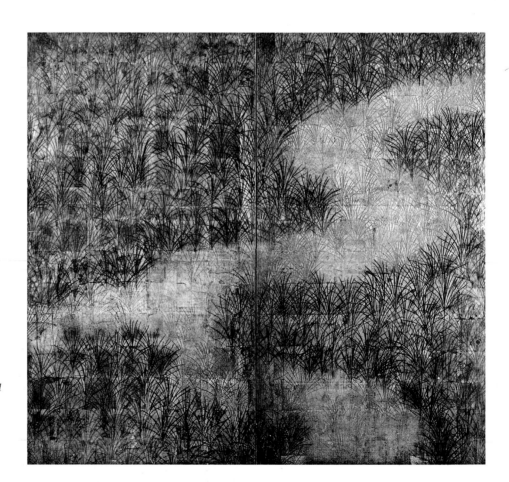

Fig. 34 Suzuki Kiitsu, *Camellias and
pampas-grass.* Pair of two-fold
screens, *c.* 1840. Freer Gallery of
Art, Smithsonian Institution,
Washington D.C., 74.35-36 [1:77].

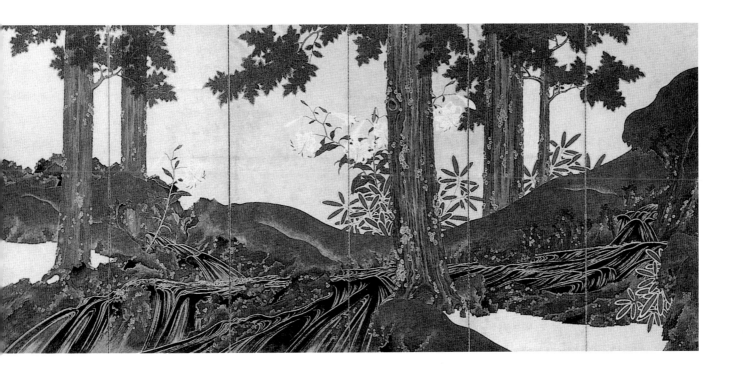

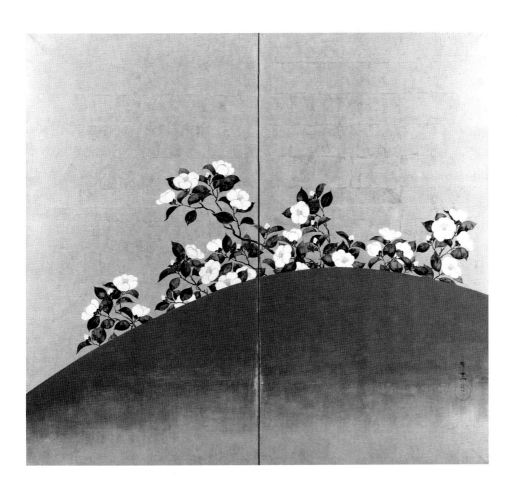

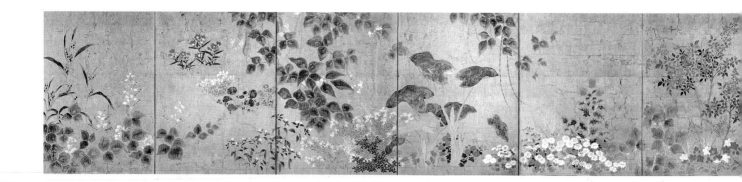

Fig. 35 Nakamura Hōchū, *Flowers and grasses of the four seasons*. Pair of six-fold screens, *c.* 1800. British Museum, JP ADD 574 [1:41].

to Seisei Kiitsu (based on Kōrin's name 'Seisei', but written with a slightly differ-ent character). Other art-names included Teihakushi, Hitsuan and Shukurinsai. At the age of 18 he became Hōitsu's principal resident pupil, and was later adopted by – and ultimately succeeded – Suzuki Reitan, one of Hōitsu's retain-ers. He generally worked as Hōitsu's companion and assistant, apparently even painting in place of the master on certain occasions. Quite a number of his works copy the style of his teacher, such as *Autumn grasses* (fig. 32), but in recent years a succession of newly discovered works have shown that he continued to develop the Hōitsu style and establish his own independent idiom, and his reputation has risen sharply. His most representative works include *Rapids in summer and autumn* (fig. 33); *Camellias and pampas-grass* (fig. 34); *Trees and flowers of the four seasons* (cat. no. 46), and *The Thirty-six Immortals of Poetry* (cat. no. 50). With his acute sense of form and witty ability to manipulate the composition, Kiitsu's true significance lies in his search for a modern decorative sense of beauty that presages elements of the art of the subsequent Meiji (1868–1912) era. He is an appropriately talented figure to bring the long Rimpa tradition to a close.

Nakamura Hōchū

Hōchū was born in Kyoto, but he spent most of his life in Osaka. The year of his birth is not known, but he died in 1819. At the end of the Kansei (1789–1801) era he went to Edo, where in 1802 he published the illustrated anthology *Kōrin gafu* (Anthology of paintings by Kōrin). It is not known if he had any direct contact with Hōitsu, but it is certainly significant that he seems to have made a personal study of Kōrin's painting style and attempted to promote this in Edo before Hōitsu. He was also a *haikai* poet and produced many *haiga* (paintings to accom-pany *haikai*). His paintings are generally highly simplified and make extensive use of the *tarashikomi* technique (cat. no. 38). They have their own idiosyncratic flavour and must have had considerable influence on the applied arts. *Flowers and grasses of the four seasons* (fig. 35) is of a unique type among the compositions of flowers and grasses by Hōchū and is painted with an unusually fine line. Hōchū certainly deserves further study.

Painters of the Meiji (1868–1912) era and after

The Japan Art Institute (Nihon Bijutsu-in), founded in 1898 and led by Okakura Tenshin (1862–1913), had as its purpose the creation of a new type of painting for Japan, and this process involved a thorough examination of past traditions. This led to the rediscovery of the art of Sōtatsu and Kōrin, whose 'boneless' (*mokkotsu*) techniques of painting without outline and rich colour sense had a strong influence on the next generation of artists. Imamura Shikō (1880–1916) was particularly drawn to the world of Sōtatsu, which he reformulated with a new personal idiom in such highly creative compositions as *Handscrolls of the*

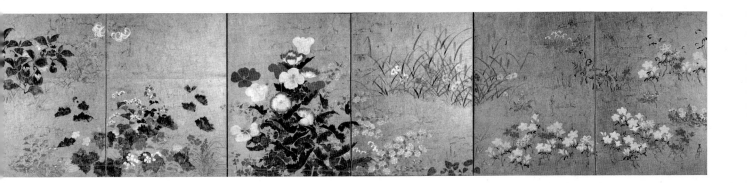

tropical country (1914, Tokyo National Museum). In the Taishō (1912–26) and early Shōwa (1926–89) eras there was much progress in the study and appreciation of Sōtatsu and Kōrin, leading to an ever higher evaluation of their standing. Many artists of the Japan Art Institute lineage, notably Hayami Gyoshū, Kobayashi Kokei (1883–1957), Yasuda Yukihiko (1884–1978) and Maeda Seison (1885–1977), absorbed some kind of influence from the tradition of Rimpa painting: there are still artists working today in the Nihonga tradition who return to Rimpa painting as a source of inspiration.

The special characteristics of Rimpa painting

The favourite subject of Rimpa painters was the common flowers and grasses. No other school of painting treated in such variety the plants of the Japanese countryside. These were even given names such as the 'Kōrin plum' or 'Kōrin chrysanthemum' and were used widely as standard motifs in the world of the applied arts, demonstrating that their simplified shapes are imbued in some way with emotions and sensibilities fundamental to the Japanese people. This does not mean, however, that great artists such as Kenzan and Hōitsu were constrained by these standard motifs. The Rimpa artists were not there to defend the traditions of a particular school of painting which had become devoid of all content. Rather, from a habitually free position, they used their own taste and volition to pick out elements from the Rimpa lineage and traditions and breathed new life into them. This proves that Rimpa art, though it takes as its subject the familiar, ordinary flowers and grasses of nature, is perpetually capable of expressing a new beauty from one period to the next, relying on the eye, the skill and the feeling of each artist who paints in the Rimpa idiom.

NOTES

This is a revised and updated version of an essay first published by Professor Yamane in the catalogue to the exhibition *Rimpa kaiga no meihin ten*, Nihon Keizai Shimbunsha and Kōbe Sogō Department Store, 1979.

1. Ernest F. Fenollosa, *Epochs of Chinese and Japanese Art*, London, William Heinemann, 1912, vol. 2, p. 126.

2. Yashiro Yukio, 'Sōtatsu hitsu matsushima byōbu', *Bijutsu kenkyū* 73 (1938), p. 3.

3. This is a new theory. The more traditional dating is given in cat. no. 15, i.e. the Genna (1615–24) era.

4. Yamane Yūzō (ed.), *Zaigai Nihon no shihō*, vol. 5: *Rimpa*, Tokyo, Mainichi Shimbunsha, 1979, no. 51.

5. Yamane Yūzō (ed.), *Rimpa kaiga zenshū: Kōrin-ha I*, Tokyo, Nihon Keizai Shimbunsha, 1979, no. 67.

6. Kōrin's letters are transcribed in ibid., pp. 57–66. This letter appears on pp. 61–2.

7. Ibid., pp. 61–2.

8. These sixty works are published in ibid.

9. Yamane Yūzō (ed.), *Rimpa kaiga zenshū: Kōrin-ha II*, Tokyo, Nihon Keizai Shimbunsha, 1980, no. 18.

10. Yamane Yūzō, 'Sakai Hōitsu hitsu seifū shufū zu byōbu ni tsuite', *Kokka* 1211 (Oct. 1996), pp. 7–14.

Sōtatsu, Kōrin, Hōitsu

The lineage of Rimpa painting as seen in the
Wind God and Thunder God screens

Masato NAITŌ
CURATOR, IDEMITSU MUSEUM OF ARTS

The Rimpa art that flourished in the Edo period (1600–1868) was the creation of multi-talented artists working in a wide range of media, notably painting, calligraphy, ceramics and lacquer. This essay will concentrate mainly on their painted works. As many previous authors have written, the achievement of Rimpa artists was to create a style of painting whose key element was the use of decorative planes. Their works are imbued with a strong sense of design, creating compositions at once gorgeous, delicate and with a refined sense of beauty. The artists of the Rimpa lineage painted in many different formats – folding screens, hanging scrolls, handscrolls and square poem-papers (*shikishi*) – but obviously the range of their subjects was not limitless and they had a preference for certain themes. To be more specific, they explored two areas of subject matter with particular passion: firstly, figure subjects, either of Daoist or Buddhist worthies or illustrations of scenes from the ancient courtly tales of Japan (*monogatari-e*); and, secondly, designs of flowers and grasses or flowers and trees, at which they were especially skilled.

Among the works of these two kinds are many which have come to symbolise the essence of Rimpa as practised by this distinctive group of artists. If a choice had to be made of just one example from the first group – scenes from court tales or Daoist and Buddhist worthies – the consensus would probably be for the renowned *Wind God and Thunder God* by Tawaraya Sōtatsu (fig. 36). This work is painted on a pair of two-fold screens with gold-leaf backgrounds and, although it bears neither signature nor seal, the attribution to Sōtatsu which has always accompanied the screens has never been doubted. Against the brightly gleaming gold ground, and accompanied by black clouds, are painted the two awesome figures of the heavenly deities, the Wind God and Thunder God, their massive, majestic forms executed with such power that they threaten to burst beyond the confines of the composition.

A distinctive aspect of the Rimpa school, in which the three outstanding geniuses Sōtatsu (worked *c*. 1600–40), Ogata Kōrin (1658–1716) and Sakai Hōitsu (1761–1828) appeared at intervals approximately one century apart, is that there was no direct family connection between the three artists, nor were they linked in teacher-pupil relationships. The tradition and transmission of Rimpa art might be regarded as a living proof of the theory of the German zoologist Ernst Haeckel (1834–1919) that the evolution of the individual (ontogenesis) results from the repetition of the evolution of the type (phylogenesis). Indeed, Rimpa is distinct from the main schools in the history of Japanese painting, which tend to be firmly cemented by family ties or a sense of communal consciousness. Each

Rimpa artist used direct exposure to the works of his predecessor to inaugurate a new lineage: Sōtatsu, of course, had appeared as an outstanding genius at the beginning of the Edo period; the next main figure, Kōrin, cherished the artistic achievements of his great predecessor; the later Edo painter Hōitsu fervently revered the earlier Kyoto master Kōrin. Thus each great artist built on the previous master's achievements, absorbing and digesting the elements – the sense of beauty and the elements of style – that a Rimpa painter needed to enable him to forge a new individual artistic idiom and move on.

There is even a sense in which the continuity of Rimpa as a school was maintained by the act of copying the great works of a predecessor. In fact, not just the powerful *Wind God and Thunder God* screens mentioned above, but other masterpieces of the Rimpa school were repeatedly copied by artists of later periods who had direct or indirect opportunities to come into contact with them. This also represented a sort of ceremony of inheritance whereby artists

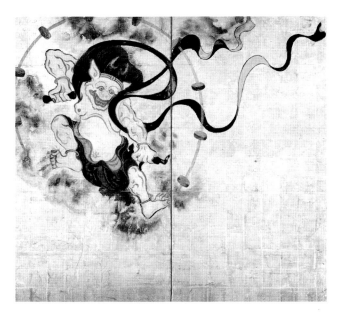

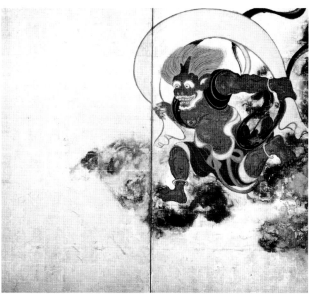

Fig. 36 Tawaraya Sōtatsu, *Wind God and Thunder God*. Pair of two-fold screens, c. 1640. National Treasure. Kennin-ji Temple, Kyoto [4:130].

acknowledged themselves as successors to the Rimpa tradition. The very fact of having the work of a long-dead predecessor in front of him and actually recreating the same composition by copying was more than usually significant for a Rimpa painter. The task of such copying was deemed essential not only in terms of study, but also to establish general recognition of his connection to the Rimpa lineage.

Interestingly, however, if the almost identical compositions painted in turn by each successive generation of Rimpa painters are meticulously compared, elements of expression individual to each artist become readily apparent; the works are not just painstaking copies. Certainly, the succession from artist to artist was carried out by attempting a work with the same composition. Yet on the other hand the copying of the artistic achievements of a predecessor was not merely an exercise in studying and practising artistic techniques: invariably the copying artist introduced his own interpretation into the work and added his own variations on the basic theme. It was not enough simply to bow one's head as a worshipper in front of the works of predecessors: while painting a work with the same composition one was also doing battle with the great masters. The very fact that such a creative project was repeated again and again gave a freshness to Rimpa art each time it was reborn. This was not merely an exercise in nostalgia or idolisation: on each occasion, Rimpa was revived.

The iconography of the *Wind God and Thunder God*

If the Rimpa school is mentioned, the work which immediately comes to mind for most people is the *Wind God and Thunder God* screens by Sōtatsu. But where did Sōtatsu's figures of the Wind God and the Thunder God originally come from? In order to answer this question, we must begin with a search for the origins of the iconography of these two deities.

An account of the Thunder God is said to appear first in the *Shanhai jing* (Japanese: *Sengai-kyō*), a book of geography and mythology of the Warring States (403–222 BC) to the Qin (221–207 BC) and Western Han (206 BC to AD 6) periods, where he is described as having a human head but with a kind of beak, and the body of a dragon. A little later, in the *Lun chong* (Japanese: *Ronkō*) of the Eastern Han (AD 25–220) period, he is described in a form that really seems like the Thunder God with whom we are familiar: a human figure striking a set of linked hand-drums. The earliest examples of the iconography of the Thunder

Fig. 37 Scene of the Thunder God from the *Legends of the founding of the Kitano Tenjin Shrine (Kōan version)*. Illustrated handscroll, 1278. Important Cultural Property, Tokyo National Museum.

God in extant works are found in wall-paintings and stone sculptures of the sixth century AD. A notable instance is at Cave 249 of the Mogao caves, Dunhuang, where the figure of the Thunder God floating in the heavens is depicted in a wonderfully grand manner.

The figure of the Wind God, too, seems to have a fairly ancient history. The earliest surviving works that adopt the classic image of a figure carrying a sack of wind on his back similarly date from around the sixth century. This image is mainly found in Buddhist-related examples.

The two deities of the Wind God and Thunder God were brought to Japan at the same time as Buddhism arrived from continental Asia, also during the sixth century. An example is known from the twelfth century of both deities being depicted together, painted in gold on the inside of the cover of the *Daijikkyō* Sutra,

scroll 25 (National Treasure, Kōya-san Reihōkan), and many variant forms appear in different kinds of pictures of the life of the Buddha and mandalas of the Lotus Sutra. In parallel with such appearances in Buddhist paintings, the two deities also began to be depicted in illustrated handscrolls of legends of the founding of various temples and shrines (*engi emaki*). Their conventional appearance came almost to be fixed, with horns, fierce expressions, hair standing on end, and holding their respective attributes. The convention for the colours of their bodies was that the Wind God would be blue or green and the Thunder God red.

There is a section in the famous illustrated handscroll of the *Legends of the founding of the Kitano Tenjin Shrine (Kōan Version)* in which the Thunder God is depicted amid black clouds, as thunder rolls down around the Seiryōden Hall of the Imperial Palace (fig. 37). It is well known that Sōtatsu's habitual working method was to study many different medieval illustrated handscrolls and to borrow figures and other motifs which he reused in his own works, and the figure of the Thunder God on Sōtatsu's screens is thought to have been taken from a similar scene in a later work in the lineage deriving from the *Kitano Tenjin Shrine* handscroll. The only differences are that the Thunder God's

Fig. 38 *Decorated sutra scrolls dedicated by the Taira family (Heike nōkyō)*, painting inside the cover of the Kannon Sutra, no. 25. Handscroll, 1164. National Treasure, Itsukushima Shrine, Hiroshima Prefecture.

body is painted white, not red; he wears a band around his head rather than a crown, and extremely large ears have been added. With respect to the Wind God, so far no one particular source has been discovered. However, it has been argued that Sōtatsu would have come into contact with Wind God imagery on several different occasions: he would have seen the paintings on the insides of the covers of the famous *Heike nōkyō* scrolls (thirty-three handscrolls of the Lotus and other sutras, commissioned by the Taira family, National Treasure, Itsukushima Shrine; fig. 38) when he repaired these; and the sculpted versions in the Sanjūsangendō Hall of Myōhō-in, just next to the Yōgen-in Temple in Kyoto, where he executed a series of sliding-door and folding-screen paintings.[1]

The revolutionary significance of Sōtatsu's screens was that he took these

two deities – who were normally depicted in Buddhist painting as mere ancillary attendants to a Bodhisattva, the Thousand-armed Kannon – and gave them pride of place as the main, dominant figures on a pair of two-fold screens, against a dazzling background of shining gold leaf. Also significant are the unprecedented innovations in colour and design which were daringly introduced. The wild and original forms of the two deities, entirely characteristic of Sōtatsu, exude ease and suppleness, imbued as they are with all the vigour of the rising merchant elite (*machishū*) of Kyoto at the time. There have been many interpretations of this pair of screens, and the enormous appeal they continue to exert is demonstrated by the extent to which people from later periods have been prompted to pursue investigations in so many different directions. Concerning the dating of the painting, the most persuasive theory at present is that it is a work of Sōtatsu's very last years, Yamane Yūzō going so far as to narrow it down to *c.* 1639.[2] The screens originally belonged to the Zen sect temple Myōkō-ji, Kyoto, but are kept in the treasure house of its head temple, Kennin-ji, also in Kyoto.

Kōrin's copy of the *Wind God and Thunder God* screens

Sōtatsu is said probably to have been brought up in a fan shop in Kyoto, and although he later executed works to the commission of the Imperial court and was awarded the rank of *Hokkyō*, even the dates of birth and death of this genius are unknown. In contrast, the next artist we are to consider, Ogata Kōrin, is known to have been the second son of the wealthy owner of the Kyoto draper's firm the Kariganeya. Kōrin's grandfather, Sōhaku (1570–1631), was the second-generation head of the Kariganeya firm, and his wife was the elder sister of the many-talented artist Hon'ami Kōetsu, a frequent artistic collaborator with Sōtatsu. It even appears that Sōhaku commissioned a painting from Sōtatsu (see commentary to cat. no. 4). So it is clear that Kōrin's family was by no means without links to the master. Kōrin succeeded to a drapery business already in gradual decline, and squandered his inheritance within less than ten years. Just before he reached the age of 40, inspired by the works of Sōtatsu and Kōetsu, Kōrin turned to the profession of painting in order to establish his own livelihood. Great painter though he later became, this certainly cannot have been the destiny he had originally imagined for himself.

Kōrin made an extensive survey of the surviving paintings of Sōtatsu, which were already antique by that time, and strove hard to study and learn from many examples of Sōtatsu's art, in terms of their technique and composition. In this process, his encounter with Sōtatsu's *Wind God and Thunder God* must have been providential. At that time the paintings were at Myōkō-ji temple, not far from the Narutaki kiln operated by Kōrin's younger brother, the talented ceramist Kenzan, and this geographical coincidence may have helped bring about the meeting between Kōrin and the *Wind God and Thunder God* screens. No written records survive to support this, but it can be conjectured that Kōrin had the opportunity to see the screens first-hand at this temple, probably some time around the end of the Hōei (1704–11) era.

Having seen these powerful portraits of the two deities, Kōrin set about making a copy (fig. 39), as was his normal practice. For artists of the Rimpa school from Kōrin onwards, who venerated already deceased masters as their teachers, this was the one and only method of study available to them – repeatedly making copies so as to come close to the essence of the beauty created by that master. Some eighty years after Sōtatsu had painted with quite literally 'heavenly perfection' the forms of the two deities, here was a renewed discov-

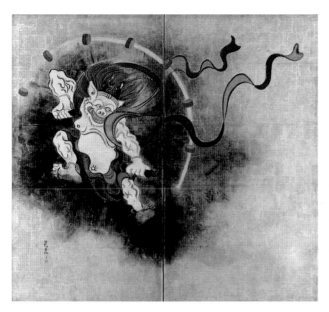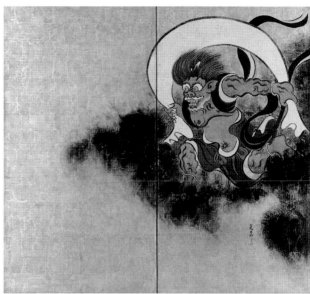

Fig. 39 Ogata Kōrin, *Wind God and Thunder God*. Pair of two-fold screens, *c.* 1710. Important Cultural Property, Tokyo National Museum [4:131].

ery and appreciation of that beauty, and an attempt to assimilate and absorb it, by one who really understood Sōtatsu's art and sought to lay claim to the title of his successor.

Kōrin copied the gold-leaf screens by Sōtatsu in the form of similar gold-leaf screens, but made the dimensions of the new versions slightly larger. Although the screens as painted by Kōrin appear at first glance to be extremely similar to Sōtatsu's originals, when one goes on to compare them in detail it becomes apparent that the two versions are rather different in terms of content.

In the case of Sōtatsu's Thunder God, the deity was painted with eyeballs in the centre of his eyes, just as if he were gazing from up in the heavens down onto the earth below (fig. 40). There is a certain humour in the construction of the face, and yet he has not lost his sense of divinity completely: the nose, the mouth and the white teeth visible within have a realism and severity seen elsewhere in examples of Buddhist sculpture. The robust bulging of the muscles on his arms and legs conveys an overall impression of violence and strength, and even though there is a recognisable element of familiarity in the depiction, the god still retains his majestic authority.

The Thunder God painted by Kōrin, in contrast, is definitely not looking down, but glaring in the direction of the Wind God on the other screen (fig. 41). Or, rather, his expression as he regards his adversary, with pupils looking out of the left corners of his eyes, is not so much glaring as smiling malevolently to himself. We have left the realm of the gods, and clearly a certain vulgar process of imitating the human world is already under way. It is a small point, but the toenails on the Thunder God's right foot, are those of a human being, as in the Sōtatsu version, whereas the left toenails are noticeably long and come to a sharp point, like those of a devil. Quite a few differences in detail between the Sōtatsu and Kōrin versions can be detected in this way, and one could go on to point out changes to certain parts of the colour scheme.

What about the Wind God? Sōtatsu's Wind God, like his Thunder God, has pupils placed right in the centre of the eyes as in a wooden sculpture, and their piercing glint has abandoned all human emotions and seems to see through all pretence – entirely appropriate for an awe-inspiring heavenly deity (fig. 42). In contrast to the Sōtatsu version, with its characteristically rough-hewn and grand expressive qualities, the gaze of the Wind God in Kōrin's version – like that of

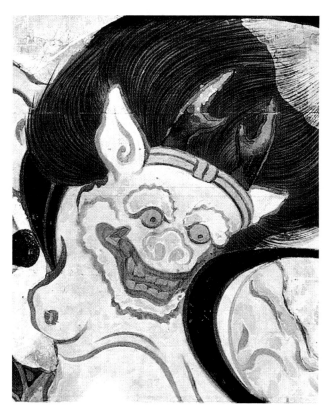

Fig. 40 Face of the Thunder God by Sōtatsu (detail of fig. 36).

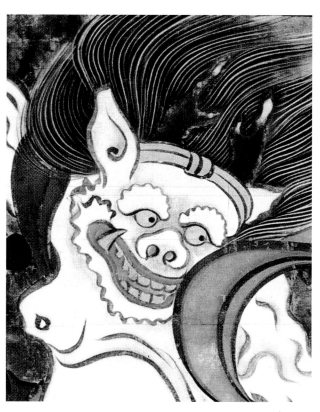

Fig. 41 Face of the Thunder God by Kōrin (detail of fig. 39).

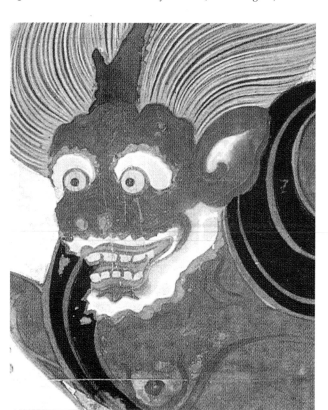

Fig. 42 Face of the Wind God by Sōtatsu (detail of fig. 36).

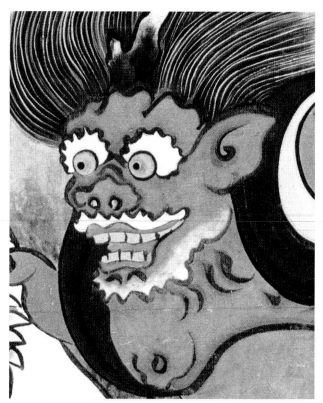

Fig. 43 Face of the Wind God by Kōrin (detail of fig. 39).

Fig. **44** Clouds around the Wind
God by Sōtatsu (detail of fig. 36).

Fig. **45** Clouds around the Wind
God by Kōrin (detail of fig. 39).

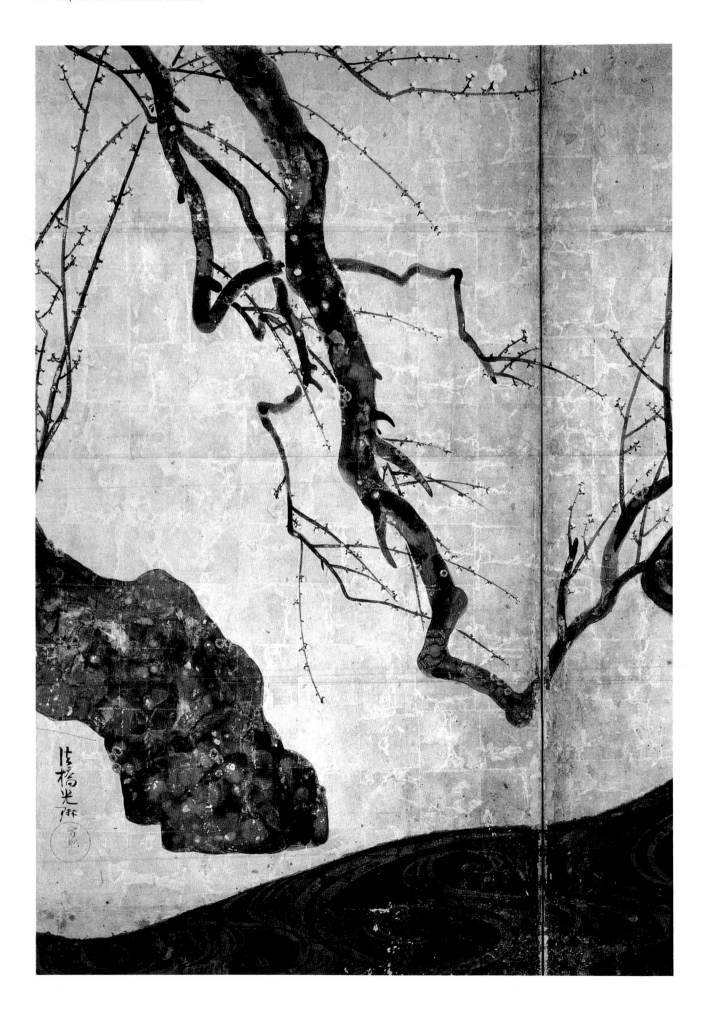

Fig. 46 Ogata Kōrin, Detail from
Red and white plum trees (fig. 19).

the Thunder God – is cast in the direction of his opponent (fig. 43). The Sōtatsu painting is soiled and flaking in a manner consistent with its antiquity, and the colours have aged in a way that makes it look like an old painting. The Kōrin version, on the other hand, is in an extremely good state of preservation, which, paradoxically, becomes a problem because it really appears to be a recent work. Factors such as this show that Kōrin's Wind God is separated by a wide gulf from Sōtatsu's heroic figure: it is somewhat vulgar but also delicate. Also, although the accents in the outlines of the body and the drapery are done in a slightly darker ink than in the Sōtatsu version, they nonetheless convey a weaker impression.

The comparison between the Wind and Thunder Gods by Sōtatsu and Kōrin further extends to the black clouds that surround them. In the Sōtatsu version, the clouds that trail in the wake of the two gods are remarkably light: the appearance of the black clouds kicked and scattered by the Wind God, for instance, brings dynamic movement to the composition (fig. 44). Those painted by Kōrin, on the other hand, are thick, more substantial masses, their dark, heavy, dull appearance restraining any sense of movement (fig. 45). Kōrin leaves some empty gold space above the two deities, whereas there is none in the Sōtatsu version. Earlier commentators have pointed out that this gives the impression that the Kōrin gods have descended somewhat from heaven. This may well be the case, but I would argue for an alternative explanation, namely that this space is opened up simply because the Kōrin version is in a slightly larger format than the Sōtatsu one.

Such a comparison of the two versions indicates clearly that although Kōrin follows the overall framework of the expressive content of Sōtatsu's original, nevertheless there are quite a few differences in the detail of the depiction. A new personal interpretation is invariably introduced when Rimpa artists from Kōrin onwards copy the works of earlier masters. To follow tradition while taking up the challenge of innovation was their main aim. When copying an old painting it was not enough to make a faithful reproduction: it was vital to rearrange the work in some way so as to put one's own stamp on it. But even though the artist who claimed the title of successor was constantly challenging the master of the distant past, in the end it was of course no easy matter to surpass the predecessor he so revered. In the present instance, too, Kōrin did not have the vigour to outdo Sōtatsu's *Wind God and Thunder God*. However, he did on another occasion come up with a highly successful response to Sōtatsu, namely the famous *Red and white plum trees* (figs 19, 46) which represents the summit of his artistic achievement. Painted like the *Wind God and Thunder God* on a pair of two-fold gold-leaf screens as if in some earthly paradise, the red and white plum trees stand face to face on either side of the stream, with its celebrated pattern of 'Kōrin waves': this is indeed a worthy rejoinder by Kōrin to Sōtatsu.

A second copy, by Hōitsu

Sakai Hōitsu, a great devotee of Kōrin, was born of samurai stock in Edo, the second son of Lord Sakai of Himeji, one of the clans who were historical allies of the ruling Tokugawa family (*fudai daimyō*). In his youth Hōitsu acted the playboy, enjoying the life of the pleasure quarters and composing comic fiction (*gesaku*), while also trying his hand at Ukiyo-e painting. In his later thirties, however, his destiny was changed when he came into contact with the works of Kōrin: embracing their beauty, he set himself the task of trying to recreate that beauty with his own hands. Significantly, he did this not in Kyoto but in the

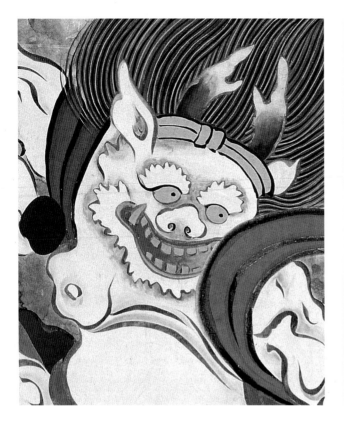

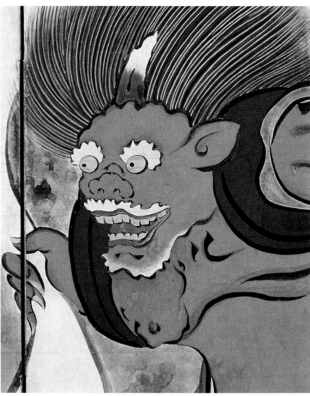

Fig. 47 Face of the Thunder God by Hōitsu (see cat. no. 39).

Fig. 48 Face of the Wind God by Hōitsu (see cat. no. 39).

eastern capital, Edo, and for this reason the group of Rimpa artists that succeeded him have come to be known as the 'Edo Rimpa' school.

In fact Kōrin had spent a period in the service of the Lord of Sakai, Hōitsu's ancestor, during his time in Edo and it is important to bear in mind that Kōrin and Hōitsu were thus not without connections, their relationship having many similarities, indeed, to that between Sōtatsu and Kōrin (see p. 28).

Hōitsu spent much time and effort seeking to discover the course of the Rimpa school since the early Edo period and studying the works of many painters from Sōtatsu and Kōetsu onwards, but the principal focus of his interest was the work of the great Kōrin. It is likely that the subjects of the paintings by Kōrin which are thought to have been passed down in the Sakai family and which must have so bewitched Hōitsu were mainly flowers and grasses. We can further imagine the powerful impact of his chance encounter with Kōrin's copy of the *Wind God and Thunder God* screens, which at that time was in the collection of the Hitotsubashi Tokugawa family, one of the three cadet branches of the shogunal line.

A significant fact not generally appreciated other than by certain Rimpa specialists is that Hōitsu seems to have been completely unaware of the existence of the original Sōtatsu paintings of the *Wind God and Thunder God* on which Kōrin's screens were based. Little could Hōitsu, in Edo, have imagined that in the Kyoto of his own day there existed the Sōtatsu versions of these screens and that at some time in the past Kōrin had executed a copy of them. In other words, even as he copied them Hōitsu was under the misapprehension that Kōrin's *Wind God and Thunder God* was an original composition by him.

This is readily apparent when one actually looks at the Hōitsu screens (cat. no. 39). To state my conclusion first, Hōitsu's version of the screens is very close to Kōrin's, even down to the details. Looked at by modern viewers such as ourselves who know all three versions and are able to compare them, however, Hōitsu's version shows conspicuous inconsistencies due to mistakes made when redrawing – something that is very understandable when a work that has

already been copied once is then copied for a second time. For example, the black eyes of Hōitsu's Thunder God are depicted in the same way as those of the Thunder God by Kōrin, apparently looking in the direction of the Wind God (fig. 47). Yet the pupils seem to be swimming in space, giving an unsettled impression. In the face, the large gap between the upper and lower teeth is weak, even comic. All these factors combine to make Hōitsu's Thunder God appear overall as if he is merely floating in space; he is full of a delicate, elegant sensibility more akin to the lightness of *haiku* poetry, rather than the awesome majesty of a heavenly being. A great deal of power has been lost by this Thunder God, who dances lightly through the air like some angel. Doubtless because Hōitsu did not know the Sōtatsu version, the drawing of the god's right hand, grasping one of the drumsticks, is weak, and the treatment of the bulges of muscle around the shins, too, has become very formulaic. Furthermore – and this is partly due to the fact that the painting is in even better condition than the Kōrin version and so the areas of colour seem very flat – of all the three versions the Hōitsu is most lacking in a sense of volume, and even appears monotonous.

These observations also apply to the painting of the Wind God. For example, in the face the distance between the eyes is wider than in either the Sōtatsu or Kōrin versions and the number of creases on the bridge of the nose is reduced, making the nose and the centre of the face in general protrude more and the area of the cheeks broader (fig. 48). Add to this the manner in which the chin is drawn in, and the Wind God's features have become very humanised. As far as the depiction of forms is concerned, the lines which suggest the musculature within the body have begun to lose the original meaning of the Sōtatsu version, the lines themselves reduced to a pattern suitably arranged on a flat surface. Also, the connection between the left leg and the body is poor, destroying the balance of the legs. In terms of their colour scheme, both Wind and Thunder Gods follow the example of Kōrin, except that the colouring seems somewhat more gaudy. Furthermore, the depiction of the black clouds beneath the feet of both gods incorporates modifications to the Kōrin version, losing Kōrin's suggestion of thickness and weight and coming to look like mere thin wisps of smoke and mist.

It may be somewhat of an exaggeration, but when we look at the two gods as painted by Hōitsu, their figures resemble vulgar Edo street types of his day, rushing headlong or thrusting out their faces and looking surprised. Considered in this light, the way in which they stare directly at one another in confrontation could even be interpreted as two Edo street toughs spoiling for a fight. In these respects it is clear that the imagery of the Wind God and Thunder God has undergone considerable transformation at the hands of Hōitsu.

The Edo Rimpa school led by Hōitsu has as its special characteristic a particularly refined sensitivity that is stylish and light. The summit of Hōitsu's artistic achievement is in the genre of paintings of flowers and grasses: regrettably, his paintings of Shintō and Buddhist subjects and Daoist and Buddhist worthies such as the Wind God and Thunder God always seem somewhat inferior to those by Sōtatsu and Kōrin. The great strengths of Hōitsu's painting lie in its lightness and clarity, and the fact that the Wind and Thunder Gods – which are even more humanised than in the Kōrin version – look just like common people from the city of Edo undoubtedly reflects to some extent this fundamental quality of his art.

Just as Kōrin had devised a kind of response to Sōtatsu by painting his famous *Red and white plum trees* screens, so Hōitsu too crystallised the whole of his art into a work in this same format, a pair of two-fold screens. Unlike Kōrin,

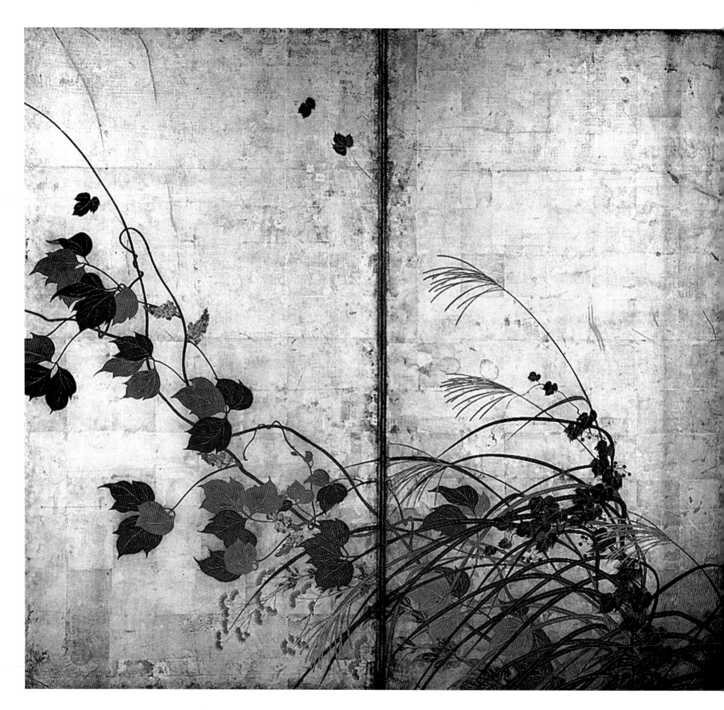

Fig. 49 Sakai Hōitsu, *Summer and autumn grasses*. Pair of two-fold screens, *c.* 1822. Important Cultural Property, Tokyo National Museum [1:71].

however, he did not employ a background of gold leaf, but rather silver leaf, onto which he painted a delicate and elegantly beautiful composition of flowers and grasses, his masterpiece *Summer and autumn grasses* (fig. 49). This work was originally painted onto the back of none other than the *Wind God and Thunder God* by Kōrin, whom he so revered. For Hōitsu, Kōrin's *Wind God and Thunder God* screens – which, as we have seen, he mistakenly believed to be an original composition by the earlier Kyoto master – represented an enormous challenge which could only be addressed in this manner.

It has been pointed out that in the production of the *Summer and autumn grasses* screens Hōitsu used the *tsukeai* ('connecting together') literary technique of *haikai* (*haiku*) poetry, a pastime that he had pursued for many years. Also called *tsukeyō* or *yoriai*, this was a device of linked poetry, whereby a connecting verse would be added to the previous verse in order to complement it and lead on to create a succession of new dimensions. In assessing the merits of the

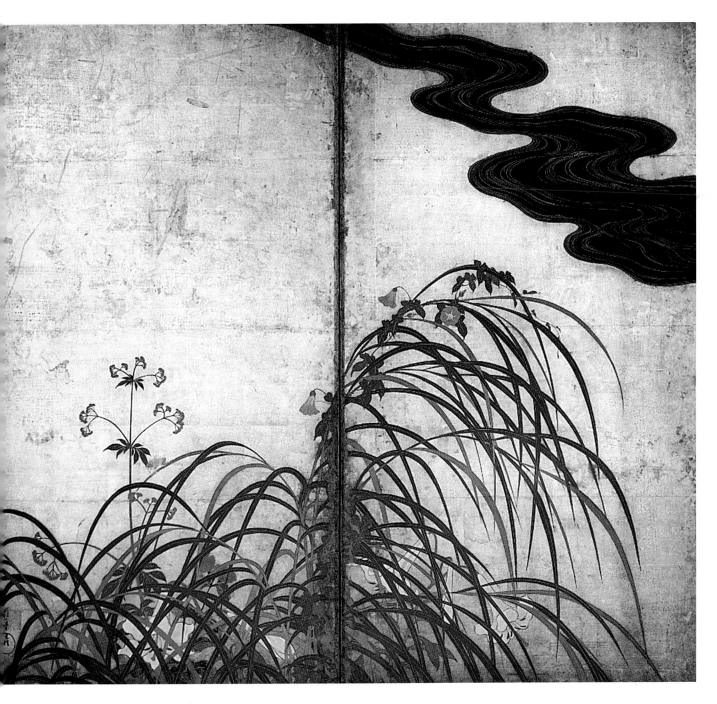

linked verses, the main criterion was how the later verse had been connected to the one that preceded it. Hōitsu reflected this extremely sophisticated kind of literary game in the *Summer and autumn grasses* by painting on the back of the screens as a response to what was painted on the front. The compositions on front and back were thus able to maintain a balance while simultaneously complementing one another in the following ways: (1) gold leaf versus silver leaf; (2) heavenly gods versus earthly flowers and grasses; (3) summer grasses drenched in rain brought by the Thunder God and autumn grasses tossed by early autumn typhoons brought by the Wind God. Hōitsu is celebrated for the manner in which he introduced the naturalistic style of the new Maruyama-Shijō school of Kyoto into Rimpa painting, and so it is no coincidence that in this most direct response possible to a surviving painting by his great predecessor he revealed his true worth in this uniquely delicate composition of flowers and grasses, a subject which was also a forte of Maruyama-Shijō painters.[3]

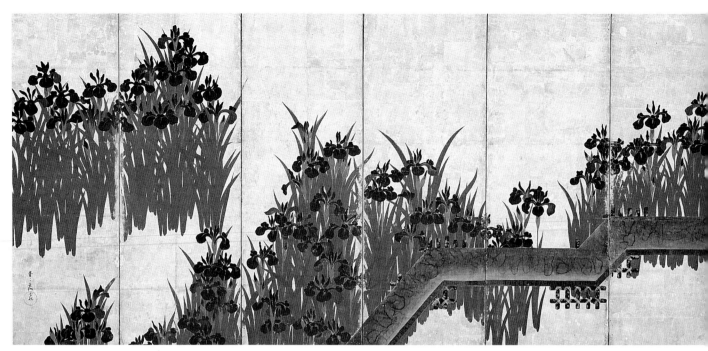

Fig. 50 Ogata Kōrin, *Eight-fold bridge over the iris pool.* Pair of six-fold screens, *c.* 1715.
Metropolitan Museum of Art, New York [4:3]; purchase, Louisa Eldridge McBurney Gift, 1953.

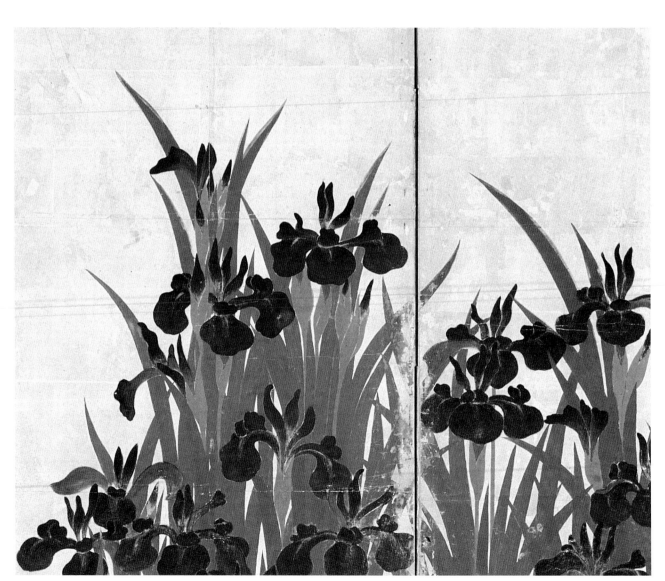

Fig. 51 Detail of fig. 50.

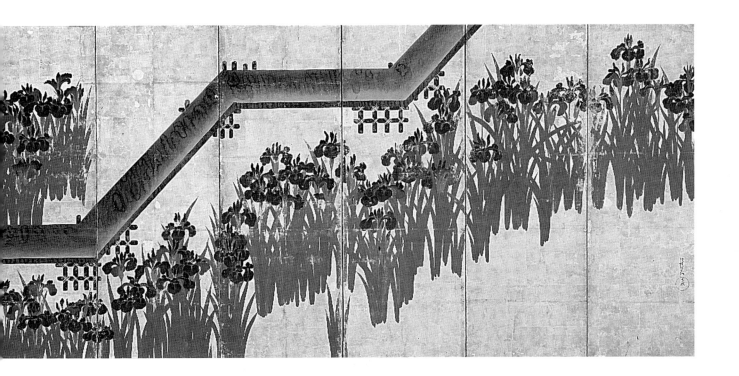

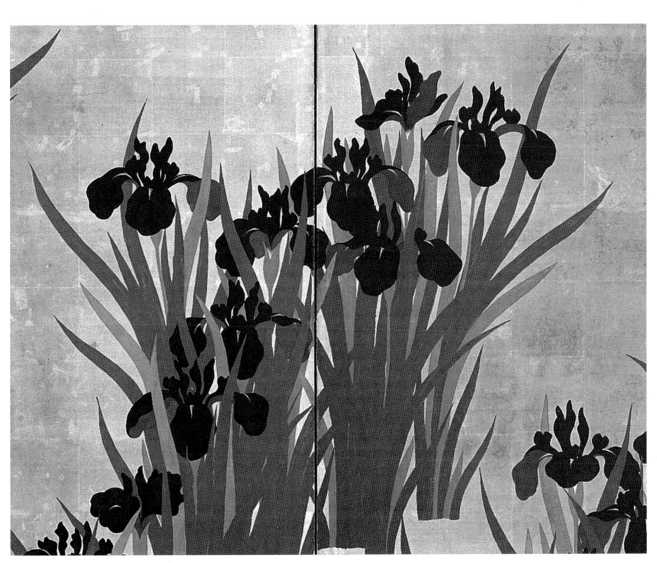

Fig. 52 Detail of cat. no. 41.

The renewal of Hōitsu's art as seen in his paintings of flowers and grasses

In comparing the various versions of the *Wind God and Thunder God* screens and demonstrating how they changed from Sōtatsu onwards, there is a danger that I may have conveyed to the reader by this one example the mistaken impression that there was, in art-historical terms, a process of decline from Sōtatsu to Kōrin and then from Kōrin to Hōitsu. Obviously such is not the case, and in order to demonstrate this I should have liked to describe the various subjects and formats that were the particular specialities of Kōrin and Hōitsu within the fertile realm of their painted works. Regrettably there is not sufficient space here to explore fully all the topics I would wish, and I shall leave my comments on Kōrin for another occasion. It is with a consideration of what Hōitsu learned from the study of Kōrin in the genre of paintings of flowers and grasses on the one hand, versus his originality on the other, that I shall conclude this essay.

Hōitsu copied many other of Kōrin's works beside the *Wind God and Thunder God* screens. Among these are copies in the genre of flowers and grasses, a subject in which Hōitsu himself also excelled. For example, in the case of Kōrin's masterpiece *Eight-fold bridge over the iris pool* (Metropolitan Museum of Art, New York, fig. 50), although Hōitsu grasped the essence of the original painting, he also made quite substantial changes of his own (cat. no. 41; see foldout opposite p. 104). Commentaries by scholars in the past have tended to focus on the modifications made: that Hōitsu deliberately did not choose the paper support of Kōrin's original version, but instead created a decorative background using thick layers of gold leaf on both the front and back of a silk support; that the motifs have been more neatly arranged by reducing the numbers of flowers; that alterations have been made to the angles of the planks and posts of the famous bridge over the iris pool in Mikawa – first immortalised in the courtly *Tales of Ise* – as it passes across both of the screens. In contrast to the abstracted flower petals of Kōrin, the draper's son, which have been arranged in a pattern like a kimono design (fig. 51), those by Hōitsu have a realism more akin to modern painting, incorporating certain naturalistic elements (fig. 52).

A significant aspect which has received surprisingly little attention hitherto is the difference in Hōitsu's depiction of the clumps of irises on the right screen and on the left. In the original version by Kōrin, the leaves of the irises are as sharp as swords, while those painted by Hōitsu are relatively soft. In comparison to the right screen in the Hōitsu version, in which the clumps of irises are drawn in a subdued way with little sense of movement, on the left screen there is an overall rhythmic feeling as if the flowers were dancing. Even though they form a pair, the method of depiction has been deliberately changed between the right and left screens.

In the past, the present author has interpreted the left screen as showing the leaves shaking in the wind while those on the right screen maintain their stillness – yet another example of the delicate differentiation in the depiction of plants in nature also seen in Hōitsu's famous screens of *Summer and autumn grasses* (fig. 49). I do not wish here to abandon this interpretation completely, but a much more significant difference between the right and left screens has subsequently occurred to me. On the right screen of the Hōitsu version, the many azure-blue flowers that have opened are, on the whole, shown in a relatively low position, buried within their leaves. However, on the left screen, the stems of the flowers have grown somewhat longer, so that the blue flowers are more visible amongst their green leaves and stand out much more clearly in the composition as a whole. When I consulted an expert in flower arrangement, I was

informed that when irises first bloom the flowers are low down inside their leaves, but that as the stems grow the flowers gradually rise upwards.[4] In other words, although the pair of screens both show clumps of irises, there is a slight lag in the stages of growth between them, the right screen being earlier and the left somewhat later. The fact that the leaves on the left screen are depicted as if they have spread more openly may not be due to the action of the wind shaking them. Rather, it may be a warning that with the passing of time since the irises have flowered the leaves have grown to their full extent and are now starting to decline and to lose their vitality.

The passage of time between the right screen and the left screen can definitely be seen as a deliberate device contrived by Hōitsu. In his copy he has added to brilliant effect an almost imperceptible flavour not in the original Kōrin painting. In fact, there is another example of Hōitsu experimenting with contrasting time frames in a pair of screens of trees and flowers, the *Red and white plum trees* (cat. no. 43) – itself a subject treated by Kōrin (figs 19, 46). On the silver-leaf background so often used by Hōitsu, the right screen shows an old plum tree violently twisting, wrapped in its rugged coat of bark, while across the left screen there stretches a smooth, slender young tree that spreads its branches in a manner as taut as a whiplash. Obviously, there is a difference in age between the two plum trees and, as in the *Eight-fold bridge over the iris pool*, it is clear that the concept of time has been introduced into the work. It is important to recall in this respect that when Kōrin painted his famous *Red and white plum trees* he did not create such an obvious distinction between the ages of the two trees.

The composition of Hōitsu's *Red and white plum trees* is not borrowed from Kōrin and is probably an original one he has devised himself: in this respect it differs from the *Eight-fold bridge* screens, which copied an older, existing work. However, when it comes to the respective depictions of the two trees in Hōitsu's screens, the red plum bears a resemblance to the forceful brush techniques used by the great Kōrin, while the white plum exhibits much more strongly Hōitsu's own personal painting style, including as it does elements of the naturalism of the Shijō school. We might even suggest that Hōitsu was in fact projecting onto the forms of these two plum trees images of the deceased Kōrin and himself, so urging himself to assume the mantle of the Rimpa tradition and determining to work towards its renewal. It is by means of such examples that we begin to appreciate the true depths of Hōitsu's art.

NOTES

1. My account of the iconographic lineage of the Wind God and Thunder God derives from Wakisaka Atsushi, 'Fūjin, raijin no zuzō-teki keifu to Sōtatsu hitsu fūjin raijin zu', *Osaka Shiritsu Bijutsukan kiyō* 4 (1984), pp. 5–24.

2. Yamane Yūzō, 'Fūjin raijin zu byōbu no igi to sono seisaku nendai', *Sōtatsu kenkyū ni*, Tokyo, Chūō Kōron Bijutsu Shuppan, 1996, and other essays.

3. A magnificent recent essay concerning the screens of *Summer and autumn grasses* is Tamamushi Satoko, *Sakai Hōitsu hitsu natsu aki kusa zu byōbu – tsuioku no gin'iro* (*E wa kataru* 13), Tokyo, Heibonsha, 1993.

4. Conversation with Ms Okamura Noriko, member of staff at the Idemitsu Museum of Arts.

3

'The Intuition and the Genius of Decoration'

Critical reactions to Rimpa art in Europe and the USA during the late nineteenth and early twentieth centuries

Timothy CLARK
ASSISTANT KEEPER, JAPANESE ANTIQUITIES, BRITISH MUSEUM

Korin! I like the name, the turn of it, and the rhythm. It undulates, trails along, and has an air of antiquity about it which practically amounts to a picture. It awakens in the true Japanese amateur, the amateur who is at all bitten, heady sensations, and, as it were, a particular vibration which is the very emanation of this strange and surprising individuality. I am one of those who believe in affinities of names and ideas and, I must confess it, who attribute a mysterious sense to the music of such and such an arrangement of syllables. The name of Korin marvellously suits the art which he represents.

Korin is in the first rank of those who have carried to the highest pitch the intuition and the genius of decoration.

<div align="right">

Louis Gonse, 'Korin', *Artistic Japan*, no. 23 (March 1890), p. 287

</div>

Japonisme, the passion for Japanese art and culture in the West during the later nineteenth century and after, is sometimes narrowly defined as the influence of Ukiyo-e colour woodblock prints on Impressionist painting. It is certainly true that Hayashi Tadamasa (1851–1906), one of two leading dealers in Japanese art in Paris (the other was Siegfried Bing, 1838–1905) and friend of Monet and Renoir among many others, sold during the years 1890–1901 no less than 156,487 Ukiyo-e prints. Yet he also handled in the same period some 846 original paintings, both screens and hanging scrolls,[1] and to judge from the illustrated catalogues of the auctions of the great French collections of Japanese art that began to take place around this time, this number undoubtedly included several hundred works of the Rimpa school. The appeal of Kōetsu, Sōtatsu and, above all, Kōrin is self-evident in the writings of French authors, both for their work as painters and, in the case of Kōetsu and Kōrin, as designers of lacquerware and ceramics. Indeed, many critics of the time praised so-called 'Kōrin lacquer' more than his paintings (it was not clear then, and there still remains some debate today, as to whether Kōrin actually painstakingly manufactured the lacquer himself – which seems unlikely – or just provided designs for specialist crafts-men to work from). Edmond de Goncourt, author of immensely popular biogra-phies of Utamaro (1891) and Hokusai (1896), also planned to include in his series of five titles on Japanese art a monograph on Kōrin, though in the event this was never realised.[2]

It is beyond the scope of the present essay to demonstrate in detail the varied Japanese influences on Post-Impressionism and Art Nouveau,[3] but the repeating,

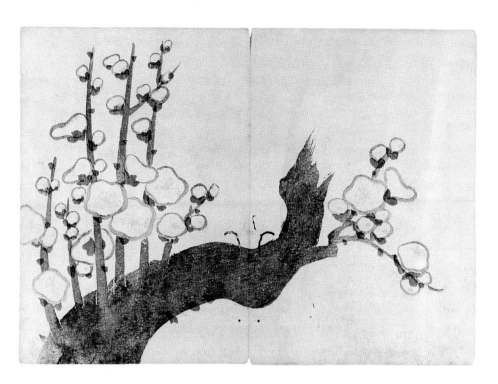

Fig. 53 Nakamura Hōchū, *Kōrin gafu* (Album of paintings by Kōrin). Colour woodblock album, 1803. British Museum, JA/JH 246.

simplified plant and animal motifs of Rimpa designs must have been as fertile a source as the bird-and-flower prints of the Ukiyo-e school. And we should not forget in this connection the many nineteenth-century printed books of Rimpa design, works such as Nakamura Hōchū's *Kōrin gafu* of 1802 (fig. 53), which have had a much greater significance in the consciousness of Western writers than ever perhaps in their country of origin.[4] It may be unreasonable to suggest that Van Gogh's irises owe as much to Kōrin and Hōitsu as to Hokusai – particularly given the impossibility in Europe and the USA of seeing even the most famous Rimpa paintings from Japanese collections in reproduction before about the early twentieth century – and yet the hundreds of Rimpa school works that littered the early French and other collections, albeit of very mixed quality, must have had considerable influence. What can be demonstrated here is that between the 1880s and about the time of the First World War there was a rapid improvement in knowledge of Rimpa art among Western scholars and collectors, which increasingly found its way into the public domain through publication, exhibition and important acquisitions by public museums. Not a little national rivalry is revealed, particularly between France, Britain and the USA. Ultimately most of the best works of Rimpa art to leave Japan ended up in American collections, a trend which has if anything increased since the Second World War.

Louis Gonse (1846–1921; fig. 54), 'un grand amateur de race bien française',[5] has claim to being the first author outside Japan to characterise in print the particular beauty and significance of Rimpa art, in passages in his pioneering *L'Art Japonais* of 1883 (later popularised in the monthly *Japon Artistique/Artistic Japan*). This was, after all, the heyday of *japonisme*, when Paris, her artists and her collectors, enthused over the discovery of a sophisticated non-European pictorial tradition at once ancient, exotic and *avant-garde*, which confronted them with an instinct and passion for design and that was sure to rescue Western art from its pursuit of empty illusionism. Just as Edmond de Goncourt was advised by Hayashi Tadamasa, so Gonse seems to have relied for much of his information on Hayashi and Wakai Kenzaburō (d. 1908), both employees of the Japanese government's Kiritsu Kōshō art exporting company, who had been sent to Paris for the Exposition Universelle of 1878 and had stayed on in Europe to establish

themselves as dealers. Wakai apparently arranged for fine specimens of Japanese art to be shipped over to Gonse from important private Japanese collections for several months while he was preparing the text of *L'Art Japonais*.[6]

Again, it is outside the scope of this essay to explore the question of what was known about Rimpa in Japan in the late Edo and early Meiji eras, in order to suggest what kind of information Gonse might have derived from his Japanese collaborators in France. Doris Croissant has shown that later Edo artists-cum-art theorists such as Kuwayama Gyokushū (1743–99) in *Kaiji higen* (1799), Tani Bunchō (1763–1840) in *Bunchō gadan* (1825), Kameda Bōsai (1761–1828) in the preface to Hōitsu's *Kōrin hyakuzu* (1815), and Hōitsu himself in *Ogata ryū ryaku impu* (1815) all discussed Rimpa in their writings.[7] It is relevant to what follows below, however, to mention that all these writers were aware of the importance of Sōtatsu, shadowy though his biography remained, as a painter of the Rimpa lineage. Significant, too, is the idea mooted by Gyokushū, himself a literati-style painter, that Rimpa painting might be regarded as a Japanese equivalent to the 'southern school' (*nansō*) of painting in China, thus placing it in opposition to the 'northern' (i.e. academic) Kanō school and allowing Rimpa to be, in a certain sense, a precursor of literati painting in Japan.[8]

Strictly speaking, the first scholar to publish on Rimpa art in a Western language may have been William Anderson (1842–1900), a surgeon from St Thomas's Hospital in London who worked in Tokyo from 1873 to 1880 and whose collection of more than 3,000 Japanese paintings formed in these years constitutes the foundation of the holdings at the British Museum.[9] In the year before his return to London, Anderson staged an exhibition from his collection in Tokyo, which was the occasion also for an ambitious lecture delivered on 24 June 1879 to the Asiatic Society of Japan entitled 'A history of Japanese [pictorial] art' and published in the society's journal.[10] His cursory reference to the Rimpa school in this pioneering address was not, however, sympathetic, concluding: 'The pictures of Kuwaurin [Kōrin] and Hauitsu [Hōitsu] have too much mannerism and too little resemblance to nature to please the European eye . . .'[11] Surgeon Anderson's blackboard drawings in anatomy classes, 'with a bold but unerring outline',[12] were the wonder of his medical pupils, and he was quick to criticise the 'typical Japanese artist' for 'caricaturing the muscles of an athlete' or 'wilfully ignoring the facts of *chiaroscuro* and the optical phenomena of perspective'.[13] In his *Pictorial Arts of Japan* (1886), while praising Kōrin's 'remarkable boldness of invention, associated with great delicacy of colouring and often . . . masterly drawing and composition', Anderson cannot refrain from qualifying this with comments on perceived faults in figure drawing:

> In his delineations of the human figure and quadrupeds, however, his daring conventionality converts some of his most serious motives almost into caricature. His men and women had often little more shape and expression than indifferently-made dolls, and his horses and deer were like painted toys; but in spite of all this, the decorative qualities of his designs leave him without a competitor.[14]

Not surprisingly, there are few masterpieces of Rimpa art in the Anderson collection.

Among the audience at Anderson's lecture in June 1879 was a young American, Ernest Francisco Fenollosa (1853–1908), who had arrived in August of the previous year to teach philosophy at Tokyo University. Fenollosa applied himself rigorously to the study of the history of Japanese art and traditional techniques and began to collect old paintings in earnest. By the summer of 1884 he

felt confident enough of his knowledge to write an extensive 'Review of the chapter on painting in Gonse's *L'Art Japonais*' in the 12 July issue of the *Japan Weekly Mail*. While praising Gonse's cultural relativism – 'M. Gonse's estimate of Japanese paintings is the only one by any *European* [my italics] writer which enters into a sufficiently tender and just sympathy with true Japanese taste and aims'[15] – Fenollosa goes on to correct him on almost every matter of fact. By this time Fenollosa had already been on several extended collecting trips to the ancient Japanese capital cities of Nara and Kyoto and he is more than a little patronising towards the French amateur, who composed *L'Art Japonais* in his country retreat at Cormeilles-en-Parisis,[16] when he writes, 'Who can doubt that, if M. Gonse had been able to spend several years in careful research on the soil of Japan, he might have written a far more complete and useful book.'[17]

Fig. 54 Louis Gonse (1846–1921). From Hôtel Drouot, Paris, *Collection Louis Gonse: Oeuvres d'Art du Japon*, 5–11 May 1924 (frontispiece).

Fenollosa's review has achieved a certain notoriety for its characterisation of Gonse's study as a 'Hokusai-crowned pagoda of generalisations',[18] a withering indictment which sought to castigate the author simultaneously for his dilettantism and his orientalism while also revealing a second primary target of Fenollosa's criticism: Hokusai. Fenollosa insists that he wishes to give Hokusai his due – 'I appreciate Hokusai up to the very last limit of his legitimate worth. It is not that I love Hokusai less, but that I love the old, great and nobler masters more' (Review p. 51) – and indeed it must have been galling for the young American art historian, flush with the discovery of so many ancient Japanese temple treasures *in situ*, to witness the manner in which armchair connoisseurs in Europe so fetishised any small sketch that could be associated with the name of Hokusai, however tenuously. And yet it is clear that at this early stage in his career Fenollosa detested Hokusai. He is plainly more than carried away by rhetoric when he states: 'If a man in the East were to write as Hokusai painted, he would be sent back to school to learn his letters' (p.22); 'in his paintings, Hokusai falls very low indeed' (p. 46); 'so in the case of Hokusai and the Ukiyoye, we miss all that indefatigable something which is implied in the word "taste", and we hear only the clever talk of the barber and bar-tender, or the unpoetical song of the rural poet, or the absurd masquerading of a second-class actor who is not at heart a gentleman' (p. 33). Of course, Fenollosa later recanted – after his trip to Europe and the USA in 1886–7 revealed the commercial possibilities of Ukiyo-e, it has been claimed[19] – and the first exhibition of Japanese art he staged as the new curator at the Museum of Fine Arts, Boston, in 1892 was, most ironically, *Hokusai and his School*.[20]

The relevant point here, however, is that, in order to demonstrate the 'mistaken' appreciation of Gonse for Hokusai, Fenollosa contrasts this in his review with the French author's 'correct' appreciation of 'the purity and nobleness' (p. 37) of Kōrin.

We have no disposition to hunt up superficial contradictions in our author's pages; but this discrepancy is so fundamental that the total problem of

Japanese art criticism is involved in it. The fact is that the lovers of the aesthetic beauties of Korin are the very men who utterly condemn Hokusai's coarseness. Korin and Hokusai stand in just the opposite poles of Japanese taste. (pp. 36–7)

Fenollosa's opinions are sadly lacking in the relativism he praised in Gonse, and must have been heavily influenced by the academic Kanō painters and conservative government bureaucrats of the Ryūchi-kai art organisation ('the very men' in the quotation above) with whom he was associated at the time, to whom the 'plebeian' art form of Ukiyo-e was automatically anathema.[21] The fact is that there was a strong strand of absolutism in Fenollosa's own thinking on art, common to many of his contemporaries and revealed by his constant attempts to measure one period of art against another, one artist against another, according to the then orthodox standards of 'absolute beauty' epitomised by the sculpture of ancient Greece and Italian Renaissance painting.[22]

Fenollosa pointed out that the stock of facts published by Gonse did not add substantially to those already presented by Anderson, but that, 'it is in the extent and vigor of his critical estimates alone that he passes far beyond the range of the latter writer' (Review p. 7). Indeed, the Anglo-Saxon authors seem to acknowledge the superiority of the French language in general, and Gonse's words in particular, for characterising the special qualities of Rimpa. Both William Anderson in *Pictorial Arts of Japan* and, later, Arthur Morrison in *The Painters of Japan* (1911) quote in the original language the following passage from *L'Art Japonais*, which clearly took on canonical status, and it is worth repeating again in full:

Kôrin . . . est peut-être le plus original et le plus personnel des peintres du Nippon, le plus Japonais des Japonais. Son style ne ressemble à aucun autre et désoriente au premier abord l'oeil des Européens. Il semble à l'antipode de notre goût et de nos habitudes. C'est le comble de l'impressionnisme, du moins, entendons-nous, de l'impressionnisme d'aspect, car son exécution est fondue, légère et lisse; son coup de pinceau est étonnement souple, sinueux et tranquille. Le dessin de Kôrin est toujours étrange et imprévu; ses motifs, bien à lui et uniques dans l'art japonais, ont une naïveté un peu gauche qui vous surprend; mais on s'y habitue vite, et, si l'on fait quelque effort pour se placer au point de vue de l'esthétique japonaise, on finit par leur trouver un charme et une saveur inexprimables, je ne sais quel rythme harmonieux et flottant qui vous enlace. Sous des apparences souvent enfantines, on découvre une science merveilleuse de la forme, une sûreté de synthèse que personne n'a possédée au même degré dans l'art japonais et qui est essentiellement favorable aux combinaisons de l'art décoratif. Cette souplesse ondoyante des contours qui, dans ses dernières oeuvres, arrondit tous les angles du dessin vous séduit bientôt par son étrangeté même. J'avoue très sincèrement que le goût de Kôrin, qui dans les premiers temps m'avait passablement troublé, me donne aujourd'hui les jouissances les plus raffinées.[23]

With language as 'refined' and as 'seductive' as the art he discusses, Gonse manages admirably to overcome his awe at the 'charme et . . . saveur inexprimables' of Kōrin's painting and we find in this passage many of the key words that will permeate all subsequent writings on Rimpa art: 'original', 'unique', 'most Japanese of Japanese', 'impressionism', 'decorative art'. To point this out is not necessarily to challenge the correctness of what Gonse says, but to alert us to a particular rhetoric which, as we shall see, was to be enthusiastically reimported back into Japan.

Gonse took account of many of Fenollosa's specific criticisms when he published a corrected, second edition of *L'Art Japonais* in 1886, mentioning in passing at the beginning of the chapter on painting 'les plus récentes recherches des Américains et des Anglais . . . Avec leur esprit précis et pratique . . . '.[24] Having given due credit to Gonse in the matter of his critical judgement on Kōrin's painting, Fenollosa had gone on in the review article – which at fifty-four pages had, in effect, become the American's own 'chapter on painting' – to make a vital correction concerning Gonse's treatment of the Rimpa school as a whole: 'Koyetsu [Kōetsu], the lacquerer, ought not to have been placed among the great painters of Japan. Man of high taste though he was, his real achievement lies in his decoration of lacquer; and as a painter he was only the merest amateur. His influence upon Korin as a painter is nothing as compared with that of Sotatsu.'[25] Although we would probably now rate Kōetsu's achievements as a calligrapher above his contributions to the design of lacquer, nevertheless Fenollosa's assessment that he was only an amateur painter and that the real precursor for Kōrin's paintings was Sōtatsu accords with the consensus among art historians today. This is, incidentally, the earliest mention of Sōtatsu in Western literature on Japanese painting that the present writer has been able to discover.

By the time of Fenollosa's *Epochs of Chinese and Japanese Art* (written in the summer of 1906, but published posthumously by his widow in 1912), however, the critical focus had shifted from Sōtatsu back to Kōetsu, and Fenollosa now asserted that the school should be named after Kōetsu rather than Kōrin: 'I refer to the school commonly spoken of as the "Korin" [Rimpa means 'Rin school', i.e. school of Kōrin], but which should be headed more properly with the name of Korin's teacher, Koyetsu.'[26] He goes on to explain the circumstances for this:

> The national significance of this school as a whole has only been recently understood, since indeed Mr. Freer, of Detroit, has brought together so many striking pieces, and especially of the work of Koyetsu. Masterpieces of this school have always been highly prized by Japanese collectors, especially men of the Kugè [Imperial aristocrat] class; but they had become so scattered by the nineteenth century, and almost forgotten, that little was said or seen of them when I first visited Japan in 1878. (p. 126)

> When I wrote my review of Gonse's 'L'Art Japonais' in 1884, I, too, was ignorant that Koyetsu had been a great painter, because I had never seen an undoubted example by him. His paintings were neither in temple nor daimio collections. And we have since found that many of them were passing under the better known names of Korin and Kenzan. To rehabilitate the fame of Koyetsu, as the founder of the school, and by far the greatest artist of Tokugawa days – in fact one of the greatest artists of any race – is one of my satisfactions in writing this book. (p. 127)

Before we follow Fenollosa's discussion any further, it should be pointed out immediately that all the screen paintings on which he lavishes praise as masterpieces by Kōetsu are now considered to be works of the Sōtatsu school, mainly dating from the second half of the seventeenth century. (Many of these are listed in the Japanese-language publication *Zaigai Nihon no shihō* [Japanese Art: Selections from Western Collections], *vol. 5: Rimpa*, 1979.)[27] It is not entirely clear how this confusion came about, especially when, as we saw in his criticism of Gonse, Fenollosa seemed to know the correct configuration among Rimpa artists in 1884 – though he says he had not seen many great Rimpa paintings at that time – and most earlier Japanese sources generally recognised the important position

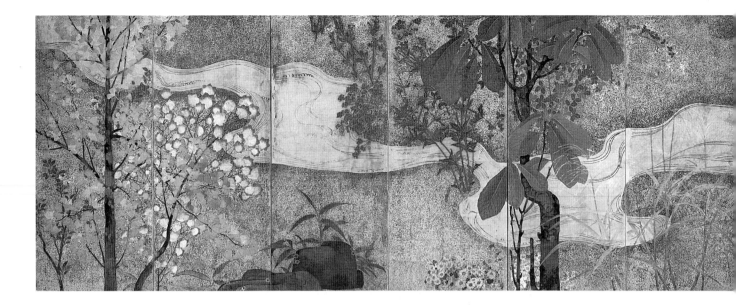

Fig. 55 School of Tawaraya Sōtatsu, *Flowers and trees by a mountain stream*. Pair of six-fold screens, late seventeenth century. Metropolitan Museum of Art, New York, Rogers Fund, 15.127, Gift of Horace Havemeyer 49.35.2 [1:60].

of Sōtatsu within the Rimpa lineage (see p. 70 above). But the answer may lie in the influence of Japanese collectors upon the major American collector Charles Lang Freer (1854–1919) and Freer's subsequent influence on Fenollosa.

According to Yashiro Yukio, it was the great businessmen-collectors Hara Tomitarō (Sankei, 1868–1939) and Masuda Takashi (Don'ō, 1848–1938) who apparently encouraged Freer in his enthusiasm for Kōetsu (or what was thought to be Kōetsu).[28] Recent research concerning the collecting tastes of these 'new *daimyō*' confirms that from 1907 onwards, calligraphy by Kōetsu suddenly became popular at exhibitions of artworks in conjunction with the great annual tea gatherings, the 'Daishi kai', hosted by Masuda and the Mitsui company.[29] It was in February of 1901 that Freer met Fenollosa, who henceforth became his principal adviser on purchases.[30] Freer was rapidly able to acquire a succession of important early Rimpa paintings – by Sōtatsu and the Sōtatsu school, as it has turned out – mainly through his agent, the dealer Matsuki Bunkyō (1867–1940), culminating in the great *Pine-islands [Matsushima]* screens (fig. 6), originally from 'a collection in Sakai' and purchased from the dealer Kobayashi Bunshichi (1864–1923) in 1906.[31]

It is difficult to judge how tastes and opinions concerning the various Rimpa artists were shifting in Japan, since relatively little scholarship was published at this time. If we use as a crude indication the number of articles concerning each artist appearing in the prestigious art-historical journal *Kokka*, from its founding in 1889 until the end of the Meiji era in 1912, the results are as follows: Kōetsu (3), Sōtatsu (11), Kōho (2), Kōrin (32), Kenzan (8), Shikō (4), Roshū (1), Kagei (1), Hōitsu (16), Kiitsu (2).[32] Clearly Kōrin still dominated perceptions of the Rimpa school as a whole, but interest in Sōtatsu was certainly not swamped by that in Kōetsu. A detailed two-part biographical article on Kōetsu by Yokoi Tokifuyu which appeared in issues nos 164 and 166 of *Kokka* in 1903, however, may have been influential.[33] Although he is able to give very few examples of paintings by Kōetsu, the author still maintains that Rimpa painting derives from him, citing the biographical compilation *Koga bikō* (*c.* 1850) as authority.[34] He also mentions an exhibition of Kōetsu 'products' (*seisakuhin*, meaning perhaps 'applied arts') which had just been held at the Tokyo Art School on 3 November 1903.[35] Until more evidence can be marshalled, conclusions must remain tentative, but we can suggest the following hypothetical development in the cult of Kōetsu as a painter: Freer is encouraged to take an interest in Kōetsu by Japanese collectors

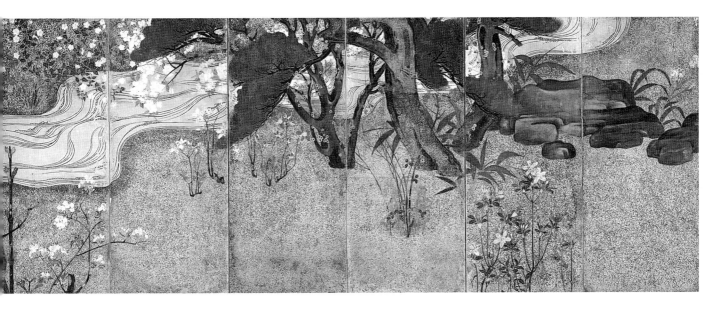

of tea utensils, who prize examples of Kōetsu's calligraphy; Freer is shown many striking unsigned Rimpa paintings from the seventeenth century which he, or his advisers, attribute to Kōetsu; many of these are acquired by Freer and seen in the USA by Fenollosa; Fenollosa is 'converted' to an enthusiasm for Kōetsu, which is reinforced by Yokoi's biographical essay, which he would have known from *Kokka*. A good example of the instability of attributions at this time is the 'Magnolia screen' discussed by Fenollosa as a masterpiece by Kōetsu (a detail is illustrated in *Epochs*). Now entitled *Flowers and trees by a mountain stream* (fig. 55) and attributed to the Sōtatsu school from the later seventeenth century, the left-hand screen was acquired by the dealer Yamanaka Sadajirō (1866–1936) at the sale of the Gillot collection in Paris in 1904,[36] attributed on that occasion to Kenzan. Seeing it in New York fresh from studying Freer's various 'Kōetsu' screens, Fenollosa declared the work to be 'a fine Koyetsu' and borrowed it to display in Boston.[37] This pair of screens, with their unique, even mysterious composition, was later reunited in the collection of the Metropolitan Museum of Art.

Fig. 56 Ogata Kōrin, *Pine-islands*. Six-fold screen, eighteenth century. Museum of Fine Arts, Boston, Fenollosa-Weld Collection, 11.4584 [3:2].

One of the results of Fenollosa's ecstatic appreciation of 'Kōetsu' paintings in *Epochs* is that Sōtatsu receives relatively short shrift. Fenollosa does praise the Freer *Pine-islands* screens and recognises that they were the source for the

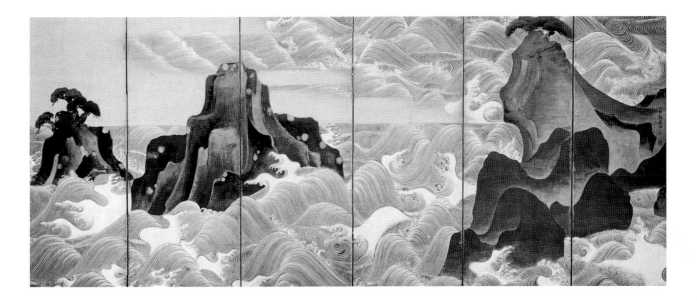

version by Kōrin on a single six-fold screen (fig. 56). This was purchased by him as early as 1880 from a *daimyō* collection and sold in 1886 to Charles G. Weld, on the understanding that it would be donated to the Boston Museum as part of the Fenollosa-Weld collection.[38] But he then goes on to criticise Sōtatsu for his 'slightly monotonous' later compositions (Sōtatsu's career is now regarded, of course, as having culminated in a great series of screen paintings during the Kan'ei [1624–44] era; see pp. 19–20 above). It is quite unclear upon which works Fenollosa is basing this assessment, though he seems to have been looking mainly at pieces in the Freer collection that would now be regarded as Sōtatsu school. When it comes to Kōrin, Fenollosa mentions the *Irises* screens (fig. 11), now in the Nezu Art Museum but at the time still in the collection of Nishi Hongan-ji Temple, Kyoto. He reproduces the left screen in a colour plate – apparently the first time this famous work was illustrated in a Western publication – and adds that he had seen them in 1882 at the 'first loan exhibition of the art club' (meaning perhaps one of the 'Exhibitions of Old Art' [Kanko Bijutsukai], organised by the Ryūchi-kai).[39] Fenollosa's appreciation of Rimpa art as a whole expands on several themes which he had praised in Gonse's book of 1883, notably the parallel drawn between Rimpa and Impressionism: ' . . . as a purely artistic school of impressionism adapted to great mural decoration, future critics will doubtless place it ahead of anything the world has ever produced' (p. 128). And such impressionism is given unique depth by the 'truth' to natural forms with which it is imbued:

> It is neither realism nor idealism, as we ordinarily misuse these words; it attempts to give an overmastering impression, a feeling vague and peculiarly Japanese, as if the whole past of the race with all its passions and loves surged back in a gigantic race memory inwrought in the inheriting nerves – a patriotism as gorgeous and free and colossal as one's grandest dreams. (pp. 127–8)

> . . . it becomes Japanese in the special sense of making a more profound and true study of Japanese objects, particularly vegetable forms and flowers, than any other school, a truer study of such subjects than any school of any race. (p. 128)

> It is in this sense that we can call the chief masters of this Korin school the greatest painters of tree and flower forms that the world has ever seen. (p. 129)

Rimpa is seen primarily as an art form patronised by the Imperial aristocracy, in opposition to the Kanō school patronised by the 'feudal' (samurai) aristocracy, Fenollosa amusingly casting the former as cavaliers and the latter as roundheads (p. 130).

Readily apparent, too, from the above quotations will be the particular 'national' traits that are ascribed to Rimpa art above all other schools. This too can be seen as an extension of Gonse's characterisation of Kōrin as 'le plus Japonais des Japonais'. Such ideas take on an increasingly nationalistic tone – in an imperialist era, of course, when nationalism was regarded by many as an admirable virtue – in the introductory essays written for the first de-luxe set of books on Rimpa, the four-volume *Masterpieces Selected from the Korin School* (*Kōrin-ha gashū*; fig. 57), published by the Shimbi Shoin Company, Tokyo, in parallel Japanese and English editions between 1903 and 1906. (This was just after the conclusion of a formal military alliance between Japan and Britain in 1902.) The first preface, dated 15 March 1903, was written by Baron Kuki Ryūichi

(1852–1931), former Vice-Minister of Education, co-founder of the conservative Ryūchi-kai and a former Director of the Imperial Museums, who was known for his championing of traditional Japanese arts and neo-traditional Nihonga painters against artists who painted in oils and watercolour in the Western manner (*yōga*).[40] According to Kuki's reductionist argument, particular climates and geographies give rise to particular manifestations of great human culture, and alongside Greek sculpture, Hebrew sacred poems, Indian beauty, the Italian Renaissance, Egyptian architecture, the 'manly culture of China', English poetry, German music and French art, the essential features of Japanese culture are Elegance and Mildness, found in all five schools of purely Japanese painting: Tosa, Kanō, Kōrin, Maruyama-Shijō and Ukiyo-e. But among these the Kōrin school 'surpasses all the others in the possession of the true spirit of Japanese painting' and 'Kōyetsu displayed virile strength, possessed a commanding and noble spirit, and was by no means deficient in free, poetic taste'. Kuki concludes by noting approvingly the great influence Rimpa painting has had on contemporary Western decorative painting.[41] (Interestingly, Laurence Binyon of the British Museum expressed quite the opposite opinion in his almost contemporary *Painting in the Far East* [1908] concerning the imitation of Rimpa in the West: 'Japanese design inherits the training, bred to instinct, of centuries of study and observation, and the efforts of modern artists in Europe to achieve the effects of Korin merely by imitation from the outside expose to ludicrous result their total insufficiency.')[42]

Fig. 57 Tajima Shiichi (ed.), *Masterpieces Selected from the Korin School*, vol. 1, Tokyo, Shimbi Shoin Company, 1903 (cover).

Kuki's sentiments are echoed in the following 'General introduction' by Tajima Shiichi of Kyoto, editor of this and several other de-luxe bilingual 'Masterpiece' series of various schools of Japanese painting published by the Shimbi Shoin company around this time. Tajima quotes with approval Gonse's and even Anderson's assessments of Kōrin already considered, adding an (unsourced) effusive panegyric by Emile Orlik (1870–1932), a painter-illustrator from Prague who had visited Japan in 1900–1 to study the techniques of colour woodblock printing:

> I have added one more name to the list of those whom I both respect and admire; he is from Japan, and his name is Kōrin Ogata. The beauty of his painting lies in its myriad of forms and in the marvellous skill he displays in treating his figures and in using colours. Such skill we have never seen hitherto and can never see again. He is the best artist of Japan: not only of Japan, but he is the best colourist in the world.[43]

The inference is clear: the devotion of a Japanophile European artist is adduced to prove that Kōrin is worthy of inclusion among the great artists of the world, just as Japan is worthy, perhaps, of admission to the 'club' of European imperial powers. We may concur that Kōrin is a great world artist, but balk at the nationalistic manner in which this is celebrated. In a wider context, Doris Croissant has suggested that it was around 1905 that Nihonga artists of the Nihon Bijutsu-in, led by Fenollosa's student Okakura Kakuzō (Tenshin,

1862–1912), sought to rediscover their roots specifically in Rimpa, which for them was a conspicuously non Western-influenced style:[44] 'Rimpa style was the Japanese equivalent of French Impressionism and should become a model for modern Japanese painting.'[45]

The Anglo-Japanese Alliance paid off handsomely for British lovers of Japanese culture with the staging of the massive Japan-British Exhibition at Shepherd's Bush in 1910, particularly outstanding being the display of 'Japanese Old Fine Arts'.[46] The Imperial Household, old *daimyō* collections, temples and shrines, the new Meiji aristocracy, industrial and bureaucratic elites (notably Kuki Ryūichi) all opened the doors of their storehouses to send many of their greatest treasures, as was appreciated by knowledgeable commentators of the time, such as Laurence Binyon.[47] Among the major works of Rimpa painting exhibited were the *Screens pasted with scattered painted fans* attributed to Sōtatsu (pair of eight-fold screens, Museum of the Imperial Collection [5:13]), *Pine-islands [Matsushima]* by Kōrin (pair of six-fold screens, formerly Baron Iwasaki Koyata collection, destroyed in the 1923 earthquake),[48] *Red and white plum trees* by Kōrin (figs 19, 46), *Azaleas* by Kōrin (hanging scroll, Important Cultural Property, formerly Dan Takuma collection, now Hatakeyama Memorial Museum [2:119]), *Persimmon tree* by Kiitsu (six-fold screen, formerly Beppu Kinshichi collection, present location unknown).

The chance to see so many masterpieces was an obvious encouragement to scholarship in Britain. In the preface to his *Painters of Japan* published the following year, 1911, Arthur Morrison wrote: 'Recent exhibitions, both of Chinese and Japanese pictures, have given us in this country unprecedented opportunities for first-hand study, and have awakened many perceptions to a new world in art', but he also gave equal credit to the many reproductions it had become possible to study in the series *Selected Relics of Japanese Art* (*Shimbi Taikan*) of the Shimbi Shoin company, the *Kokka* journal and other Japanese publications.[49] Morrison certainly put to good use the more detailed biographical information and extended captions to works made available in the Shimbi Shoin volumes, in particular, producing a general account of the history of Japanese painting that is still useful today and generally avoiding the hyperbole and opinionated style of earlier critics. He employs a few succinct phrases that get close to the heart of Rimpa: 'Such noble designs may be called 'decorative' or 'conventional' or anything else, but they present a mental vision of nature in essence that leaves an enduring impression on the imagination' (vol. 2, p. 9). Or again, concerning Kōrin: 'No painter in the world's history has so daringly reduced his subjects to his own conventions without for an instant losing suggestiveness', 'Korin carries the style of Sotatsu defiantly to its climax' (vol. 2, p. 7). Morrison is also much closer to the mark than most previous writers, for instance, concerning the relationship between Sōtatsu and Kōrin, especially in his comparison of their respective versions of the *Wind God and Thunder God* and *Pine-islands* screens. The debt owed to Sōtatsu by Kōrin had, in fact, been proposed by Laurence Binyon in a lecture to the Japan Society of London in 1908,[50] a theme further developed in his *Painters of the Far East* of the same year. Whilst initially accepting Fenollosa's demonstration of Kōetsu as the first great painter of the Rimpa school, Binyon would later realise that there was in fact no definite evidence to link the unsigned screens in the Freer and other collections to Kōetsu and he wisely made revisions to the fourth edition of his book, published in 1934, making the attributions much more tentative.[51]

Binyon reviewed Morrison's *Painters of Japan* as 'thorough, lucid and competent', its only major failing being that the author relied for most of the illustra-

Fig. 58 School of Ogata Kōrin, *A wave-beaten rock (Pine-island).* *Tsuitate* converted into a two-fold screen, eighteenth century. British Museum, JP 1265; given by Sir W. Gwynne-Evans, Bt [3:3].

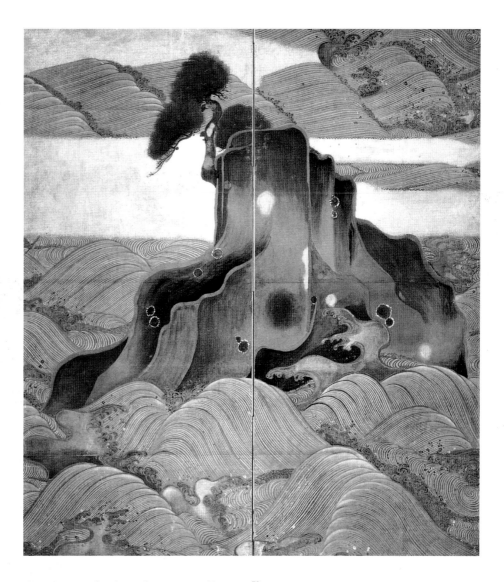

tions on works from his own collection.[52] Two of the major paintings illustrated in the Rimpa chapter – *Descent of the Thunder-God on the palace of the Fujiwara* (six-fold screen), attributed to Sōtatsu, and *A wave-beaten rock (Pine-island)* (*tsuitate* converted to a two-fold screen, fig. 58) attributed to Kōrin – are now both in the British Museum collection. Modern scholarship, however, has reattributed the former work to an independent artist of the Yamato-e lineage working in the later seventeenth century, and the latter to the studio of Kōrin.[53]

The great Shepherd's Bush exhibition of 1910, which included treasures of Japanese art that may never again make the journey to Britain, is perhaps a useful point at which to end this brief survey of the critical and in many ways formative writings concerning Rimpa produced in Europe and the USA during the Meiji (1868–1912) era. Although several key works of Rimpa painting did leave Japanese ownership during this period, notably the *Pine-islands* screens (fig. 6) and *Dragons and clouds* (pair of six-fold screens [3:185]) by Sōtatsu now in the Freer Gallery of Art, in general it should be observed that most of the great screens of the school remained in their country of origin; some, indeed, such as the *Red and white plum trees* by Kōrin belonging to the then Count Tsugaru Tsuguakira and Kōrin's *Wind God and Thunder God* belonging to Count Tokugawa Satotaka, were in 1910 still safely in the great *daimyō* collections for which they were originally executed. The status that Rimpa had achieved by the end of the Meiji era as the most representative national style of

Japanese art looked set to ensure that such a situation prevailed. Following the Second World War and the Occupation there was a second wave of American enthusiasm for Rimpa, particularly the later Edo Rimpa school of Hōitsu and his pupils, but that is a quite separate story.

For all the passionate enthusiasms of early French collectors, very little great Rimpa painting has remained in Europe. This was already apparent to Morrison, surely referring to the Pierre Barboutau collection sold in 1904,[54] when he warned in *The Painters of Japan*:

> Korin, a name itself beautiful as a picture, as M. Gonse has said, is one of the few names of Japanese artists familiar in Europe; where, sad to say, it has mostly been seen attached to imitations and forgeries. I have particularly in mind a certain ambitious collection offered for sale some years ago on the Continent, the catalogue of which was overweighted with more than a score of items attributed to Korin, every one of which was false, and pretty obviously so. A little judgement, and probably no more money, might have procured the owner a single specimen which would have given distinction to the collection. The genuine works of the master are not to be swept up a dozen at a time by the casual globe-trotter, trot he never so well weighted with bank notes. The amateur who after years of experience finds himself the possessor of one true Korin may count himself fortunate, and if he be worthy the charge, nothing in his collection will offer him greater delight.[55]

NOTES

1. These figures were originally reported in Shibui Kiyoshi, 'Ukiyo-e no yushutsu', *Mita bungaku* (1939), pp. 90–97, and have been quoted more recently in Yamaguchi Seiichi, 'Kobayashi Bunshichi jiseki', *Saitama Daigaku kiyō sōgō hen* 6 (Feb. 1988), p. 16.

2. See Edmond de Goncourt's diary entry for 25 May 1888, quoted in Siegfried Wichmann, *Japonisme: The Japanese Influence on Western Art since 1858*, London, Thames and Hudson, 1981, p. 12.

3. See Wichmann, op. cit. (n. 2 above).

4. A list of Rimpa printed books already appeared in William Anderson, *Catalogue of the Japanese and Chinese Paintings in the British Museum*, London, Trustees of the British Museum, 1886, pp. 405–6. This was soon amplified into an annotated bibliography in Louis Gonse, 'Korin', *Artistic Japan* 23 (March 1890), pp. 294–6. For a more recent appreciation, see Jack Hillier, 'The Rimpa revival: Hōchū, Hōitsu and Minwa', in *The Art of the Japanese Book*, 2 vols, London, Sotheby's, 1987, vol. 2, pp. 654–69.

5. Raymond Koechlin and Gaston Migeon, 'Louis Gonse', introduction to the sale catalogue *Collection Louis Gonse: Oeuvres d'Art du Japon*, Paris, Hôtel Drouot, 5–11 May 1924, p. 13.

6. Louis Gonse, *L'Art Japonais* (rev. edn), Paris, Maison Quantin, 1886, p. 9.

7. Doris Croissant, 'Sōtatsu und seine Nachfolger im Urteil der Edo-Zeit', *Sōtatsu und der Sōtatsu-Stil: Untersuchungen zu Repertoire, Ikonographie und Ästhetik der Malerei des Tawaraya Sōtatsu (um 1600–1640)*, Münchener Ostasiatische Studien, Band 3, Wiesbaden, Franz Steiner, 1978, pp. 93–101.

8. Ibid., pp. 95–6.

9. The collection was acquired by the Trustees in 1881 for £3,000 and, according to the inventory made at the time, consisted of 927 hanging scrolls, 101 handscrolls, 27 albums, 3 screens, 5 framed pictures and 2,236 unmounted drawings, totalling 3,299 items. See Timothy Clark, 'Japanese paintings at the British Museum', *British Museum Magazine* 13 (Spring 1993), pp. 15–18.

10. William Anderson, 'A history of Japanese [pictorial] art', *Transactions of the Asiatic Society of Japan* VII (1879), pp. 339–74.

11. Ibid., p. 356.

12. Obituary, *The Lancet*, 10 November 1900, p. 1368.

13. William Anderson, *Pictorial Arts of Japan*, London, Sampson Low, 1886, p.251.

14. Ibid., p. 66.

15. Ernest F. Fenollosa, 'Review of the chapter on painting in Gonse's *L'Art Japonais*', *Japan Weekly Mail*, 12 July 1884; repr. Boston, James R. Osgood & Co., 1885, p. 5.

16. Koechlin and Migeon, op. cit. (n. 5), p. 6.

17. Fenollosa, op. cit. (n. 15), p. 5.

18. Ibid., p. 21.

19. Warren I. Cohen, 'If ukiyo-e were what people wanted to buy, Fenollosa would learn to appreciate them', in *East Asian Art and American Culture: A study in international relations*, New York, Columbia University Press, 1992, p. 53.

20. Ernest F. Fenollosa, *Special Exhibitions of the Pictorial Art of Japan and China, No. 1: Hokusai and his School*, Boston, Museum of Fine Arts, 1893.

21. See Satō Dōshin, 'Ryūchi-kai', in Ellen P. Conant *et al.*, *Nihonga, Transcending the Past: Japanese-Style Painting, 1868–1968*, The Saint Louis Art Museum, 1995, pp. 78–9.

22. Fenollosa applied similar standards to the study of Ukiyo-e. See Timothy Clark, 'Kunisada and decadence: the critical reception of nineteenth century Japanese figure prints in the West', in *Modern Japanese Art and the West*, Tokyo, Meiji Bijutsu Gakkai, 1992, pp. 89–100.

23. Louis Gonse, *L'Art Japonais*, Paris, Maison Quantin, 1883, pp. 231–2.

24. Louis Gonse, *L'Art Japonais* (rev. edn), Paris, Maison Quantin, 1886, p. 6.

25. Fenollosa, op. cit. (n. 15), p. 34.

26. Ernest F. Fenollosa, *Epochs of Chinese and Japanese Art*, London, William Heinemann, 1912, vol. 2, p. 126 (in the chapter 'Modern aristocratic art in Japan').

27. Freer's acquisitions after 1900 of Rimpa screens and their impact on Fenollosa's scholarship are discussed in Yamane Yūzō, 'Sōtatsu hitsu *Matsushima zu* byōbu e megutte', in *Zaigai Nihon no shihō*, vol. 5: *Rimpa*, Tokyo, Mainichi Shimbunsha, 1979, pp. 106–13.

28. Yamane, op. cit. (n. 27), p. 107. Yashiro Yukio, *Nihon bijutsu no tokushitsu*, Tokyo, Iwanami Shoten, 1943; 2nd rev. edn 1965, p. 710.

29. Christine M. E. Guth, *Art, Tea and Industry: Masuda Takashi and the Mitsui Circle*, Princeton University Press, 1993, p. 153.

30. Helen Nebeker Tomlinson, 'Charles Lang Freer: pioneer collector of oriental art' (Ph.D. dissertation), Ann Arbor, University Microfilms International, 1979, pp. 258, 347. 'Fenollosa appeared in Detroit almost on call whenever a new shipment arrived from one of Freer's dealers' (p. 361); 'In spite of his prejudices and limitations, Fenollosa was Freer's best possible insurance policy in protecting the caliber of his collection' (p. 375).

31. Concerning Freer's relationships with his various dealers see Yoshiaki Shimizu, 'An individual taste for Japanese painting' *Apollo* CXVIII, no. 258 (August 1983), pp. 136–49.

32. These statistics derive from the exhaustive Japanese-language bibliography on Rimpa compiled by Matsuo Tomoko in Murashige Yasushi and Kobayashi Tadashi (eds), *Rimpa*, vol. 5: *Sōgō (bessatsu)*, Kyoto, Shikōsha, 1992, pp. 68–85.

33. Yokoi Tokifuyu, 'Hon'ami Kōetsu, jō/ge', *Kokka*, no. 164 (1903), pp. 163–8, and no. 166 (1903), pp. 218–23.

34. Ibid., no. 164, pp. 167–8.

35. Ibid., no. 166, p. 223.

36. Paris, Galeries Durand-Ruel, *Collection Ch. Gillot: Objets d'art et peintures d'Extrême-Orient*, 8–13 February 1904, lot 2060.

37. Fenollosa, op. cit. (n. 26), p. 134.

38. The problems of authenticity surrounding the Kōrin version of the *Pine-islands* screen at the Museum of Fine Arts, Boston (11.4584) are discussed at length by Yashiro Yukio, 'Sōtatsu hitsu Matsushima byōbu', *Bijutsu kenkyū* 73 (1938), pp. 1–8. For more recent opinions, see Yamane, op. cit. (n. 27) and Kōno Motoaki, 'Matsushima zu byōbu', in Kobayashi Tadashi (ed.), *Nihon bijutsu taikan*, vol. 1: *Daiei Hakubutsukan I*, Tokyo, Kōdansha, 1992, pp. 236–8.

39. Fenollosa, op. cit. (n. 26), p. 137, pl. opposite p. 112.

40. Ellen P. Conant, 'Refractions of the rising sun: Japan's Participation in international exhibitions, 1862–1910', in Tomoko Satō and Toshio Watanabe (eds), *Japan and Britain: An*

Aesthetic Dialogue 1850–1930, London, Lund Humphries, 1991, pp. 79–92. Kuki is discussed on pp. 84–5.

41. Kuki Ryūichi, 'Preface' in Tajima Shiichi (ed.), *Masterpieces Selected from the Kōrin School*, vol. 1, Tokyo, Shimbi Shoin, 1903, pp. iv–viii.

42. Laurence Binyon, *Painting in the Far East*, London, Edward Arnold, 1908, p. 205.

43. Tajima Shiichi, op. cit. (n. 41), 'General introduction', pp. ix–xv.

44. Doris Ledderose-Croissant, 'Die Auseinandersetzung zwischen *Nihon-ga* und *Yōga* in Theorie un Praxis', *Asiatische Studien/Études Asiatiques* XXXI, no. 1 (1977), pp.16–17.

45. Doris Croissant, *Kōdansha Encyclopaedia of Japan*, Tokyo, Kōdansha, 1983, vol. 6, p. 318, *s.v.* 'Rimpa'.

46. Office of the Imperial Japanese Government Commission to the Japan-British Exhibition, *An Illustrated Catalogue of the Japanese Old Fine Arts Displayed at the Japan-British Exhibition, London, 1910*, Tokyo, Shimbi Shoin, 1910.

47. Conant, op. cit. (n. 40), p. 87.

48. Discussed in Yashiro, op. cit. (n.38), p. 4ff.

49. Arthur Morrison, *The Painters of Japan*, 2 vols, London, T.C. & E.C. Jack, 1911, vol. 1, pp. v–vi.

50. Laurence Binyon, 'Some phases of Japanese painting', *Transactions and Proceedings of the Japan Society of London* VIII (1907–8), pp. 96–112: the reference to Sōtatsu and Kōrin is on p. 104.

51. Laurence Binyon, *Painting in the Far East*, London, Edward Arnold, 1908, 4th rev. edn 1934, pp. 219, 220, pl. XXXVI.

52. Laurence Binyon, 'The painters of Japan', *Saturday Review* 112 (30 Sept. 1911), pp. 427–8 (review).

53. Japanese Painting 1256 and Japanese Painting 1265 respectively. See Kobayashi Tadashi, op. cit. (n. 38), nos 13, 25.

54. Paris, Hôtel Drouot, *Collection P. Barboutau: Peintures – estampes et objets d'art du japon*, 3 June 1904, lots 73–112.

55. Morrison, op. cit. (n. 49), vol. 2, pp. 5–6.

Catalogue

The Idemitsu Collection of Works of Rimpa Art

The Idemitsu Museum of Arts is a private museum in Tokyo with an extensive collection of works of fine and applied art, principally antiquities from Japan and Asia.

Since the time of the Museum's first Director, Mr Sazō Idemitsu (1885–1981), there have been in the collection paintings, calligraphy, ceramics, lacquer and other works by Rimpa artists from the Edo period (1600–1868), in particular those from the schools of Sōtatsu and Kōrin. The first comprehensive display of these, entitled 'Exhibition of Works of the Rimpa School' (*Rimpa sakuhin ten*), was held in 1985 and had considerable scholarly impact.

Subsequently, under the present Director, Mr Shōsuke Idemitsu, it was decided to make the Rimpa collections more comprehensive and many important new acquisitions were effected, particularly of works by Hōitsu and Kiitsu of the Edo Rimpa school which had been lacking hitherto. It was as a result of these additions that it became possible to stage a new 'Rimpa' exhibition in 1993. Both of the above exhibitions were carried out with a great deal of guidance from the leading scholar of Rimpa art, Yūzō Yamane, Emeritus Professor of Japanese Art History, Tokyo University.

The works in the Idemitsu collection today are fully representative of the complete lineage and course of development of the Rimpa school.

1 Attributed to Tawaraya Sōtatsu
(worked *c*. 1600–40)

Screens pasted with scattered painted fans, late Keichō (1596–1615) or early Genna (1615–24) era

Pair of six-fold screens; ink, colour, gold and silver on paper, each 154.7 x 353.6 cm

A total of twenty fans are pasted in a scattered arrangement across a pair of screens which have delicately detailed underpainting in gold and silver of luxuriant pampas-grasses on an autumn moor. Each of the fans also has background decoration in gold and silver leaf and paint suggesting clouds, mist, eddying water and earthen banks, over which are painted flowers and trees of the four seasons.

The glittering gold and silver and rich, lovely colouring of the fans combine to create a powerful impact. However, none of them bears any signature or seal and in the past there have been two main theories as to their authorship: either a stylistic precursor of Sōtatsu or the artist Sōtatsu himself. In recent years a majority of scholars have favoured the latter theory.

The best-known examples of the novel spatial structure and the new freedom in the distribution of forms developed by Sōtatsu are found in the paintings he supplied for the outer and inner surfaces of the covers of some of the famous *Heike nōkyō* handscrolls (thirty-three decorated handscrolls of the Lotus and other sutras presented by the Taira clan to the Itsukushima Shrine, Hiroshima, in 1164 [5:1, 3:S14]) when he repaired and embellished them. These are regarded as an early work dating from 1602, and it is plausible that the present fan paintings, which show a similar aesthetic sensibility, can be ascribed to Sōtatsu's own hand, working around the late Keichō (1596–1615) or early Genna (1615–24) era.

The underpaintings on the screens are not thought to be by either Sōtatsu or his school and one suggestion has been that they are by an artist of the rival Hasegawa school. In their present configuration the composition is not continuous and is out of order, inconsistencies which must result from the fans having been pasted to pre-existing screens which had to be adapted to the purpose.

2 School of Tawaraya Sōtatsu

Screens painted with scattered fans, later Kan'ei (1624–44) era

Pair of six-fold screens; ink, colour and gold on paper, each 153.4 x 355.8 cm

Paintings in the format of a folding fan were a particular speciality of Sōtatsu and his school, and his Tawaraya workshop is known to have marketed fan paintings in the city of Kyoto. These took the form not only of works to be stuck onto ribs and actually used as fans, but also – more often – of fans painted as decoration directly onto large formats such as folding screens. In the present work the fan shapes have been painted in such a way that they appear to have been scattered across the surface of the screens. Many similar examples are known from the Sōtatsu school.

Most of the fans have motifs of flowers of the four seasons, supplemented with the occasional portrait of one of the 'Immortals of Poetry' (*kasen*) or a character from one of the courtly tales. The fact that each fan has a background consisting of clouds shaped like horizontal bands of mist makes it clear that the screens were intended as interior furniture, with prime attention given to their decorative splendour. Like many similar works of this kind, they are thought to be the result of a collaborative effort by the group of individual artists that constituted the Sōtatsu workshop, a so-called 'studio' piece. The screens may be dated to the later Kan'ei (1624–44) era.

3 Tawaraya Sōtatsu

'Musashi Moor' (*Musashino*) episode from *Tales of Ise* (*Ise monogatari*), *c*. 1637

Shikishi painting mounted as a hanging scroll; ink, colour and gold on paper, 34.5 x 20.9 cm

4 Tawaraya Sōtatsu

'Young grass' (*Wakakusa*) episode from *Tales of Ise* (*Ise monogatari*), *c*. 1637

Shikishi painting mounted as a hanging scroll; ink, colour and gold on paper, 24.5 x 20.9 cm

Several groups of small square *shikishi* paintings on the theme of *Tales of Ise* are thought to have been produced by Sōtatsu and his followers. These have now become scattered, but to date a total of fifty-nine compositions have been identified. The present paintings are from a group of thirty-six formerly in the collection of Masuda Takashi (Don'ō, 1848–1938).

The scene depicted in cat. no. 3 comes from episode 12 of *Tales of Ise*, 'Musashi Moor', in which fleeing lovers hide in the long grasses but are forced to give themselves up when guards of the provincial governor threaten to set fire to the moor. The poem reads: 'Do not set fire today/ To Musashi Plain,/ For my beloved husband/ Is hidden here,/ And so am I' (trans. Helen Craig McCullough). As previous scholars have noted, the idea for the composition derives from both the *Variant illustrated handscroll of the Tales of Ise* (*Ihon Ise monogatari emaki*) and the woodblock *Ise monogatari* printed at Saga in 1608. In addition, certain details of the poses of the figures, such as the two guards holding torches, are taken from the *Illustrated handscroll of the Hōgen disturbances* (*Hōgen monogatari emaki*). Stylistically, the painting builds on the 'line for the eye and hook for the nose' (*hikime kagihana*) technique of the so-called 'women's [court] painting' (*onna-e*) tradition, and adds to this the 'boneless' (*mokkotsu*, i.e. without outline) elements of the background landscape, as perfected by Sōtatsu and his followers. Delicately detailed and full of lyricism, it nevertheless maintains an overall sense of amplitude and may be regarded as a masterpiece among this genre of small square paintings of the courtly tales.

The scene depicted in cat. no. 4 comes from episode 49 of *Tales of Ise*, 'Young

grass', and here too the composition of the figures has been borrowed from the *Illustrated handscroll of the Hōgen disturbances*. The inscription constitutes the whole text of this short episode, which is principally an exchange of poems:

Once a man, stirred by the beauty of his younger sister, composed this poem:

How regrettable it is
That someone else
Will tie up
The young grass
So fresh and good for sleeping.

She replied,

Why do you speak of me
In words novel as the first
Grasses of spring?
Have I not always loved you
Quite without reserve?

(TRANS. Helen Craig McCullough)

There is a tradition that the paintings in the group formerly in the Masuda collection were commissioned by the wife of Ogata Sōhaku (1571–1631), second-generation head of the Kariganeya drapery business in Kyoto, for the coming of age of their son Sōken (1621–87, Kōrin's father). This would date them to about 1637, when Sōtatsu was at the height of his powers. The inscriptions on the paintings in this group can be shown to have been executed mainly in the decade *c.* 1633–43. Annotations (perhaps by Kojima Sōshin, 1580–after 1653) on the backs of many of the group give the names of the calligraphers, and there may well be similar inscriptions on the reverse of these works (presently obscured by the mounts).

5 School of Tawaraya Sōtatsu

Scenes from *Tales of Ise* (*Ise monogatari*), mid-seventeenth century

Six-fold screen; ink, colour, gold leaf and silver on paper, 146.2 × 350.4 cm

This is one of only two known screens by the Sōtatsu school on the theme of *Tales of Ise*; the other is in the collection of the British Museum (fig. 59). Scenes from five episodes are spread over the large format of the six-fold screen. From the top right corner these are: the third part of episode 23, 'Young woman at Takayasu' (*Takayasu no musume*), in which the lover's ardour cools when he sees the slovenly manner in which she heaps rice into a bowl; episode 24, 'Birch bow' (*Azusa-yumi*), in which a distraught wife, pursuing her husband, falls down beside a spring and writes a poem on a rock with her own blood; episode 9, 'Journey to the East: Mt Utsu' (*Azuma-kudari – Utsunoyama*), when the travellers to the East meet a wandering ascetic on a narrow path overgrown with ivy and recognise him as someone they once knew in the capital; episode 65, 'Ceremony of purification' (*Misogi*), showing a courtier holding a Shinto ritual of purification beside a river in an attempt to rid himself of a love that threatens to ruin his career; and finally, episode 117, 'Imperial progress to Sumiyoshi' (*Sumiyoshi gyōkō*), in which the Emperor exchanges poems with the god of Sumiyoshi. The manner in which this last scene in the top left corner is abruptly cut off suggests that the composition originally continued onto a pairing left-hand screen.

Fig. 59 School of Tawaraya Sōtatsu, *Scenes from 'Tales of Ise'*. Six-fold screen, second half of the seventeenth century. British Museum, JP ADD 299. Given by the Hon. Mrs Robert Wood.

As has been noted by previous scholars, much of the composition is based, like cat. no. 3, on the *Variant illustrated handscroll of the Tales of Ise* (*Ihon Ise monogatari emaki*), with individual motifs lifted from various other medieval handscrolls.[1] The *Variant illustrated handscroll of the Tales of Ise* has the characteristically active line quality of the so-called 'painting in men's style' (*otoko-e*). The present screen, on the other hand, though it derives motifs from this source, employs styles and techniques typical of the Sōtatsu school, in particular the importance given to decorative features, with the use of heavy outlines and thick colours, and the borrowing of forms from a wide range of earlier handscrolls.

[1] *Shūkongō-jin engi emaki* (Illustrated handscroll of legends of the deity Shūkongō-jin), *Kōan-bon Kitano Tenjin engi emaki* (Illustrated handscroll of legends of the founding of the Kitano Tenjin shrine [Kōan version]), *Hōgen monogatari emaki* (Illustrated handscroll of the Hōgen disturbances), *Uneme-bon Saigyō monogatari emaki* (Illustrated tales of the monk Saigyō [Uneme version]) and others.

6 School of Tawaraya Sōtatsu

**'Heartvine' (Aoi) chapter from
Tale of Genji (Genji monogatari)**,
mid-seventeenth century

Fragment from a screen (now framed);
ink, colour, gold and silver on paper,
29.5 x 41.5 cm

7 School of Tawaraya Sōtatsu

**'The paulownia court' (Kiritsubo)
chapter from Tale of Genji (Genji
monogatari)**, mid-seventeenth century

Fragment from a screen (now framed); ink,
colour and gold on paper, 28.5 x 52.0 cm

8 School of Tawaraya Sōtatsu

**'Heartvine' (Aoi) chapter from
Tale of Genji (Genji monogatari)**,
mid-seventeenth century

Fragment from a screen (mounted as a
hanging scroll); ink, colour and gold on
paper, 28.2 x 57.2 cm

9 School of Tawaraya Sōtatsu

**'The maiden' (Otome) chapter from
Tale of Genji (Genji monogatari)**,
mid-seventeenth century

Fragment from a screen (mounted as a
hanging scroll); ink, colour and gold on
paper, 26.0 x 46.6 cm

The most famous screen painting from
the Sōtatsu school on the subject of
the *Tale of Genji* is undoubtedly the
pair of screens illustrating the 'Gate-
house' (*Sekiya*) and 'Channel buoys'
(*Miotsukushi*) chapters (fig. 7), a master-
piece from the brush of Sōtatsu himself.
In addition to this celebrated work, sev-
eral other *Genji* screen paintings were
once known. These were of two types,
either screens onto which were pasted
fan paintings or small square *shikishi*
paintings of particular scenes from the
novel, or else screens which combined
various scenes from the novel into a
single composition. Of the latter kind
were two works of particular note: an
eight-fold screen of medium height for-
merly in the Fujii family collection,
showing scenes from the first eighteen of
the fifty-four chapters of *Genji*; and a
pair of six-fold screens formerly in the
collection of Dan Takuma (1858–1932)
combining one scene from each of all
fifty-four chapters. Most regrettably, all
three of these screens were broken up

and the paintings cut into individual
scenes, which survive as fragments in
various collections. Cat. no. 6 derives
from the Fujii collection screen, while
cat. nos 7–9 are from the Dan collection
pair of screens.

As previous scholars have noted, the
compositions of screens such as these
rely heavily on earlier Muromachi-
period works such as *Screens with scat-
tered fans illustrating the Tale of Genji*
(*Genji monogatari semmen-chirashi zu
byōbu*, Jōdo-ji Temple, Hiroshima Prefec-
ture) and *shikishi* paintings on *Genji*
themes by Tosa Mitsuyoshi (1539–1613).
In addition, certain elements are derived
from medieval handscrolls such as *Illus-
trated handscroll of legends of the deity
Shūkongō-jin* (*Shūkongō-jin engi emaki*)
and *Illustrated handscroll of legends of the
founding of the Kitano Tenjin shrine (Kōan
version)* (*Kōan-bon Kitano Tenjin engi
emaki*), giving a revealing perspective
into the working practices of the Sōtatsu
school. In this process the pictorial con-
tent of each scene is shifted away from
its original, explanatory nature within
the framework of the novel, creating
individual, elegantly coloured compo-
sitions more flexible in nature and open
to comparatively freer interpretation by
the viewer.

Each of the pair of screens formerly in
the collection of Dan Takuma bore a
round 'Inen' seal impressed near the
outside edge; the screen formerly in the
Fujii family collection had the signature
'Sōtatsu Hokkyō' (Sōtatsu, of *Hokkyō*
rank) in the lower left of the composi-
tion. Both should be credited to artists
working in the Tawaraya (Sōtatsu)
studio. It has been argued, based on the
style of the compositions, that the Dan
screens probably predate the Fujii one.
On the other hand, judging by its ele-
gant, detailed figure style, the Fujii
screen should be considered superior in
quality.

10 Tawaraya Sōtatsu (or pupil)

**The courtier-poet Ōtomo no
Chūnagon Yakamochi, with a
waka poem**, Kan'ei (1624–44) era

Signature: (painting) *Sōtatsu Hokkyō*
('Sōtatsu, of *Hokkyō* rank')
Seal: (painting) *Seiken*
Two *shikishi* mounted as a hanging scroll; ink,
light colour and gold on paper, 19.1 x 20.6 cm
(painting), 18.8 x 16.5 cm (poem)

A portrait of one of the so-called
'Immortals of Poetry' (*kasen*), from a
group originally mounted on a pair of
six-fold screens formerly in the collec-
tion of the Sugaike family. The thirty-six
portraits were subsequently removed
from the screens and are now divided
among different collections.

The thirty-six poets originally included
on the screen do not in fact derive
from the well-known group of 'Thirty-
six Immortals of Poetry' selected by
Fujiwara no Kintō (966–1041) in about
1009–12; rather, most are taken from the
first half of the *Illustrated competition
between poets of different periods* (*Jidai fudō
uta-awase e*), based on a selection of a
hundred famous poets made by Retired
Emperor Gotoba in the 1230s. This is a
feature shared by most paintings of
Immortals of Poetry by the Sōtatsu
school. Though small in scale, this is one
of the very highest quality paintings in
the group of poet portraits bearing a
Sōtatsu signature and is accepted as a
work either by Sōtatsu himself or by a
very accomplished pupil, dating from
the Kan'ei (1624–44) era.

The accompanying poem is from the
Shin kokin waka shū anthology, written in
Kōetsu-style calligraphy over a gold
underpainting of willows in Sōtatsu
style. When mounted on the original
screens, each portrait of a poet was
accompanied by a poem written on a
decorated *shikishi* paper. However, the
poems selected had no particular con-
nection with the poets concerned and
must simply have been available when
the screen was first constructed.

11 Shōkadō Shōjō (1584–1639, calligraphy) and attributed to Tawaraya Sōtatsu (underpainting)

***Waka* poem over a painting of water plants,** possibly Genna (1615–24) or early Kan'ei (1624–44) era

Shikishi mounted as a hanging scroll; ink, colour and gold on paper, 20.5 x 17.8 cm

The painting was originally contained in a folding album of underpaintings of plants and grasses on *shikishi* papers in Sōtatsu style, onto which the calligrapher and painter Shōkadō Shōjō inscribed poems by the Thirty-six Immortals of Poetry. The poem here is by Chūnagon Tomotada. The album was subsequently broken up and divided among nine collectors, each of whom acquired four of the paintings.

The discovery of a seal (undeciphered, but apparently a stylised character) on the back of the painting inscribed with a poem by Fujiwara no Kiyomasa confirmed that the underpaintings, as on other fan paintings of a similar type, were done by artists of the Sōtatsu workshop. Further research is needed to identify the individual painters; Sōsetsu, for example, might have been responsible for underpaintings of this kind. Based on the style of Shōkadō's calligraphy, the work has been dated to the Genna or early Kan'ei era.

12 Hon'ami Kōetsu (calligraphy) and Tawaraya Sōtatsu (underpainting)

***Waka* poems over a painting of lotuses,** *c.* first half of the Genna (1615–24) era

Fragment from a handscroll, mounted as a hanging scroll; ink and gold on paper, 33.2 x 51.5 cm

This is a fragment from a handscroll which combined papers of many different colours, originally over twenty metres in length. The underpaintings, by Sōtatsu, are of lotuses in various forms – their flowers, buds, leaves, etc. – with poems from the *Ogura selection of one hundred poems by one hundred poets* (*Ogura hyakunin isshu*) inscribed over them by Hon'ami Kōetsu. Among works of this kind, the original handscroll was particularly satisfying in the rhythmical development of its successive scenes, depicting the short life-span of the lotus, redolent with spiritual Buddhist symbolism of the impermanence of existence. Sadly, more than half of the work was destroyed in the great Kantō earthquake of 1923 and the remaining portion was subsequently cut into fragments, now divided among different collections [2:84; see also fig. 5].

The surviving fragment from the end of the handscroll bears the signature 'Taikyoan' followed by a handwritten *kaō* seal. Based on a stylistic consideration of both calligraphy and underpainting, the work should be dated to around the first half of the Genna (1615–24) era.

13 Hon'ami Kōetsu (calligraphy) and a pupil of Tawaraya Sōtatsu (underpainting)

***Waka* poems over paintings of the moon and bush-clover, and creeper,** *c.* Genna (1615–1624) era

Seal: *Kōetsu*
Handscroll; ink, gold and silver on silk, 33.0 x 928.6 cm

The opening section shows the large disc of the full moon floating above a moor of luxuriant autumn grasses, then clumps of bush-clover blowing in the wind, their flowers glistening in the moonlight. The later section shows rhythmical arrangements of hanging creeper. Scattered over these along the full length of the handscroll are twenty-two *waka* poems selected from the first autumn section of the Imperial anthology *Kokin waka shū* (compiled 905 or 914). At the end of the scroll is a square black seal reading 'Kōetsu'.

In such collaborative works between Sōtatsu and Kōetsu, it has long been recognised that Sōtatsu's lovely designs in gold and silver paint do not merely have the subsidiary role implied by the term 'underpainting'; rather, calligraphy and painting constitute partners of equal stature in a unique artistic dialogue. Two types of underdesign, either painted or printed, are known. The present work is of the former type and is a fine example of the special synthesis between painting and calligraphy achieved by the Rimpa school at the beginning of the Edo period.

The handscroll was formerly in the collection of Hara Tomitarō (Sankei, 1868–1939), together with the related *Waka poems over underpaintings of pine trees* (Cleveland Museum of Art) which is also inscribed with poems from the anthology *Kokin waka shū*. The underpaintings of the Idemitsu work are executed with a noticeably different artistic sense from those known to be by Sōtatsu himself, and it has been argued that they are most likely the work of a talented pupil. It is further argued that all such works with gold and silver underpainting by Sōtatsu himself are on paper, rather than the silk support found in this instance. So the present work should be attributed for the time being to a pupil of Sōtatsu working around the time of the Genna (1615–24) era.

14 Hon'ami Kōetsu (calligraphy) and
Tawaraya Sōtatsu (designs for underprinting)

**Waka poems over printed designs of
plants and flowers,** 1628

Inscription: *Kan'ei gonen hachigatsu
nichi/Takagamine-yama Taikyoan/Toshi nanajū
yū ichi* ('A day in the eighth month, Kan'ei 5
[=1628], Mt Takagamine, Taikyoan, seventy-
one years old')
Seal: *Kōetsu*
Handscroll; ink and printed gold on paper,
33.7 x 465.0 cm

Woodblocks have been used to print an
underdesign of plants and flowers in
gold, over which are inscribed ten *waka*
poems selected from the second autumn
section of the anthology *Kokin waka shū*
(compiled 905 or 914). The designs are
divided into four sections: willow,
cherry, creeper, and crabgrass (*mehishiba*)
with hare's-foot fern (*shinobu-gusa*): they
loom out of the background in silhouette
form, the printed ink collecting unevenly
in places in a most attractive manner.

Such luxurious handscrolls decorated
with motifs in gold and silver, printed
from wooden blocks cut from designs by
Sōtatsu, were produced in large quanti-
ties in collaboration with the paper-
maker (*kamishi*) Sōji. These were then
inscribed by Kōetsu with *waka* and Chi-
nese-style *kanshi* poems. During the
Keichō (1596–1615) era, the printed
designs strongly reflected the artistic
sense of Sōtatsu himself, but their pro-
duction then seems to have transferred
exclusively to Kōetsu and his circle. It
appears that during the Kan'ei (1624–44)
era they were employed in large num-
bers simply as printed underdesigns for
handscrolls with calligraphy by Kōetsu.

The present work has designs printed
from the same blocks as many other sur-
viving examples, such as those in the
Manno Art Museum, Osaka, and the
MOA Museum of Art, Atami. However,
it lacks special printing effects seen in
these related examples, such as the
deliberate use of only part of a particular
block or repeated overprintings of a
single block. Also, it is printed only in
gold, without the addition of silver.

15 Attributed to Tawaraya Sōtatsu
(or pupil)

Moon and autumn grasses, *c.* Genna
(1615–24) era

Seal: *Inen* (both screens)
Pair of six-fold screens; ink, colour and gold
leaf on paper, each *c.* 155.1 x 360.6 cm

Against a background completely cov-
ered in gold leaf are depicted a profu-
sion of bush-clover, pampas-grass and
Chinese bellflowers growing on a moor
in autumn. The clumps of short-lived
autumn plants and flowers are painted
in such delicate detail that they all but
fade away, and are filled with a lyrical
sensibility. This has long been celebrated
as a masterpiece by Sōtatsu.

The screens share a common subject
and the 'Inen' seals with a pair in the
collection of the Metropolitan Museum
of Art, New York, with which they may
be compared. The Metropolitan screens
are painted on a ground of gold sand,
rather than gold leaf, and in view of the
comparatively flat arrangement of the
autumn grasses, which lack a sense of
rhythm, the Idemitsu version is gener-
ally regarded as superior in terms of pic-
torial elegance. For this reason, the
Metropolitan screens have been attrib-
uted to a pupil of the Sōtatsu school.
Concerning the present screens, opinion
is divided: they are regarded as either an
early work by Sōtatsu himself, or one by
a skilful pupil adept in the style of
Sōtatsu's early period. The screens are
dated around the Genna (1615–24) era.

16 School of Tawaraya Sōtatsu

**Flowers and grasses of the four
seasons,** first half of the seventeenth
century

Seal: *Inen* (both screens)
Pair of six-fold screens; ink, colour and gold
leaf on paper, each *c.* 157.0 x 355.0 cm

An example of screens depicting flowers
and grasses of the four seasons against a
plain gold-leaf background, as devel-
oped by the pupils and followers of
Sōtatsu. This was a particular speciality
among the repertoire of subjects of the
school and many such screens survive
today.

The finest example among the group
bearing the usual 'Inen' seal is a set of
four sliding-door panels of *Flowers and
grasses*, formerly in the collection of the
Tamaki family (now Kyoto National
Museum [1:25]), which are attributed to
a senior pupil of Sōtatsu. The many
other screens of the same type, of vary-
ing levels of quality of execution, should
be regarded as the work of several dif-
ferent members of the Sōtatsu work-
shop, active during the seventeenth
century. Since the main intention seems
to have been to experiment with permu-
tations of images of the four seasons,
there is little sense of completeness in
the compositions when viewed across
both screens; indeed, there is often flexi-
bility as to which screen is placed on the
right and which on the left. Such consid-
erations undoubtedly reflect the artistic
aims of the Sōtatsu school, creating com-
positions of a highly decorative nature
which evoke the sense of an encyclo-
paedic collection of flowering plants.

In screens of this kind it is normal for
the various flowers and grasses to be
grouped in some way according to the
particular season they represent. The
present work, however, lacks any such
unifying concept and the seasons are all
mixed up together. Furthermore, the dis-
tribution across the screens is repetitive
and the individual motifs are consider-
ably conventionalised and lacking in a
sense of life. For these reasons it should
be ascribed to an unknown artist, proba-
bly working in the Sōtatsu school during
the first half of the seventeenth century.

17 School of Tawaraya Sōtatsu

Flowering and fruiting trees,
mid-seventeenth century

Six-fold screen; ink, colour, gold leaf and
silver on paper, 151.2 x 356.6 cm

Magnolia (*hō*) and fir (*momi*) trees in the
top right are divided by the line of a
slope, curving like some great whale's
back, from citrus fruit trees and white
camellias in the foreground. Although
the subject is very simple, the vivid con-
trasts of the colours, carefully calculated
composition and fine detail of the depic-
tion all combine to very striking effect.

Screens in which large expanses of
bright green colour, depicting various
trees, are used against a gold back-
ground are occasionally encountered
among works of the Sōtatsu school.
These are generally thought to be by
artists working in the generation after
Sōtatsu, and the present work can be
included in this group. The additional
use of silver paint across the background
in this case succeeds in creating an
added sense of spatial depth within the
composition.

18 School of Tawaraya Sōtatsu

**Flowers and grasses of the four
seasons,** second half of the seventeenth
century

Pair of six-fold screens; ink, colour and gold
leaf on paper, 57.2 x 235.0 cm

Although of small size, these screens are
of a similar type to cat. no. 16. Flowers
and grasses are depicted in a relatively
naturalistic manner: though the compo-
sition is compact, the spaces around the
plants are full of a sense of life and
though the groups of wild plants have
been tidied up, they also seem very nat-
urally arranged. The feeling evoked is
somewhat different from the sense of
artificial space created in the gold-leaf
screens of flowers and grasses done by
the generation of artists following on
directly from Sōtatsu. Rather, they share
many qualities in terms of style and date
with works by Kitagawa Sōsetsu*, such
as pairs of screens of *Flowers and grasses
of the four seasons* in the collections of the
Cleveland Museum of Art [1:29] and the
Nezu Art Museum, Tokyo [1:30].

19 Attributed to Tawaraya Sōtatsu

Pines on the shore (top) and **Flowers
and grasses,** late Keichō (1596–1615) or
Genna (1615–24) era

Two folding fans mounted as framed
paintings; ink, colour, gold and silver leaf
on paper, 54.9 x 16.9 cm (top) and
54.3 x 16.7 cm

20 Attributed to Tawaraya Sōtatsu

Trees (top) and **Plants,** Kan'ei
(1624–44) era

Two designs for folding fans mounted as
hanging scrolls; ink and colour on paper,
52.6 x 17.0 cm (top) and 52.0 x 16.9 cm

Since the Tawaraya workshop is said
originally to have been a fan shop, it
comes as no surprise that many fans by
artists of the Sōtatsu school survive.
Sometimes actual fans are pasted onto
screens (cat. no. 1); alternatively, fan-
shaped outlines are painted directly onto
the screen and filled in with designs
(cat. no. 2). The pair of paintings in
cat. no. 19 have vertical folds and wear
showing that they were stuck onto the
ribs of a folding fan and actually used.
Many different types of gold and silver
are applied to create a gorgeous decor-
ative background, over which scenery
and other impressively substantial motifs
are executed in pigment.

Stylistically there are many elements
in common with the paintings done by
Sōtatsu in 1602 on the reverse of the
covers of the medieval *Heike nōkyō* hand-
scrolls owned by the Itsukushima Shrine
[5:1, 3:S14]: for example, the fresh colour
sense, whereby the gold and silver and
other colours reverberate against one
another, and the very free creative sensi-
bility seen in the mist and earth banks
depicted symbolically in gold and silver.
There is a clear connection, too, with the
recently rediscovered *Screens pasted with
scattered painted fans* (cat. no. 1). How-
ever, the present two fans should be
dated slightly later than these, from the
late Keichō (1596–1615) to the Genna
(1615–24) era.

The two fans in cat. no. 20 both have
writing in the blank areas of the design,
giving instructions for decorative appli-
cations of gold and silver, e.g. 'apply
gold paint' (*dei-biki*). Various possibili-
ties suggest themselves: these could be
samples with instructions for producing

similar finished works in the studio, trial
works or half-completed works. In any
event, they permit us to glimpse the way
in which fans were produced in the
Sōtatsu workshop. Stylistically they may
be compared with works such as the
Screens pasted with scattered painted fans in
the Freer Gallery of Art, Smithsonian
Institution, Washington, D.C., and dated
to the Kan'ei (1624–44) era.

The paintings were formerly in the
Ueno family collection.

21 Tawaraya Sōtatsu

Shennong, God of Agriculture, Kan'ei
(1624–44) era

Signature: *Hokkyō Sōtatsu*
Seal: *Taiseiken*
Inscription by Wang Jiannan (d. 1645)
Hanging scroll; ink on paper, 80.2 x 35.7 cm

The majority of the figure paintings in
ink by the Sōtatsu school show Daoist or
Buddhist worthies. It has been demon-
strated that several of the depictions of
holy men are taken from the Chinese
late Ming printed illustrated book *Xianfo
qizong* (Japanese: *Senbutsu kisō*). Even
those figures which do not derive from
this source are familiar as subjects of
Chinese painting: the immortals Xiama
(Gama) and Tieguai (Tekkai), the monks
Hanshan and Shide (Kanzan and Jit-
toku), the legend of Xu You (Kyo Yū)
and Chao Fu (Sō Ho), and so on. Almost
all these subjects survive in several ver-
sions, indicating that ink paintings of
Daoist and Buddhist worthies were one
of the main products of the Sōtatsu
workshop.

Shennong (Japanese: Shinnō), 'God of
Agriculture', is a title given to the mythi-
cal Chinese emperor Yandi, who is said
to have taught agricultural techniques to
his people. Also regarded as the founder
of traditional Chinese medicine (Japan-
ese *kampō*), he was a common subject for
paintings. Here his unearthly features,
appropriate to his superhuman status as
a Daoist Immortal, have been skilfully
rendered in the ink techniques unique to
Sōtatsu. The ink is handled broadly, in
soft strokes full of moisture, to richly
expressive effect, and the painter's
eschewal of any severe outlines shows
him at his most characteristic. This is
extremely precious as one of the very

few examples of a genuine ink painting thought to come from the brush of Sōtatsu himself.

The inscription is by Wang Jiannan (Japanese: Ō Kennan, d. 1645), who is said to have emigrated to Japan from Ming China during the Keichō (1596–1615) era, and it must therefore have been written at a time very close to the period of activity of Sōtatsu and his pupils.

22 Ogata Kōrin (1658–1716)

Portrait of the poet Sōgi, before 1694

Signature: *Kōrin hitsu*
Seal: *Koresuke*
Inscription attributed to Prince Shōren'in Sonshō (d. 1694)
Hanging scroll; ink and slight colour on silk, 82.3 x 27.0 cm

This is currently the earliest known of the surviving genuine works by Kōrin. It bears the same signature and seal as the hanging scroll *Portrait of the poet Botanka Shōhaku* (Private Collection, Japan [4:120]). The two works also share a similar elegant, somewhat sombre painting technique using just ink and slight colour, and both should be regarded as early examples of Kōrin's style before he was awarded the *Hokkyō* title in 1701.

Furthermore, the inscription on the present work is attributed to Prince Shōren'in Sonshō, who is known to have died at the age of 44 on the 15th day of the 10th month, 1694, so it is extremely likely that the painting was executed before that date. This makes the scroll the earliest known of Kōrin's works – probably done when he was 36 or 37 years old – and an invaluable work in tracing the development of his style.

Iio Sōgi (c.1421–1502), like Botanka Shōhaku, was a famous poet of 'linked verse' (*renga*). This seated portrait has many unsteady, even clumsy, passages of brushwork; yet, pervaded with the style of the ink-painter Shōkadō Shōjō (1584–1639), it is nevertheless character-ful and elegant. The first part of the inscription derives from the anthology *Sōgi Hōshi shū* (Collection by the monk Sōgi), and the second part from *Shinsen Tsukuba shū* (Newly selected Tsukuba collection), compiled by Sōgi and others.

23 Ogata Kōrin

Hotei kicking a ball, c. late 1690s

Signature: *Kōrin hitsu*
Seal: *Koresuke*
Hanging scroll; ink on paper, 101.9 x 28.9 cm

Among Kōrin's paintings of Daoist or Buddhist worthies, the figures of Gods of Good Luck such as Hotei and Jurōjin are particularly well known. These are often executed in ink and light colours as hanging scrolls, or in underglaze iron-oxide painting (*sabi-e*) as decoration on square dishes by his younger brother Kenzan.

This humorous treatment of Hotei playing court football (*kemari*) in the tall, narrow format of the hanging scroll is regarded as the finest example of Kōrin's paintings of this deity, in particular because of the elaborate structure of the composition. Hotei has kicked the ball high in the sky, where it hovers at the top of the composition like the full moon. Far below, close to the centre of the scroll, is the comical figure of Hotei himself, following the ball with his gaze, and below him lies his mendicant monk's sack (*zuda-bukuro*) on the ground. All these elements have been arranged in a highly intellectual and calculated fash-ion: not only have the relative depths and heights of the various items been realigned along the vertical axis of the composition, but the curving shapes of the ball, of Hotei's head, shoulders and belly and of the sack are deliberately made to echo one another, only to be finally skewered, as it were, by the signature and seal placed in the exact centre at the bottom. The division of ink tones between light and dark is extremely delicate, providing further evidence of the stylistic influence of Shōkadō Shōjō on Kōrin's ink paintings of the first period of his career, when he was actively studying works by other artists.

The scroll, like cat. no. 22, should thus be dated to the early part of Kōrin's career, when he was aged about 40, just before he received the *Hokkyō* title in 1701.

24 Ogata Kōrin

The deified Sugawara no Michizane with pine and plum trees (preparatory study), c. 1701–2

Seal: *Kōrin*
Hanging scroll; ink on paper, 100.7 x 38.0 cm

Kōrin's son Juichirō was adopted into the Konishi family, who were hereditary officials at the Kyoto mint, and a large quantity of documents and preparatory drawings relating to Kōrin were passed down to their descendants. Among the drawings are many studies and copies of other works by Kōrin himself, which are of tremendous value in the study of the artist.

The Konishi family preparatory draw-ings are designated an Important Cul-tural Property and are presently divided between the Agency for Cultural Affairs, Tokyo, and the Osaka City Museum. However, it appears that as early as the end of the Edo period some of the mate-rial left the possession of the Konishi family, notably in response to a request by the painter Sakai Hōitsu, and it is thought that many drawings by Kōrin presently distributed among various col-lections originally formed part of the Konishi archive.

The present work, also known by the title *Vision of Michizane* (*Musō Tenjin zu*), is thought to derive from the Konishi family and to have become dispersed in this manner. Dressed in formal court robes and seated on a cloud, the deified spirit (Tenjin) of the famous statesman and poet Sugawara no Michizane (845–903) comes floating down from the top of the composition. In the bottom right corner are a plum tree with two branches stretching like taut wire in dif-ferent directions, and a pine sporting luxuriant beds of needles. The conven-tion of depicting the deified Michizane together with plum and pine – and occa-sionally with cherry – derives from the tradition that these were the trees that he particularly prized. It is also probably a reference to the 'flying plum tree' (*tobi-ume*) which came to Michizane's place of exile at Chikushi in Kyushu, when he summoned it with a poem; also to the legend of the 'pine trees which grew in one night' (*ichiya matsu*) at Kitano Shrine, Kyoto, after Michizane's death.

Details such as the manner in which

the outlines of the cloud have been turned into a pattern are idiosyncratic and of particular interest. The spontaneous brushstrokes used here are quite different from the more polished techniques that would be employed for the finished painting, underlining the importance of genuine sketches such as these in the study of Kōrin's *oeuvre*. The present sketch may be dated to *c.* 1701–2. The seal, though genuine, was probably added at a later date.

25 Attributed to Ogata Kōrin (fan painting) and Suzuki Kiitsu (1796–1858, painted mount)

Mt Fuji, with a surround of pampas-grass, early eighteenth century (fan painting), mid-nineteenth century (painted mount)

Signature: *Seisei Kiitsu* (on painted mount)
Seal: *Shukurin* (on painted mount)
Fan painting, mounted as a hanging scroll; ink, colour, gold and silver on paper, 50.1 x 15.9 cm (fan), 127.2 x 55.0 cm (painted mount)

The finest example of a fan painting of Mt Fuji by Kōrin is unquestionably that on the *Box pasted with painted fans* (Important Cultural Property, Yamato Bunkakan, Nara [5:25, 3:55]). This is a small wooden box for personal accessories (*te-bako*), which was first covered with gold leaf and then pasted with twelve scattered painted fans. The painting of Mt Fuji is on the front of an inner tray, and the creases clearly show that it was originally stuck onto ribs and used as a folding fan. The Yamato Bunkakan fan painting bears both the signature and seal of Kōrin and is a key work, fundamental to the study of his *oeuvre*.

Executed in azurite blue, the Yamato Bunkakan composition, showing the slopes of Mt Fuji crowned with snow at the summit and a forest of pine trees below, shares elements in common with the Idemitsu painting. Though the Idemitsu fan lacks any signature or seal, the use of colour and brush techniques are also similar, and in the absence of any evidence to the contrary it should also be regarded as a genuine work by Kōrin, albeit of lesser quality than the Yamato Bunkakan version.

Kōrin would of course have had the actual experience of witnessing Mt Fuji's majestic appearance during his journey along the Tōkaidō highway to Edo, as he left his native Kyoto far behind, lending an additional emotional dimension to his depiction not found in more conventional treatments of the subject. The fan was later surrounded with a painted mount of pampas-grasses by Suzuki Kiitsu. There are other examples of Kiitsu providing painted mounts for sketches by Kōrin in this manner, a clear indication of his feelings of respect towards this past master of the Rimpa lineage.

26 Ogata Kōrin

Designs for tea bowls for Kenzan, *c.* 1711

Inscription: *Shinsei chawan [no] tame gahon* ('Designs for Shinsei's [Kenzan's] tea bowls')
Signature: *Seisei ga*
Handscroll; ink on paper, 16.5 x 201.5 cm

These designs for the decoration of tea bowls were done by Kōrin and given to his younger brother, the potter Kenzan. A total of thirteen subjects are drawn on a small handscroll: first, seven designs relating to the 'three friends' of the scholar-gentleman – pine, bamboo and plum; next, two designs of Hotei, one of the Gods of Good Luck and the Daoist/Buddhist figure most frequently painted by Kōrin; finally, two designs of a horse and two designs of a deer. The first four designs are consciously given the outlines of tea bowls of various shapes. Interestingly, however, the subsequent images are drawn in a free and ample manner that does not wish to be bound by the conventional limitations of sample illustrations for craftsmen. Particularly splendid is the free and forceful depiction of the spiky branch of plum, which overshoots the edge of the tea bowl on which is is supposed to be painted. Such skill with the brush – the abbreviated strokes handled with such lightness and delicacy – could only have been achieved by the master Kōrin. Another example of similar specimen designs is known, this time three pictures of Hotei which were addressed to Kōrin's pupil Rinsui.

The present handscroll compares favourably with finished paintings by

Kōrin in his abbreviated ink style. From the point of view of designs addressed to his younger brother, Kōrin can be seen as instructing Kenzan with models of painting techniques to be used in the decoration of ceramic vessels; indeed, these paintings provide valuable evidence concerning the actual method of collaboration between the two brothers in the production of ceramics. The designs may be dated to after Kōrin's return to Kyoto from Edo, *c.* 1711.

There is an abbreviated copy of this scroll in the Burke Collection, New York.

27 Attributed to Ogata Kōrin and pupil

Blossoming red and white plum trees, *c.* 1712–13, with later additions (?)

Pair of six-fold screens; ink, colour and gold leaf on paper, each *c.* 151.0 x 346.0 cm

Blossoming red and white plum trees are elegantly arranged across a pair of six-fold screens. Though the work is unsigned, the use of the *tarashikomi* technique on the trunks of the trees and in other places confirms that it is by a Rimpa artist. The screens were formerly in the collection of the Hitotsubashi Tokugawa family, one of the three collateral Shogunal lines. Originally they were attributed to Sōtatsu or his school, but subsequently there have been many other theories and the question of authorship remains unresolved. However, most scholars agree that left and right screens appear to be by different hands, and that part or all of the unusual flowing water in azurite blue and the rocks at the bottom of each screen were added at a later date.

The manner of depicting the branches on the left screen, whereby they twist and turn violently up and down, is particularly striking. In the archive of Kōrin's studies formerly belonging to the Konishi family there is a preparatory drawing for a piece of *maki-e* lacquer with a design of a plum tree very similar in form to this. After the existence of this drawing became known, the possibility that the red and white plum trees on the five right-hand panels of the left screen were painted by Kōrin has been considerably strengthened. As far as the rest of the composition is concerned, it has been pointed out that the meandering,

unsteady form of the branch on the right screen is reminiscent of the work of Kōrin's pupil Fukae Roshū. These two arguments together lead to the interesting hypothesis that an unfinished work begun by Kōrin in about 1712–13 was later completed by a pupil, perhaps Roshū.

28 Attributed to Ogata Kōrin or pupil

Rose mallows, first half of the eighteenth century

Seal: *Hōshuku*
Six-fold screen; ink, colour and gold on paper, 120.5 x 378.0 cm

A screen depicting rose mallows (*fuyō*), which blossom from late summer into autumn. The design is arranged so that the mass of plants at the bottom right, with their roots hidden from view, is complemented by a row at the upper left with their tops cut off by the edge of the screen.

The structure of the composition has been criticised for its lack of organic completeness, and when examined closely there are several places where breaks occur in the continuity of the design, undeniably creating a sense of disruption. The reason for this is, in fact, that fragments from what were originally a pair of screens have been reassembled by a later owner to form a single screen.

The white or pale pink mallow flowers were overpainted with a wash of silver, which has now tarnished and blackened. The use of gold leaf for certain of the leaves creates another unusual, highly striking effect, although it has been pointed out that a similar technique is found on the cedar doors painted with *Chinese lions* (Yōgen-in Temple, Kyoto [3:200]), attributed to Sōtatsu.

A hanging scroll by Kōrin with the subject of birds flying over rose mallows is known. The present work should probably be dated to the first half of the eighteenth century and ascribed to Kōrin or a pupil of the next generation.

29 Attributed to Ogata Kōrin or pupil

Shintō ceremony of purification (Misogi), first half of the eighteenth century

Two-fold screen; ink, colour and gold leaf on paper, 164.5 x 180.5 cm
Important Art Object

With white paper emblems of purification (*gohei*) placed before him, a courtier is seated on the bank of a river which flows in a bow-like arc from the top right to the bottom left corner of the composition. Above his head and in the bottom right, in counterpoint to the direction of this current, are large bamboo baskets of rocks, used as artificial embankments, a skilful device unifying the composition within the square format.

The subject of a man conducting a ceremony of purification immediately brings to mind episode 65 from *Tales of Ise* (*Ise monogatari*), the episode known as 'Misogi' (ceremony of purification). In the 'Purification to deny love' (*Koi seji no misogi*) scene, a young man has fallen passionately in love with a court lady, but the liaison is most unsuitable and threatens his career and advancement. He therefore organises a *misogi* ceremony of purification – traditionally conducted at the water's edge – in an attempt to rid his heart of the love that is causing him such grief. This scene is frequently depicted in works by Rimpa artists, from Sōtatsu onwards. However, the present composition differs somewhat from the standard iconography, raising the possibility that the subject here might be a different one – namely, the depiction of a particular *waka* poem by Fujiwara no Ietaka (1158–1237) from the *Shin chokusen shū* anthology. Whatever the precise reference, a sense of desolation certainly seems to envelop the lonely figure, seated with his back towards us but showing a profile view of his troubled features beneath the *eboshi* court cap.

In the past there was much debate as to whether this is a work by Sōtatsu or Kōrin. More recently, however, it has been pointed out that the composition and handling have elements in common with works by an accomplished pupil of Kōrin, presently identified only by his use of a seal read as 'Seiotsu/Seiitsu' (or possibly 'Seishi'?), and there is a growing

conviction that the screen may indeed be a work of this pupil. The screen was formerly in the collection of the Satake family, and subsequently belonged to Hara Tomitarō (Sankei).

30 Ogata Kenzan (1663–1743)

Autumn maple, c. 1730s

Signature: *Shisui Shinsei*
Seal: *Reikai*
Hanging scroll; ink and colour on silk, 114.0 x 48.9 cm

Kōrin's younger brother is generally referred to by the name Kenzan. This was the name he used for his activities as a potter, famous for his wares in Kyoto style (cat. nos 55–65), while for works of calligraphy or painting he always used the art-name Shinsei. The fact that he is better known as Kenzan reflects how comparatively few his painted works are, and almost all of these were done from his seventies onwards.

A maple tree, brilliant with autumn foliage, fills the width of the hanging scroll in spectacular manner. The somewhat stylised patterning of the forms of the leaves, captured at different stages in the delicate process of turning red, creates an impression at once soft and benign. One of the changing aspects of nature, witnessed perhaps in autumn mountains or some quiet corner of the city, has been captured in Kenzan's distinctive, slightly amateur and awkward style.

At the top of the painting is an inscription by Kenzan himself, a Chinese-style couplet describing trees glistening in the evening sun after autumn winds and rain have abated. Another painting by Kenzan of the same subject (Private Collection, Japan [2:336]) – signed 'old man of seventy-eight' and therefore datable to *c*. 1740 – bears an identical inscription. In this other version the small twigs of the tree are executed with a delightful touch and the trunk, which makes very effective use of the *tarashikomi* technique, is brimming with life.

31 Ogata Kenzan

Plum, pinks, bush-clover and snow, 1742

Signature: (snow scroll) *Karaku hachijū-rō Kan Shisui Shinsei ga* ('Painted by Kan Shisui Shinsei of Kyoto, old man of eighty')
Seals: (snow scroll) *Reikai*; (other three scrolls) *Furiku*
Set of four paintings mounted as hanging scrolls; ink and colour on gold leaf, each c. 24.0 x 28.6 cm

This set of small paintings shows flowers and grasses of the four seasons and, unusually for Kenzan, they are on a gold-leaf ground. Spring is represented by plum, summer by pinks, autumn by bush-clover; for winter, there is the gentle line of a hillside with trees covered in snow. Clearly Kenzan was to some extent imitating the painting style of his brother Kōrin, such as in the use of the *tarashikomi* technique on the trunk of the plum tree. In addition, each work combines poetry and painting in relatively equal measure, in the traditional manner of literati artists.

The snow subject includes the age of eighty in the signature, dating the work to 1742, the year before Kenzan's death. Though presently mounted as a set of four hanging scrolls, the paintings were originally used to decorate four small sliding doors for *fukuroto-dana* cupboards up to the side of a *tokonoma* alcove.

The inscriptions are all *waka* poems deriving from classical sources: the anthology *Rokkasen shū* (spring), the 'Hahakigi' (Broom-tree) chapter of *Tale of Genji* (summer), and the anthology *Setsugyoku shū* (autumn, winter).

32 Ogata Kenzan

Chrysanthemums, 1743

Signatures: (recto) *Hachijū-ichi rō Kan Shinsei* ('Kan Shinsei, old man of eighty-one');
(verso) *Shisui Shinsei*
Seals: [indecipherable]
Folding fan painted on both sides; ink, colour and gold leaf on paper, 54.2 x 19.6 cm

It seems that Kenzan was well aware that his achievements in painting would never match those of his elder brother Kōrin, and it is known that he requested designs from Kōrin for the magnificent square dishes that they created together. Unlike Kōrin, Kenzan had a strong sense of the literati tradition and ceaselessly strove to perfect all three classic genres of poetry, calligraphy and painting (*shishoga*). Perhaps for this reason most of his paintings are graced with his own inscriptions of poetry.

Within Kenzan's painted *oeuvre*, the proportion accounted for by fan paintings – obviously a small format – is relatively large. Until recently only a few were known that employ gold backgrounds, such as the fan painting of *Rose mallows* (Tokyo National Museum). The present fan, which has just been rediscovered, is another work of this kind, decorated on both sides with white chrysanthemums against gold leaf in a similar manner. Within the group of gold-ground fans, the form of the signatures and seals on the Idemitsu example is particularly close to those on the *Rose mallows*. The fact that the painting techniques employed for these two fans are different, however, clearly requires further careful comparative study.

One of the signatures on the Idemitsu fan gives Kenzan's age as eighty-one, indicating that it was painted in 1743, the year he died. After Kōrin's death, Kenzan moved to Edo and the frequent use in his signature after that date of appellations such as 'Karaku' ('capital of flowers', a poetic name for Kyoto) and 'Keichō Itsumin' ('hermit away from Kyoto'), show just how strong was his consciousness of – and pride in – his status as a Rimpa painter from Kyoto.

33 Fukae Roshū (1699–1757)

Flowers and grasses of the four seasons, mid-eighteenth century

Seal: *Roshū*
Six-fold screen; ink, colour, gold leaf and silver on paper, 62.8 x 197.6 cm

Roshū, a late pupil of Kōrin, is now known by very few works, all of which are of plant and flower subjects. His style is old-fashioned and closer to Sōtatsu than to Kōrin, so much so that previously, when the use of his seals had yet to be established, Roshū was mistakenly thought to be a painter of the Sōtatsu school.

The present screen, recently rediscovered, is one of the most significant in Roshū's *oeuvre*. The only full-size screen by Roshū currently known, and his most famous painting, is a single, six-fold *Flowers and grasses of the four seasons* (Important Cultural Property) in the collection of the Manno Art Museum, Osaka [1:40]. The Idemitsu work is thus already of interest for being a medium-size single, six-fold screen on the same subject.

Furthermore, the right side of the Idemitsu screen – a mass of spring plants such as horsetails, ferns and white azaleas beneath the spreading branch of a red azalea – is extremely similar in feeling to the composition of the Manno version. The left side of the screen also shares the motif of begonias with the Manno version, but the special feature here is the manner in which the profusion of begonias forms a diagonal shape that complements the line of the main azalea branch on the right side. The intention is clearly to establish a spatial balance between the two sides of the composition.

It cannot be said that the Idemitsu screen shares the highly idiosyncratic composition, full of centripetal energy, of the Manno version, which is itself based on grass and flower compositions bearing the 'Inen' seal of the Sōtatsu lineage. Nevertheless, in common with all works by Roshū, it does contain a strong emotional charge, heavily tinged with pathos.

Three versions of screen compositions by Roshū are known, which have as their theme the 'Narrow Ivy Path' from *Tales of Ise* (see fig. 29), providing another,

analogous example to the existence of the Manno and Idemitsu versions of the present subject. The mysterious effect employed for the background of the Idemitsu screen, however, whereby gold and silver have been mixed in such a complicated fashion, may be the result of later repairs, or of Roshū having reworked an older screen.

34 Watanabe Shikō (1683–1755)

The Zen patriarchs Hongren (left) **and Huineng** (right), mid-eighteenth century, before 1751

Signature: *Watanabe Shikō*
Seal: *Shikō no in*
Pair of hanging scrolls; ink on paper,
96.5 x 28.2 cm (right), 97.3 x 28.3 cm (left)

A pair of hanging scrolls depicting the fifth- and sixth-generation heads of the Zen sect of Buddhism in Tang dynasty China: Hongren (Japanese: Kōnin, 604–77, left) and Huineng (Japanese: E'nō, 638–713, right). Depicted in a free and unconventional style, Hongren is shown with pine seedlings and a spade over his shoulder, while Huineng is seated leaning on a large pestle, engrossed in reading a book.

In a previous existence Hongren is said to have been an ascetic who cultivated pine trees on Mt Potou. He hoped to receive teaching from the fourth-generation Zen patriarch Daoxin (Japanese: Dōshin) but was unable to accomplish this because of his advanced age. It was only after rebirth into his next life that he was able to fulfil this profound ambition, ultimately becoming fifth-generation head of the sect. Huineng, together with Shenxiu (Japanese: Shinshū), was a leading pupil of Hongren. After becoming sixth-generation head, he is famous for having expanded the Southern Sect of Chinese Zen, which subsequently developed into the so-called 'five patriarchs and seven sects', including the Linji (Japanese: Rinzai) and Caodong (Japanese: Sōtō) sects prominent in Japan.

The brushstrokes employed for the outlines are made to taper and swell in a soft, clinging manner, and in areas such as the monks' robes there is a free use of the *tarashikomi* technique, enhancing the sense of volume. Almost all Shikō's ink

paintings are in Kanō style, and the present Rimpa-style work is therefore unusual. The two scrolls of the fifth and sixth Zen patriarchs were separated for a long time in their history and it is only in recent years that, fortunately, they have been reunited in the same collection.

The inscriptions are by Dairyū Sōjō (1694–1751), 341st abbot of Daitoku-ji Temple, Kyoto, and so the scrolls most likely date from before his death.

35 Watanabe Shikō

White wisteria and azalea,
mid-eighteenth century

Signature: *Watanabe Shikō*
Seal: *Shikō no in*
Hanging scroll; ink and colour on silk,
93.0 x 34.8 cm

In the background of this scene of early summer are twisting branches of wisteria with their hanging clusters of white flowers, while in the foreground are blossoming azaleas and sprouting bamboo. The depiction of the rocks in *tarashikomi* technique, with their sense of soft weightiness and dotted rings of moss added here and there, shows all the elements of the Rimpa style.

Shikō trained first in the Kanō school, but later seems to have had some contact with Kōrin and Kenzan. This dual affiliation resulted in his skilful ability to switch at will between the Kanō and Rimpa painting modes. The present painting is an example of a plant and flower composition in the Kanō mode, one of many works by Shikō on such themes, employing similar brush techniques and a similar use of colour. Indeed, the same motifs are also found on other screens and hanging scrolls. This painting can therefore be described as a typical work by the artist.

36 Attributed to Watanabe Shikō

Album of wading birds, mid-eighteenth century

Folding album; ink and colour on paper,
21.2 x 28.3 cm

One aspect of Shikō's career as a painter was the production of so-called 'pictures from life' (*shasei zu*). The famous *Illustrated handscroll with true depictions of types of bird* (*Chōrui shashin zukan*, Private Collection, Japan [3:154]), later copied by Maruyama Ōkyo (1733–95), is a comprehensive compendium based on a lifetime's experience spent drawing birds from life. It is extremely important both for establishing the firm connection between Shikō and the later Ōkyo and as an example of painting from life in the Edo period.

Though unsigned, the album of *Wading birds* in the collection of the Idemitsu Museum of Arts can be attributed with confidence to Shikō. It contains fifteen pages, several showing two birds. Wading birds also appear in the *Illustrated handscroll with true depictions of types of bird*, but in the Idemitsu album they are drawn in painstaking detail and carefully coloured, and are sufficiently accurate to serve as illustrations to an encylopaedia of natural history. Indeed, Shikō would have produced paintings such as this under the influence of the circle of the Kyoto courtier Konoe Iehiro (1667–1736), with his philosophy of the empirical, scientific study of plants, animals and other natural phenomena (*honsōgaku*). It is from such beginnings that the later Edo period school of painting from life was to evolve.

The album is accompanied by a letter bearing the signature Maruyama Mondo, attributing the work to Shikō.

37 Tatebayashi Kagei (worked mid-eighteenth century)

Rooster and hen, mid-eighteenth century

Signature: *Kōkiken Kagei*
Seal: *Hōshuku*
Hanging scroll; ink and colour on paper, 100.6 x 46.0 cm

Kagei, a late pupil of Kenzan in Edo, followed Kōrin's painting style. At present he is known only by a small number of works. Other paintings depicting birds and animals are *Birds beneath a tree in the snow* (Asian Art Museum of San Francisco)[1] and another scroll with the subject of fowl (Private Collection, Japan). The forms of the rooster and hen in the present work have their origins in paintings by Kōrin: in *Kōrin hyakuzu* (One hundred pictures by Kōrin, published 1815) there is recorded a pair of hanging scrolls which may have provided the source. A newly rediscovered addition to Kagei's *oeuvre*, the painting exemplifies many of the common elements of his style: a somewhat rough touch and a lack of brightness, due to the preponderance of heavy colouring.

This is the first recorded instance of Kagei's incorporation of the art-name (*gō*) Kōkiken in his signature, which may be added to the list of those already known: Kiusai, Itsuyū and Taisei.

[1] Nihon Keizai Shimbun (eds), *America's Love for Japan*, Tokyo, 1995, no. C10.

38 Nakamura Hōchū (d. 1819)

Fan paintings pasted on screens, early nineteenth century

Signature: (each fan) *Hōchū kore [o] egaku* ('This is painted by Hōchū')
Seal: (each fan) [indecipherable]
Twelve fans mounted on a pair of six-fold screens; ink and colour on paper, each fan *c.* 54.3 x 21.6 cm

Each leaf of a pair of six-fold screens has had a single fan painting pasted onto it, giving a total of twelve fans. Two-thirds of these depict flowers and grasses of the four seasons and the remainder show scenic motifs, Daoist and Buddhist worthies, etc.

Paintings on fan-shaped papers were a particular speciality of Hōchū. They all feature similar bold outlines and a technique which leaves these outlines in reserve (*hori-nuri*), applying colours mixed with shell-white (*gofun*) carefully up to the edges of the lines, almost like filling in a colouring book. The style is uniquely Hōchū's own – highly unconventional and full of humour.

Though presently pasted on screens, each fan painting shows evidence of having been folded, suggesting that they were originally mounted on bamboo spines and actually used as fans.

39 Sakai Hōitsu (1761–1828)

Wind God and Thunder God, *c.* early 1820s

Signatures: *Hōitsu hitsu* (right screen); *Uge Hōitsu hitsu* (left screen)
Seals: *Bunsen* (right screen); *Bunsen* (two different seals, left screen)
Pair of two-fold screens; ink, colour and gold leaf on paper, each *c.* 132.8 x 318.8 cm

The summit of Tawaraya Sōtatsu's artistic achievement is represented by his pair of gold-leaf screens *Wind God and Thunder God* (fig. 8), which depict these two deities of the Buddhist heavenly realm (*tenbu*) in a wonderfully bold and open-hearted manner. Some seventy or eighty years after they were painted, Kōrin, the next great master of the Rimpa lineage, executed a copy which was passed down in the Hitotsubashi Tokugawa family (fig. 39). Then, more than a hundred years after Kōrin's copy, Sakai Hōitsu, the leading painter of the Rimpa school in Edo, made his own copy of the screens, after the Kōrin version.

Hōitsu is thought to have come into contact with Kōrin's version some time between the publication of the two illustrated catalogues of Rimpa works compiled by him – *Kōrin hyakuzu* (One hundred pictures by Kōrin) of 1815 and its sequel *Kōrin hyakuzu kōhen* of 1826 – since a reduced-size copy of the screens appears in the latter. Furthermore, a reference to the Kōrin version of the screens appears in the entry for the twelfth month, Bunsei 3 (=1820) in *Sumiyoshi-ke koga tome-chō* (Notes on old paintings belonging to the Sumiyoshi family), probably occasioned by Hōitsu's being requested to give an authentication of the paintings, and so this may well be the date when Hōitsu was able to see the Kōrin version and make his copy.

In general, when Hōitsu made copies of older Rimpa paintings he had a tendency to make fairly substantial changes to the original: in this instance, too, differences can be detected, such as a slight alteration in the relative heights of the Wind and Thunder Gods and a greater sense of movement given to their respective clouds. Since the original Sōtatsu work there had been a steady loss in the awesome aspect accorded to these fierce deities, and in the present Hōitsu version they have a much more cheerful appearance, with popular appeal.

For both Kōrin and Hōitsu, the act of copying the *Wind God and Thunder God* screens became an affirmation of their succession to the Rimpa painting tradition, a tradition which was so curiously lacking in direct master-pupil relationships. However, both artists went on to make their own responses to Sōtatsu's work with similar pairs of two-fold screens that crystallised the essence of their individual and very different artistic personalities: Kōrin's *Red and white plum trees* (figs 19, 46) and Hōitsu's *Summer and autumn grasses* (fig. 49).

40 Sakai Hōitsu

Summer and autumn grasses (preparatory study), dated 1821

Seal: *Hōitsu* (both screens)
Pair of two-fold screens; ink and colour on paper, each 162.0 x 181.4 cm

The work that best represents the essence of Hōitsu's art is the pair of two-fold screens with silver-leaf backgrounds *Summer and autumn grasses* (fig. 49), which combine naturalistic depiction with the traditional decorative qualities of the Rimpa school. They were originally painted onto the back of the pair of two-fold screens by Ogata Kōrin, *Wind God and Thunder God*, in the collection of the Hitotsubashi Tokugawa family (fig. 39). This recently discovered preparatory study for the finished painting is thought to have been used by Hōitsu when he presented the design to his Hitotsubashi patron.

The preparatory study is mounted on a pair of two-fold screens like the finished paintings. Two important docu-

ments relating to the production of the screens (perhaps originally forming paper wrappers for them) are pasted onto the reverse side of each screen. They include various pieces of information that generally confirm the earlier suppositions of scholars: that this was a work with 'silver background' produced 'at the request of Lord Hitotsubashi of the First Rank [Tokugawa Harusada, 1751–1827]'; that the composition was devised in such a way that the 'Thunder God and Wind God on the front painted by Kōrin' would correspond to 'rain on summer grasses and wind in autumn grasses on the back'; that either the finished work or this preparatory study was probably 'completed and presented [to the Tokugawa family] on the 9th day of the 11th month, Bunsei 4 [=1821]'. The same document explains that this preparatory study was later passed down to Hōitsu's pupil Tanaka Hōji (1814–84).

Though executed in rough colouring and brushwork on plain, coarse paper, the preparatory study is almost identical in composition to the finished painting. When compared in detail, however, certain small differences are revealed which show just how delicate and acute was the artist's sensibility in striving to create ever more refined forms. On the screen of autumn grasses, in particular, the positions of the fluttering red ivy leaves and the curves of the drooping stems and leaves have been slightly altered in the finished painting, so as to modify the sense of the strength of the wind. Though the sketch is executed with an easy, flowing touch, the brush-strokes are filled with tension, conveying a most vivid impression.

For the finished painting silver leaf rather than gold leaf was deliberately chosen. Furthermore, the composition placed summer grasses battered by the rain on the back of the Thunder God, and autumn grasses blowing on a moor on the back of the Wind God. Although he sought in this way to remain in tune with the concept of Kōrin's earlier work that he so respected, we also get a vivid sense of just how passionately Hōitsu applied himself to creating his compositions, spurred on by a creative ambition that sought even to surpass the achievements of the earlier master.

41 Sakai Hōitsu

Eight-fold bridge over the iris pool, c. early 1820s

Signature: *Uge Hōitsu hitsu* (both screens)
Seals: *Bunsen* (two different seals, both screens)
Pair of six-fold screens; ink, colour and gold leaf on silk, each 161.6 x 397.8 cm
See foldout opposite p. 104

It was Kōrin, the most influential painter of the Rimpa school, and much admired and emulated by the later Hōitsu, who first executed two different pairs of screens of clumps of irises against a gold background. The subject derives, of course, from the famous scene in 'Journey to the East' (*Azuma-kudari*), episode 9 of *Tales of Ise* (*Ise monogatari*), in which Ariwara no Narihira and his followers stop to admire the celebrated eight-fold bridge over an iris pool in the Province of Mikawa. In his two versions Kōrin strove for quite different effects. The original version (Nezu Art Museum, fig. 11) repeats several patterned forms of irises across the composition, placing the emphasis on the overall sense of design in a manner reminiscent of Sōtatsu's decorated papers of the early seventeenth century. In contrast, the later version (Metropolitan Museum of Art, New York, fig. 50) actually includes the bridge among the irises that bloom in profusion, so emphasising that the painting is illustrating an ancient *monogatari* tale, specifically *Tales of Ise*. The present painting by Hōitsu is based on the second of these two versions by Kōrin.

Though he follows the composition of Kōrin's original very closely, Hōitsu adds certain innovations of his own: for instance, he reduces the number of flowers so as to clarify the iris motif, and distributes their sword-like leaves in a wonderfully rhythmical manner. Furthermore, his unique creative imagination can doubtless be seen at work in the deliberate contrast between the flickering effect of the left screen, in which the leaves seem almost to dance, and the relative stillness of the right screen. Also significant is the choice of a silk support instead of paper, which considerably alters the lustrous effects of the gold-leaf ground.

Thus even a work such as this, which

is executed very much in accordance with the tradition of Rimpa artists copying from the past, can be seen as recreating that tradition in a new way, imbued as it is with Hōitsu's uniquely elegant sense of form. It is thought that the screens were painted in the first half of the Bunsei (1818–30) era at the request of a saké wholesaler in the Kayaba-chō district of Edo, one Nagaoka Isaburō. They subsequently belonged to the Daikokuya eel restaurant at Reigan-jima, and finally to the Iwasaki Yatarō collection.

42 Sakai Hōitsu

Birds and flowers of the twelve months, second half of the Bunsei (1818–30) era

Signatures: (first to eleventh months) *Hōitsu hitsu*; (twelfth month) *Hōitsu Kishin hitsu*
Seals: (first month) *Ugean, Bunsen*; (second to twelfth months) *Bunsen*
Twelve paintings mounted on a pair of six-fold screens; ink and colour on silk, each 140.7 x 51.6 cm

A favourite subject in Hōitsu's repertoire was a set of twelve compositions of birds and flowers of the twelve months. Four complete sets are widely known: three of these are sets of hanging scrolls in the Imperial Collection [1:94], the Shin'enkan (USA) [1:96] and the Hatakeyama Memorial Museum, Tokyo; the fourth is a set of paintings, slightly different in conception, mounted on a pair of screens in the Kōsetsu Art Museum, Kobe [1:98]. A few scholars have also been aware of the existence of five paintings from another, dispersed set (with inscriptions by Kameda Ryōrai, 1778–1853). The present set of paintings is a new discovery, preserved in what is apparently their original mounting, pasted to a pair of six-fold screens.

Many of the compositions of the Idemitsu set – particularly the first month – are similar to those in the Shin'enkan collection, and the third, fourth, ninth, tenth and eleventh months are close to those in the dispersed set. This similarity and other factors such as the style and the forms of the signatures suggest a date of execution close to these other sets, that is, in Hōitsu's final years, during the late Bunsei (1818–30) era.

There is a deliberate and daring

imbalance in each of the compositions. The fresh, brilliant colouring of the flowers, birds and insects is set off most effectively by the *tarashikomi* technique used extensively in the pale *sumi* (ink) of the stems and branches. The motifs derive without exception from Hōitsu's standard repertoire: we can appreciate to the full the special world of his bird-and-flower painting which, combining as it does the traditional Rimpa style with new, naturalistic elements, appeals as much to the intellect as it does to the emotions.

The reverse side of the screens was later painted with a composition of *Bamboo and sparrows* in *sumi* by Hōitsu's pupil Yamada Hōgyoku (dates unknown).

43 Sakai Hōitsu

Red and white plum trees, first half of the Bunsei (1818–30) era

Signature: *Hōitsu hitsu*
Seals: *Bunsen* (two separate seals)
Pair of six-fold screens; ink, colour and silver leaf on paper, each *c.* 152.5 x 319.6 cm

This major work by Hōitsu has only recently been rediscovered. Against an all-over background of silver leaf, a single blossoming red plum tree is painted on the right screen and a single white plum on the left.

Plum trees had been a favourite subject of the great Ogata Kōrin throughout his career. The best-known examples are the pair of two-fold screens *Red and white plum trees* (figs 19, 46), but Kōrin painted many other versions in both screen and hanging scroll format, using a variety of brush techniques. Hōitsu, too, included plum as a motif in many of his bird and flower paintings. In this instance, as in his masterwork *Summer and autumn grasses* (fig. 49) and other works, the artist has deliberately elected to use an unusual silver background, and the pair of screens is of the largest and grandest size – clearly he was endowing the two plum trees with a special, symbolic meaning.

The red plum on the right screen, with its violently twisting trunk and gnarled bark, has all the appearance of being an old tree and was doubtless painted with the example of Kōrin's earlier masterpiece in mind. In particular,

the technique by which the end of the trunk sweeps confidently upwards, with the ink stroke fragmenting as groups of brush-hairs divide, is reminiscent of similar brushwork used by his predecessor Kōrin in his own works.

44 Sakai Hōitsu

Weeping cherry, *c.* Bunsei (1818–30) era

Inscription: *Someyasuki/hito no kokoro ya/itozakura* ('How quick to tinge, is the heart of man – weeping cherry')
Signature: *Hōitsu shoga* ('Calligraphy and painting by Hōitsu')
Seal: *Bunsen*
Fan painting; ink and colour on paper, 53.0 x 18.6 cm

45 Sakai Hōitsu

Candle stand, *c.* Bunsei (1818–30) era

Inscription: *Hototogisu/teshoku nikurashi/yoi no sora* ('Cry of the cuckoo – the lantern is hateful, under an evening sky')
Signatures: *Hōitsu, Ōson saiga* ('Painted a second time by Ōson')
Seals: *Uge, Kyosō Hōitsu* ('Great Priest Hōitsu')
Fan painting; ink and colour on paper, 48.5 x 17.6 cm

Two delicate and attractive painted fans. The former includes a poem as if inscribed on a poem-slip (*tanzaku*) hanging from the branches of the weeping cherry. The painting of the candle stand on the latter seems to have been added by Hōitsu at a later date.

46 Suzuki Kiitsu (1796–1858)

Trees and flowers of the four seasons, mid-nineteenth century

Signature: *Seisei Kiitsu* (both screens)
Seal: *Isandō* (both screens)
Pair of six-fold screens; ink, colour and gold leaf on paper, each *c.* 132.8 x 318.8 cm

A pair of screens of medium size depicting trees and flowers of the four seasons. The composition continues across both screens, either side of a flowing stream in the centre.

Plants and flowers appropriate to the changing seasons are clustered around the central elements of the red and white plum tree on the right screen and the maple with brilliant autumn foliage on the left. The plant and flower motifs mix elements of naturalism with a strong overall sense of pattern. Their simplified shapes are complemented by a daring use of colour, creating an enjoyable effect of ornamental design. Another work by Kiitsu which can similarly be situated halfway between painting and decorative pattern is the hanging scroll *Chrysanthemum and flowing water* (Gitter Collection, USA [2:298]).

A flat, decorative style was of course a feature of the Rimpa school and this work certainly belongs to that tradition. However, certain details, such as the manner of depicting the group of rocks, show the influence of the painter Watanabe Shikō (compare cat. no. 35), who studied the Kanō as well as the Rimpa style. Overall, the work exhibits Kiitsu's uniquely personal creative sensibility, quite clearly removed from the world of his teacher Hōitsu. The screens are in comparatively fine condition, their clear, brilliant colouring continuing to refresh and delight.

47 Suzuki Kiitsu

Cherry blossom and maples,
c. late 1830s to early 1840s

Signature: *Kaikai Kiitsu*
Seal: *Teihakushi*
Six-fold screen; ink, colour and gold leaf
on paper, 50.6 x 200.4 cm

A screen which unites the the two motifs of nature poetry for spring and autumn: cherry and maple, respectively. However, the maple is not depicted with its red colouring, and so in this particular painting it is not acting as a signifier for autumn.

At the top of the screen it is mainly the roots and bottoms of the trunks of the maples that are featured, as well as the ends of the branches that stretch down to intersect with them. The manner in which these thick trunks, painted using the *tarashikomi* technique, seem to spread out to each side recalls the most famous work by one of Kiitsu's predecessors in the Edo Rimpa lineage, the screen of *Maples* (fig. 30) by Tawaraya Sōri (worked late eighteenth century). In response to the positioning of the maple, the cherry in full bloom has been brought down to the foreground right-hand corner. In contrast to the maples, just the tops of the blossoms are shown, daringly cut off by the edge of the screen in a manner which, if anything, serves to exaggerate the implied size of the cherry tree. The individual cherry flowers have been depicted as if in a pattern pressed flat against the painting surface, creating a highly decorative effect.

When it comes to autumn the two trees will reverse their relative positions: the maple with its brilliant red foliage will force the flowerless cherry into subservience. It is by means of such assocations that the artist hoped to imbue this work with the sense of the fertility of the ever-repeating cycle of the seasons.

48 Suzuki Kiitsu

Autumn grasses, c. late 1820s to early 1830s

Signature: *Kiitsu hitsu*
Seal: *Teihakushi*
Hanging scroll; ink, colour and gold leaf on paper, 23.7 x 73.8 cm

Almost the entire space of the brilliant gold-leaf ground is taken up with a profusion of autumn grasses of various kinds. All the standard 'seven grasses of autumn' have been duly included, and yet their depiction is full of energy with the curving stems and leaves overlapping one another and creating a wonderfully vivid expression of life-force.

Kiitsu did many compositions of autumn grasses during his career but the form of the signature and seal in this case suggests a work from the early period, before 1832. Such depictions became a particular speciality of the artist's repertoire, repeated many times into his final years. A feature of Kiitsu's small-scale paintings of autumn grasses is that he is not content only to convey a delicate impression of the season, but also imbues the groups of plants and flowers with a considerable sense of movement and power.

The present appearance of the painting, mounted as a hanging scroll, is certainly arresting, with its unusually wide horizontal format. However, the vertical join in the centre of the composition and the fact that there are repaired holes at either extremity where metal fittings for sliding door panels have been removed, makes it clear that originally these were two painted doors for a set of small wall cupboards (*to-busuma*, often located next to the formal *tokonoma* alcove) that were subsequently joined to form the present hanging scroll. It appears that Kiitsu received a particularly large number of commissions for sliding-door and screen paintings; among the many examples which have survived are *Cranes* (Feinberg Collection, USA [3:107]), *Wind God and Thunder God* (Fuji Art Museum [4:133]), *Autumn plants* [2:212] and *Wisteria* [2:115] (both Idemitsu Museum of Arts).

49 Suzuki Kiitsu

Rose mallows, c. late 1820s to early 1830s

Signature: *Kiitsu hitsu*
Seal: *Shukurin*
Hanging scroll; ink and colour on silk,
122.8 x 56.7 cm

A single scroll depicting blossoming red, white and pink rose mallows (*tachi-aoi*), a motif with poetic associations of summer. Just like his teacher Hōitsu, Kiitsu venerated the artistic style of Kōrin. Indeed, he went through a period in which he poured all his energies into emulating the achievements of this great master of the past. Kōrin and his brother Kenzan of course painted many compositions of rose mallow, and this work represents Kiitsu's challenge to their earlier examples.

In comparison to the depictions by Rimpa artists of a century or so before, the style of the rose mallows here, with their elements of naturalism, is strongly and unmistakably Edo Rimpa in feeling. Having said this, Kiitsu was notable in his later years for the way in which he produced a succession of masterpieces in a variety of distinct styles. In comparison to works in which he is searching for his own distinctive beauty of form, it has to be admitted that the style of the present work is somewhat immature, or perhaps unsophisticated.

The form of the signature is in the cursive style of Kiitsu's earliest period, from the late Bunka (1804–18) era to the early Tempō (1830–44) era. Particular features of the calligraphic style allow a tentative dating to the later half of his early period, that is to say c. 1825–35.

50 Suzuki Kiitsu

The Thirty-six Immortals of Poetry,
dated 1845

Signature: *Seisei Kiitsu*
Seal: *Shukurin*
Hanging scroll with painted mounting;
ink and colour on silk, 190.0 x 70.3 cm

A painting combining in one composition portraits of the so-called 'Thirty-six Immortals of Poetry' (*Sanjū-rokkasen*) of classical *waka* verse, as selected by Fujiwara no Kintō (966–1041) in *c.* 1009–12. Not only the central area with the portraits of the poets, but also the entire surrounding area of the scroll – what at first glance appears to be a brocade mount – has in fact been hand-painted by the artist.

A group portrait of the thirty-six poets, of similar composition and treatment on a two-fold screen, was a subject painted by each successive generation of Rimpa artists, probably beginning with Kōrin and continuing through his pupils and on to Hōitsu. In this instance the composition has been modified slightly to fit the format of the vertical hanging scroll, and a number of similar versions by Kiitsu are known.

The painted 'mount' in this example is particularly striking, the artist having been free to choose different colourful patterns for its various parts (*ichi-monji*, *chū-mawashi*, *tenchi*, etc.) and even for the two vertical 'hanging' *fūtai* at the top. The brilliant detail of the so-called 'Shu brocade' (or 'Shujiang', *Shokkō*) geometric pattern immediately surrounding the central area (*chū-mawashi*) contrasts effectively with the elegant beauty of the fans scattered on a stream (*ōgi-nagashi*) in the top and bottom sections (*tenchi*). These reveal the true inventiveness of the artist, who specialised in painted mounts of this kind, experimenting frequently with novel and unusual ideas in this way.

An inscription by Kiitsu on the accompanying paulownia wood storage box says that the painting was done on the first day of the third month, Kōka 2 (=1845). Another box inscription in a different hand says that the painting was formerly in the collection of one Shioda Yōan.

51 Suzuki Kiitsu

Handscroll of miscellaneous subjects,
c. Bunsei (1818–30) era

Signature: *Kiitsu hitsu*
Seal: *Joun*
Handscroll; ink on paper, 29.4 x 802.5 cm

An illustrated handscroll in which the motifs have been most evocatively rendered entirely in light and dark shades of *sumi* ink. A total of twenty-five subjects are depicted, mostly consisting of flowers and grasses of the four seasons. However, the unexpected appearance in the middle of the scroll of three unrelated subjects – the lucky god Fukurokuju, a crane and a turtle – suggests that this was originally produced as a model for students to copy (*e-dehon*), and not simply as a handscroll of flowers and grasses.

The paper of the handscroll is lightly sized, but it appears that the artist anticipated a blurring of the ink in certain areas which were left deliberately unsized – achieving an expressive effect akin to the *tarashikomi* technique used in full-colour Rimpa painting. The brush is handled with extraordinary bravura and confidence; indeed, this is a fine example of the striving for beauty of line and ink tonality which came to constitute in itself one of the main preoccupations of the Edo Rimpa school.

The various plants – Adonis flower (*fukuju-sō*), plum, dandelion, sometimes a branch plucked from a tree – are skilfully orchestrated so as to appear in a wonderfully satisfying rhythm as the scroll unfurls. The handscroll can be dated early in the artist's career during the Bunsei (1818–30) era, quite close to *Rose mallows* (cat. no. 49).

52 Hara Yōyūsai (d. 1845), Sakai Hōitsu
and others

Design books for lacquer wares,
dated 1841 and 1843

Five volumes; ink and occasional colour
on paper, each *c.* 31.6 x 22.2

It has long been known that Sakai Hōitsu provided many designs for the lacquer craftsman Hara Yōyūsai. Indeed, quite a few lacquer pieces in *maki-e* (sprinkled design) technique survive, attesting to the collaboration between artist and craftsman.

Yōyūsai set up a studio which is said to have had the express aim of applying Rimpa designs to the production of pieces of *maki-e* lacquer, and this can indeed be deduced from the albums of preparatory drawings formerly owned by him. Three groups of such albums are known: one volume in the Museum of Fine Arts, Boston; one volume in the Yamato Bunkakan, Nara; and the present five volumes in the Idemitsu Collection. It is likely that these represent only a fraction of Yōyūsai's original reference collection, which has now become scattered. The albums feature on each page preparatory drawings by Hōitsu, Kiitsu and others for *maki-e* lacquer pieces such as *inrō* (medicine cases), saké cups and hair-combs, as well as other kinds of sketches. In addition to demonstrating that Hōitsu and the other Edo Rimpa artists produced large numbers of designs for works of applied art by Yōyūsai, they also provide evidence of detailed discussions between Hōitsu and Yōyūsai. In four out of the five Idemitsu volumes, three different dates appear: 5th and 8th months, 1841, and 7th month, 1843.

The albums of preparatory designs enable us to reconstruct the process whereby Hōitsu produced a wide variety of designs for *maki-e* lacquer pieces to the request of patrons, notably for the households of feudal lords related to the ruling Tokugawa dynasty (*shimpan daimyō*), or for those lords who were historically their close allies (*fudai daimyō*). In addition it is fascinating to see how Hōitsu and the later generations of Rimpa artists devoted themselves to the production of designs for three-dimensional objects in just the same way as their predecessors in the earlier Rimpa tradition, who had been so well versed in all the arts.

53 Nonomura Ninsei (worked second half of the seventeenth century)

Tea storage jar with a design of poppies, second half of the seventeenth century

Overglaze and gold enamels, height 42.4 cm
Important Cultural Property

More than 40 centimetres tall, this is the largest of the tea storage jars made by Ninsei, its relaxed shape formed on a wheel. The body is of rough clay from Shigaraki which has been covered all over in white slip, and onto this have been painted bright poppies, creating a lively rhythm with their various heights. In particular, the red of the poppies and the green of the leaves were applied using the *tarashikomi* technique unique to the Rimpa school, which produces a contrast between thick and thin areas of glaze. Indeed, it is sometimes suggested that the design may have been created with the assistance of a painter of the Sōtatsu school. Cut gold leaf squares have been fired onto the shoulder and cloud-shaped areas of black enamel applied around the base.

54 Attributed to Hon'ami Kōetsu

Incense container with a design of a rabbit and grasses, early seventeenth century

Red Raku ware, diameter 8.5 cm
Important Art Object

As well as being a great calligrapher, celebrated as one of the 'three great brushes of his age', Hon'ami Kōetsu also showed a rare ability in the fields of ceramic and lacquer production. He is thought to have begun making ceramics after the grant of land at Takagamine by Tokugawa Ieyasu, from 1615 onwards. The most common type of ware he produced was Raku, under the guidance of the second- and third-generation heads of the Raku lineage, father and son Jōkei and Dōnyū (Nonkō). Working in red, black and white Raku ware, Kōetsu was particularly skilled at creating tea bowls.

This incense container, with its cleverly contrived construction, certainly has elements in common with the style of Kōetsu's tea bowls. The lid is decorated with a rabbit in pampas-grass, created using a combination of iron-oxide lines over areas of unglazed earthenware. It is in fact rare to find a ceramic by Kōetsu with a pattern or design such as this. The shape is moulded by hand and the surface has been boldly scraped with a spatula, creating a number of uneven, slanting planes. The spatula has also been used to create a clear ridge line around the body of the vessel.

Kōetsu received instruction in the tea ceremony from the tea master Furuta Oribe (1543–1615) and this incense container displays the freedom of modelling typical of so-called 'Oribe taste'. An inscription on the outer box suggests that the piece, which was formerly in the collection of Matsudaira Fumai (1751–1818), later passed into the collection of Hara Tomitarō (Sankei, 1868–1939).

55 Ogata Kenzan

Lidded box with a design of pine trees and waves, Hōei (1704–11) era

Signature: *Kenzan*

White slip, underglaze cobalt-blue, overglaze gold and silver enamels, 23.4 × 23.8 cm (lid), 20.3 × 20.7 cm (box)
Important Cultural Property

This is the most famous of the group of lidded boxes created by Kenzan and is generally considered his masterpiece among works of this kind. The shape imitates a lacquer box, but since the lid is considerably larger than the body, the piece was clearly intended for display rather than practical use.

The natural coarseness of the clay is exploited on the outer surface of the box, over which is painted a group of pine trees in white slip, underglaze cobalt-blue and overglaze gold and silver enamels. Unlike his predecessor Ninsei (cat. no. 53), Kenzan made little use of overglaze silver enamel decoration, which has a tendency to tarnish black; this is a rare instance of his having employed it. The inside of the lid and body is covered in white slip, over which is painted a design of waves in underglaze cobalt-blue and gold. The wave pattern is skilfully painted with a dynamic touch, leading to the suggestion that it may have been done by Kōrin. The pines, by contrast, are painted in a somewhat rougher manner and are more likely to be by Kenzan himself. The box is designed in an ingenious way, so that the images on the lid and in the interior combine to form what is normally the single painting composition of 'pine trees on a seashore' (*hamamatsu zu*), such as also seen in the pair of *Pine-islands* screens by Sōtatsu (fig. 6).

The 'Kenzan' signature is written in large iron-oxide characters in the middle of the base of the piece. According to Nagoya Akira, whose chronology of Kenzan's works has been followed in dating the pieces in this catalogue, this is typical of the period around the Hōei (1704–11) era (see Nagoya Akira, 'Tōki ni okeru "Kenzan" mei ni tsuite', in Gotō Bijutsukan (eds), *Kenzan no tōgei*, Tokyo, 1987).

56 Ogata Kenzan

Bowl with a design of pampas-grass and butterflies, Hōei (1704–11) era

Signature: *Kenzan*

White slip and underglaze cobalt-blue, diameter 23.2 cm, height 7.4 cm

The somewhat coarse body has been fired at a high temperature and the piece is similar in technique to a group of lidded boxes by Kenzan, epitomised by cat. no. 55. The butterflies and some of the pampas-grass were first painted in white slip and further pampas-grass was then added on top in underglaze cobalt-blue. The pampas-grass is expressed simply by means of highly decorative curving lines, but these are made to overlap and tangle so as to evoke the image of a moor in autumn extending far into the distance. The grasses continue around the outside edges of the bowl, but the top part of the interior has been left blank, so as to open up resonating space within the structure of the design.

Attention should be drawn to similarities with a lidded box with a design of pampas-grass in the collection of the Suntory Museum of Art, Tokyo. Although the design on both pieces is similar, the lines of the curved leaves on the present bowl are shorter and more incisively drawn, evoking a greater sense of movement than on the lidded box.

The 'Kenzan' signature is written in

iron-oxide in the centre of the base. This signature is almost identical to that on the Suntory box and both suggest a date around the Hōei (1704–11) era.

57 Ogata Kenzan

Bowl with a design of flowing water, first half of the eighteenth century

Signature: *Kenzan*
White slip and underglaze cobalt-blue, diameter 23.2 cm, height 11.3 cm

The somewhat coarse body has been fired at a high temperature. The design is of so-called 'Kōrin waves' painted daringly on both the inside and outside. The area of the water was first prepared with a layer of white slip and the eddies then painted in cobalt-blue. These cobalt-blue lines are thick and somewhat rough, certainly not fluent, and seem to have been done by someone inexperienced in applying decoration to ceramics. The rim, too, has been enlivened by wave-shaped cutting.

The 'Kenzan' signature is written in iron-oxide in the centre of the base and perhaps suggests a date around the Hōei (1704–11) era. The construction of the piece, a fairly deep bowl with a flared mouth and figurative cutting around the rim, is similar to that of the bowl in cat. no. 63.

58 Ogata Kenzan

Bowl with a design of maple leaves on the Tatsuta River, first half of the eighteenth century

White slip, low-fired underglaze cobalt-blue and iron-oxide and overglaze polychrome enamels, height 19.2 cm, diameter 7.5 cm

Bowls with flared mouths incised with irregular shapes seem to have been a particular type devised by Kenzan, and they are generally referred to as 'flared bowls' (*sori-bachi*) or 'incised bowls' (*sukashi-hachi*). In addition to the present example of fallen autumn maple leaves on the Tatsuta River, a group of similar bowls are known in which the designs are derived from various motifs – Mt Yoshino, snow-covered pines, wisteria, maple leaves, blossoming kerria, chrysanthemums, etc. The unusual manner in which the shapes of the vessels have become part of the design concept is particularly prized.

The sides of the present vessel have been covered in white slip and waves picked out in cobalt-blue and black enamel. Between these waves are floating maple leaves in red, yellow and green enamels. The 'Kenzan' signature on the base is written in large, iron-oxide characters inside a white cartouche also outlined in iron-oxide, and has every indication of having developed into a kind of trade mark. This suggests a date after the move of the kiln to Nijō Chōjiya-chō in 1712. Another pierced bowl of almost the same shape, also with a design of maple leaves on the Tatsuta River, is in the collection of the Manno Art Museum, Osaka.

59 Ogata Kenzan

Set of square dishes with designs of birds and flowers of the twelve months, late Genroku (1688–1704) or early Hōei (1704–11) era

Signature: (twelfth month, on base) *Kenzan Shinsei sho*, with handwritten seal (*kaō*)
Overglaze enamels, each *c*. 17.0 x 17.2 cm

A set of twelve square dishes, each with a design on the front based on *Square paintings of birds and flowers of the twelve months to accompany poems by Teika* by Kanō Tan'yū (1602–74), and two *waka* poems inscribed on the back. At least four sets of twelve dishes based on this source are known, the most important of which is in the collection of the MOA Museum of Art, Atami, dated 1702. Kenzan seems to have been particularly fond of poems by Fujiwara no Teika (1162–1241) on the theme of the glories of the passing seasons in Japan and also did many paintings on the same subject.

The designs on the dishes can be divided into two groups, those in Kanō style (first, third, fifth, eighth, tenth and eleventh months) and those in Rimpa style (second, fourth, sixth, seventh, ninth and twelfth months), and the patterns on the outside edges divide into the same two groups. It is thought that the proportion of works with decoration in Kanō style was higher during the first half of the period of Kenzan's activity at the Narutaki kiln (1699–1711), that is to

say, before his elder brother Kōrin began to assist him. The *waka* poems on the back of each dish appear to have been inscribed by Kenzan himself in the deliberately decorative manner of 'scattered writing' (*chirashi-gaki*). However, the style of this calligraphy lacks the sense of innovative urgency seen on the group of dishes in the MOA Museum of Art, and the present group should thus probably be dated slightly later than 1702.

60 Ogata Kenzan (dish and calligraphy) and Ogata Kōrin (painted design)

Square dish with a design of bamboo, Hōei (1704–11) era

Signatures: *Kōrin ga*; *Kenzan Tōin Shinsei sho*
Seals: *Kenzan*, *Tōin*, *Shōko*
Underglaze iron-oxide, 22.0 x 22.0 cm

Several characteristics of this piece confirm that it originally formed part of a set, ten pieces of which are in the collection of the Fujita Art Museum and have recently been designated as an Important Cultural Property. These are: the patterns on the rim (plum on the inside, segmented flower design and lattice on the outside); the seals ('Tōin' and 'Shōko', both applied with a stencil and both upside down); and the similar size. At present thirteen pieces from the set are known, including the group in the Fujita Art Museum, but an inscription on a box accompanying the Fujita pieces makes it clear that it was originally a set of twenty dishes.

The dish is slab-built into a perfect square, and covered with white slip. The result could be described as a ceramic version of the square format for painting and calligraphy (*shikishi*), for which Kōrin supplied an iron-oxide design executed in the manner of an ink painting, and Kenzan wrote the inscription. This refined combination of calligraphy, painting and ceramic – on the model of scrolls by literati which combined poetry in elegant calligraphy with painting – was one of Kenzan's unique contributions to the history of ceramic production. The design, dominated by the trunks of the bamboo, surely owes much to the example of Sōtatsu's underpaintings in gold and silver (cat. nos 13, 14), but the incisive brushwork, skilfully

modulating the light and dark tones of the glaze, is quintessentially Kōrin. Kenzan's Chinese-style couplet describes how rain washes [the bamboo] clean and pure, while the breeze wafts a delicate fragrance from it.

61 Ogata Kenzan (dish and calligraphy) and Ogata Kōrin (painted design)

Square dish with a design of autumn flowers and grasses, c. Hōei (1704–11) era

Signatures: *Kōrin ga*; *Kenzan Shinsei sho*
Seals: *Tōin, Shōko*
Underglaze iron-oxide, 22.1 x 22.0 cm

This dish, like cat. no. 60, is thought to belong to what was originally a set of twenty dishes, ten of which are now in the collection of the Fujita Art Museum. However, it has been pointed out that there is a portion missing from the stencil-applied 'Shōko' seal (near the left end of the top), suggesting that this piece may have been produced slightly later than the others.

The hand-written seal (*kaō*) used by Kōrin on this set of dishes (said to be a stylised version of the character *kotobuki*, 'long life') is different in form from the highly abbreviated one used by the artist during his time in Edo (*c.* 1704–9). Additional factors, such as Kōrin's use of the 'Hokkyō' title on some of the Fujita pieces and the general style of the painting, suggest that the dishes were produced during the period after Kōrin returned to live in Kyoto, *c.* 1710.

The design, executed in gentle brushstrokes, shows chrysanthemums and pampas-grass laden with late autumn dew. In contrast to Kōrin's expansive painting, the inscription by Kenzan appears somewhat self-effacing, written with relatively small characters. The Chinese-style couplet describes how, by hiding deep among the flowers, the damp dew imitates the depths of autumn.

All in all, this group of dishes represents a high point in the collaboration between Kōrin and Kenzan.

62 Ogata Kenzan

Incense burner with lid in the form of a Chinese lion, c. 1715

Signature: *Kenzan Shisui Shinsei sho*
Seals: *Kenzan, Shōko, Tōin* (all handwritten)
Underglaze iron-oxide, height 27.0 cm

A piece in the so-called 'Painted Korean' style (*e-gōrai*, actually based on Chinese Cizhou ware), with all-over white slip over which are painted designs in iron-oxide. The grand chrysanthemum and cloud patterns that spread over the whole vessel are further enhanced by the bold use of scratched-away lines within each motif. The shape is created in a mould, ensuring that there are no irregularities, and overall the piece has a very high degree of finish for a ceramic vessel. In particular, the Chinese lion-shaped knob on the lid is full of life and energy, attesting to the high level of carving and modelling skills practised by the artisans in Kenzan's workshop.

A very similar Chinese lion incense burner in the collection of Stanford University, USA, bears the date 1715 and it is likely that the present piece was made about the same time, during the period of Kenzan's Nijō Chōjiya-chō kiln. From a later painting, *Self-portrait, purchasing a Chinese lion incense burner by Kenzan* (Idemitsu Museum of Arts) by the Nanga school painter Tanomura Chikuden (1777–1835), and the contents of the inscription on that work, we know that Kenzan's Chinese lion incense burners were particularly prized by literati. The seven-character Chinese-style couplet inscribed by Kenzan on the back of the piece compares the awesome anger of a captured bear to the magnificent spirit of running tigers and leopards.

63 Ogata Kenzan

Incised bowl with a design of reeds and wild geese, Shōtoku (1711–16) or Kyōhō (1716–36) era

Signature: *Kenzan*
White slip, underglaze iron-oxide, green and gold enamels, diameter 19.6 cm, height 12.3 cm

As explained in the commentary to cat. no. 58, bowls with flared mouths incised with irregular shapes seem to have been a particular type devised by Kenzan, and they are generally referred to as 'flared bowls' (*sori-bachi*) or 'pierced bowls' (*sukashi-hachi*). A group of other similar pieces is known with painted motifs such as Mt Yoshino, pines in the snow, wisteria, autumn maples, kerria (*yamabuki*) and chrysanthemum flowers, and the elegant beauty of their design is highly prized.

The initial step in the application of the pattern was in this case to cover the entire piece with white slip. The first layer of decoration was the stylised bands of mist in iron-oxide, over which were painted reeds in overglaze green enamel and flying geese in gold enamel. The result is an elegant and highly refined example of the Rimpa style. A particularly witty touch – unique to Kenzan's ceramics – is provided by the pierced holes around the rim, which also take the form of stylised bands of mist.

The 'Kenzan' signature on the base is written in large iron-oxide characters inside a white cartouche also outlined in iron-oxide, and has every indication of having developed into a kind of trade mark. The style of the calligraphy suggests a date after the move of the kiln to Nijō Chōjiya-chō. Another pierced bowl with a design of reeds and wild geese very similar to the present piece is in the Rockefeller collection (Asia Society, New York).

64 Ogata Kenzan

Jar with a design of maple leaves,
Shōtoku (1711–16) or Kyōhō (1716–36) era

Signature: *Kenzan*

Overglaze enamels, diameter of mouth
9.0 cm, diameter of body 15.9 cm,
height 14.5 cm

Vessels with this characteristically stable
shape, where the diameter is at its
widest in the middle of the body, are
known as 'short necked jars' (*tankei-ko*)
and are relatively rare among Kenzan's
works. The body is of fine, yellowish-
grey clay, which is low-fired. White slip
was first applied all over the piece. Most
of the surface was then covered with
closely interlocking paper stencils, so as
to leave the forms of stylised maple in
white reserve against a background of
thickly applied, quite heavy green glaze.
Finally, smaller stylised maple leaves of
similar shape in red, blue, yellow and
black enamels were painted in the centre
of each of the larger maple leaves left in
white reserve. Within Kenzan's *oeuvre* it
is relatively common to find food cups
(*mukōzuke*), such as cat. no. 65, and
bowls on which patterns of camellia or
plum blossoms have been left in white
reserve against a green background.
However, no other examples are known
with such a rich colour scheme as the
present jar: the four-coloured maple
leaves floating on the white slip ground
are breathtakingly brilliant.

The 'Kenzan' signature is written on
the base in large, bold iron-oxide charac-
ters. The left and right elements of 'Ken'
spread further apart as they approach
the bottom of the character, and accord-
ing to the chronology suggested by
Nagoya Akira, this would date the piece
to the period after the move to the Nijō
Chōjiya-chō kiln in 1712. If we judge
ceramics by their shape as much as by
their decoration, the present jar should be
evaluated very highly within Kenzan's
works as a whole. Two more jars with
maple leaf decoration, of similar tech-
nique, are in the collection of the Freer
Gallery of Art, Smithsonian Institution,
Washington, D.C.

65 Ogata Kenzan

**Set of five food cups with a design of
camellia flowers,** Shōtoku (1711–16) or
Kyōhō (1716–36) era

Signature: *Kenzan*

White slip and overglaze enamels, diameter
10.8 cm, height 6.8 cm (each)

In this work a stencilling method has
been employed to apply the design, a
technique that is a particular speciality
of Kenzan's ceramics. First, white slip
was applied only to those areas which
were planned to be left in white reserve.
Paper stencils were then placed on both
the inside and the outside surfaces of the
cups, so as to make the white camellia
blossoms stand out when a thickish
green glaze was applied to the back-
ground. Finally, yellow stamens were
added to each flower, also using stencils.
The design concept is simplicity itself,
but for that very reason the contrast
between green and white is all the more
splendidly vivid, the yellow stamens
adding their own faint and delicate
beauty. The manner in which the rim of
each cup has been cut to match the pat-
tern and suggest the eight-petalled
shape of a camellia flower also reveals
an exquisite sense of taste.

Each cup bears a 'Kenzan' signature
within a vertical oblong outline, in iron
oxide. From the particular features of
the 'Ken' character, they can be dated
after the kiln moved to Nijō Chōjiya-chō
in 1712. The overall style may be
regarded as representative of the period
of increased production of Kenzan
ceramics.

66 Nin'ami Dōhachi (1783–1855)

**Bowl with a design of cherry and
maple,** first half of the nineteenth century

Seal: *Nin'ami*

Overglaze enamels, diameter 18.4 cm

Nin'ami Dōhachi was a Kyoto potter.
He learned ceramic techniques from
Okuda Eisen (1753–1811) and in 1822
was granted the 'Nin' character from the
prince-priest of Ninna-ji Temple and the
'ami' characters by the prince-priest
Daigo Sambō-in to form the name
'Nin'ami'. Of all the ceramic craftsmen
of the late Edo period he was the most
active in utilising Rimpa school designs,
mainly those in Kenzan style.

The present vessel is practically
buried in an all-over design, on both
inside and outside surfaces, of cherry
and maples. This kind of design was a
particular speciality of Dōhachi and is
known as *kumo-nishikide* ('cloud brocade
style'). There is a splendid balance
between the opposing colours of the
cherry blossom in full bloom and the
autumn maple foliage. These leaves, in
particular, have the charming shape
reminiscent of 'Kōrin-style' patterns,
and the veins of the leaves have been
incised with a needle. A square seal
reading 'Nin'ami' has been applied to
the lower outside of the bowl, and there
is a box inscription by the maker on the
top of the lid that reads: '*Kumo-nishiki*
painting, bowl, Dōhachi [seal]'.

67 Style of Ogata Kenzan

**Medicine case (*inrō*) with a design of
scattered fans,** nineteenth century

Signature: Kōrin

Overglaze enamels, 5.7 x 6.6 cm

The piece is complete, with medicine
case (*inrō*), bead (*ojime*) and toggle (*net-
suke*) all ceramic. It was produced from a
mould and low-fired. The design is of
all-over scattered fans, and inside each
fan-shape is a motif such as plum, pine
or chrysanthemum in the so-called
'Kōrin style'. It was probably made in the
late Edo period at the time of a vogue for
Kōrin-style designs. The *ojime* has a
design of Chinese bellflowers in over-
glaze enamel, signed 'Ken' (of Kenzan).
The *netsuke* is moulded in the form of an
old man encircling a crane with his arms.

1 (detail)

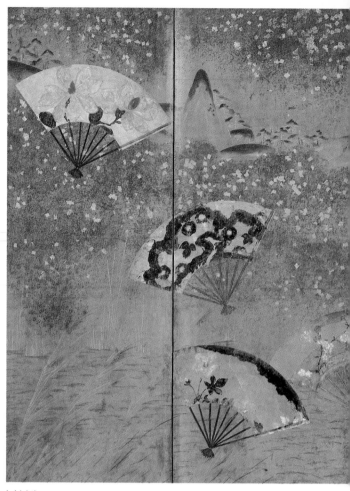

1 (right)

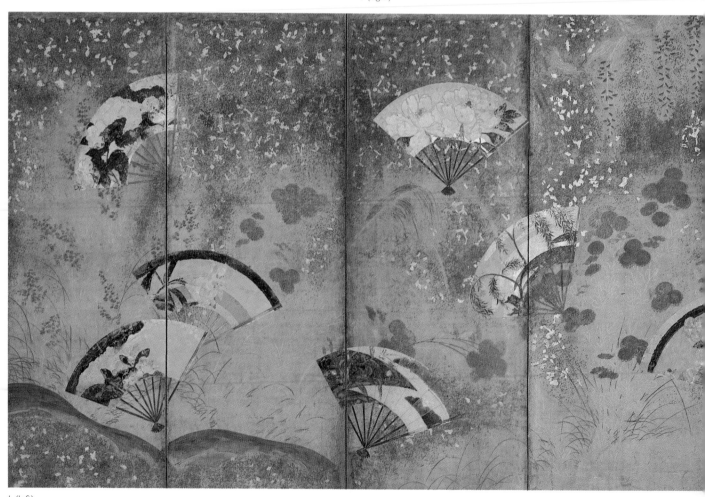

1 (left)

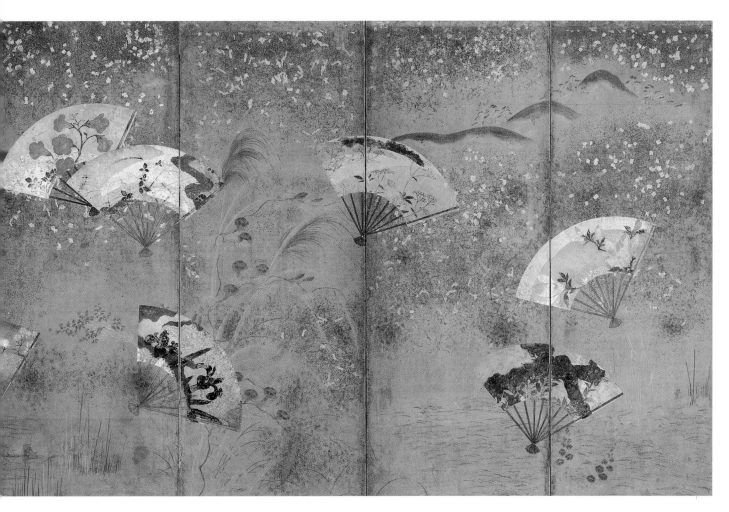

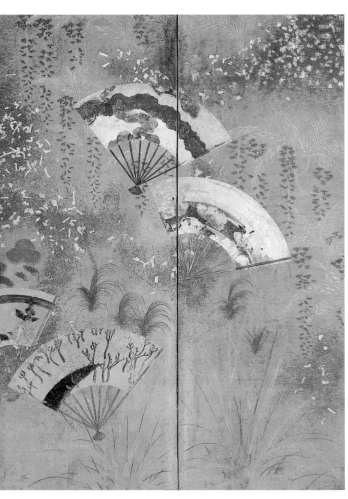

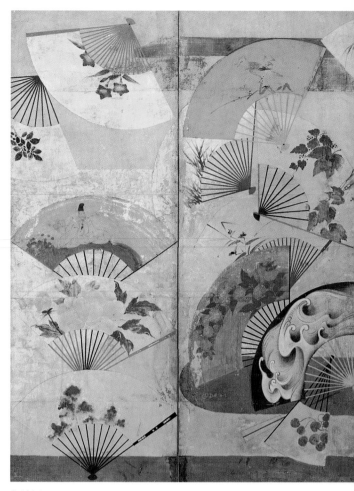

2 (right)

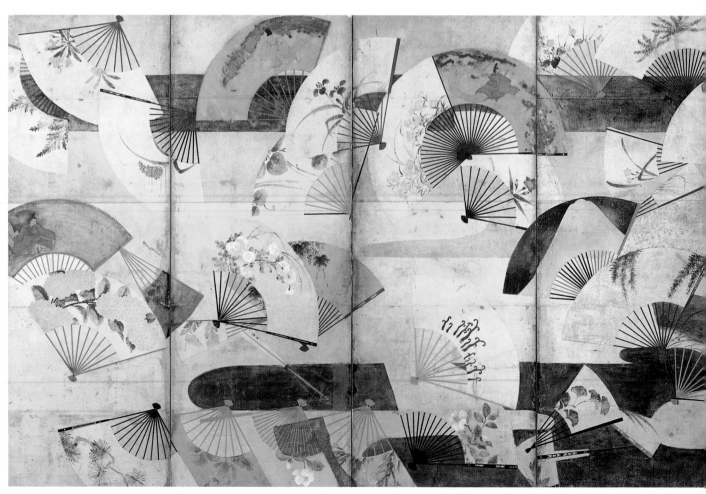

2 (left)

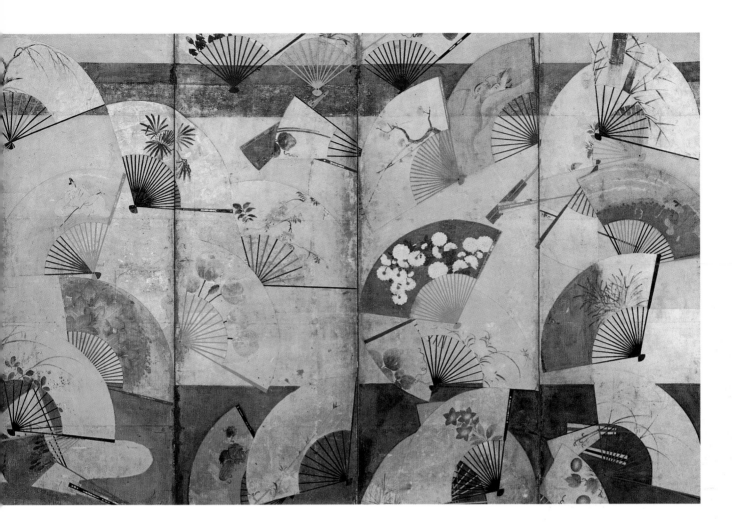
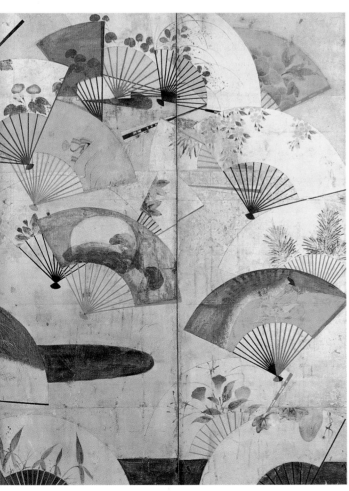

むさしのは
けふはな
やきそ
わか草の

つまも
こもれり
われもこもれり

3

4

5

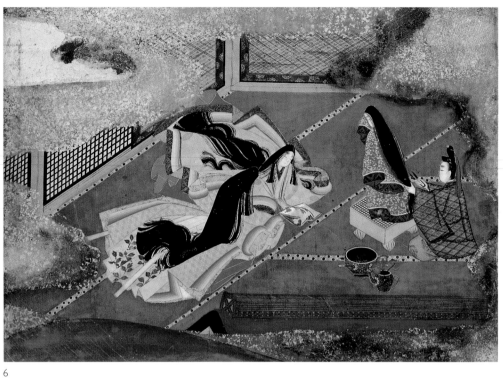

6

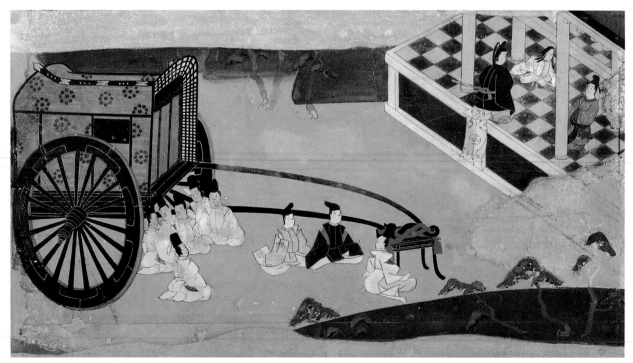

7

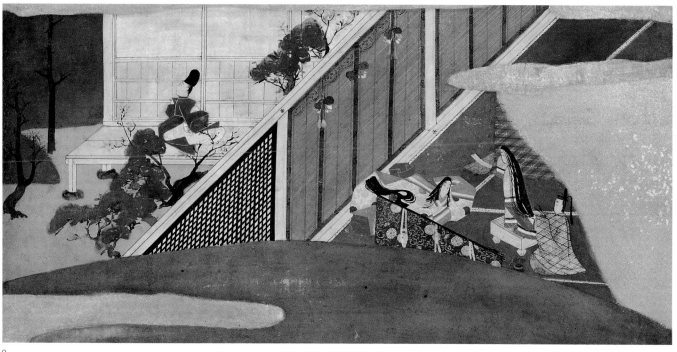

8

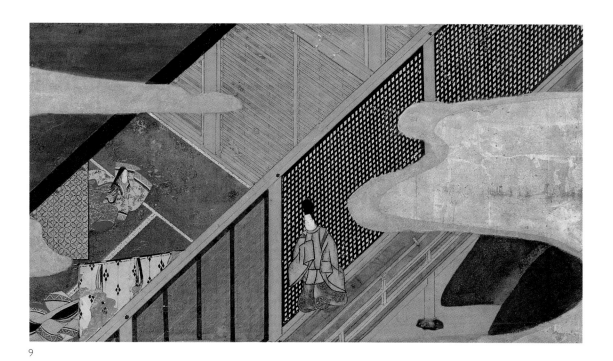

9

10

11

浮舟屋浪まよ一の戸の
りすこと竹をなう

人こゝり
平兼盛

一のぬきしくまうろ
なつ原を物やおもつゝ
人ゝのつゝて
言生せ人

ありきふことに
いまさゝ
たちゝゝ人一神に
ふうおもりうゝ加

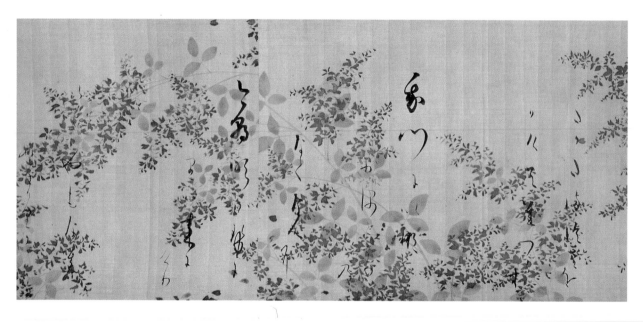

寛永五年八月日
鷹峯山大虚庵
齢七十有一

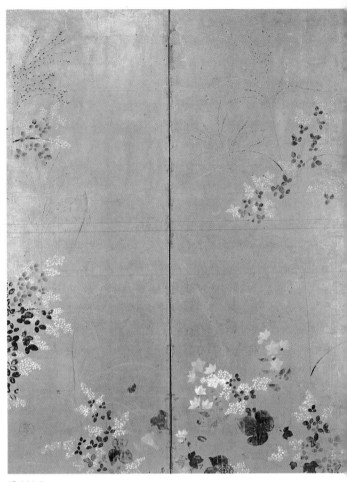

15 (right)

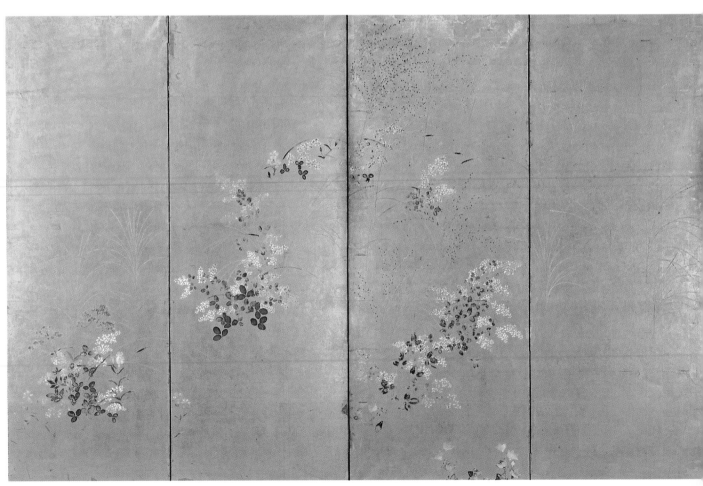

15 (left)

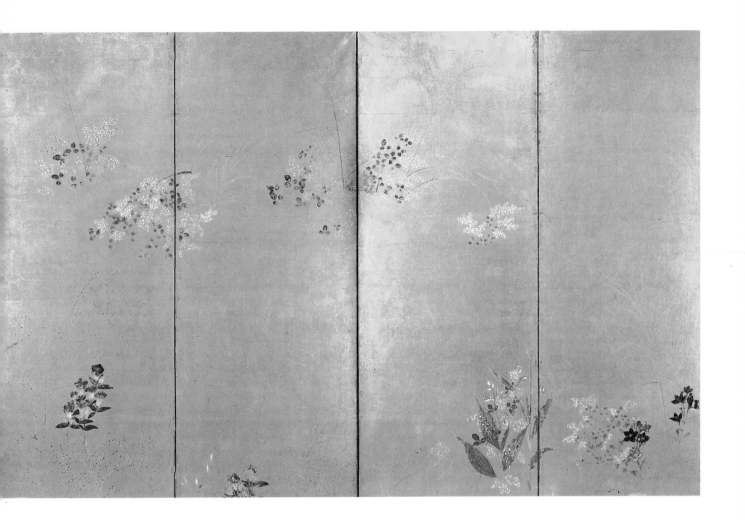

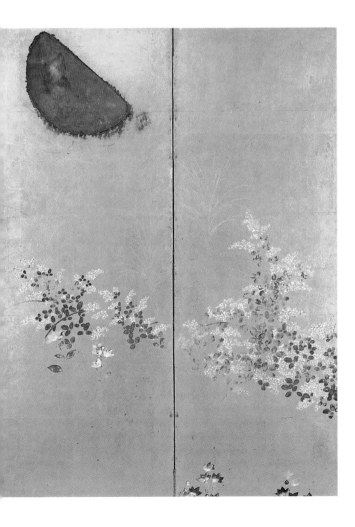

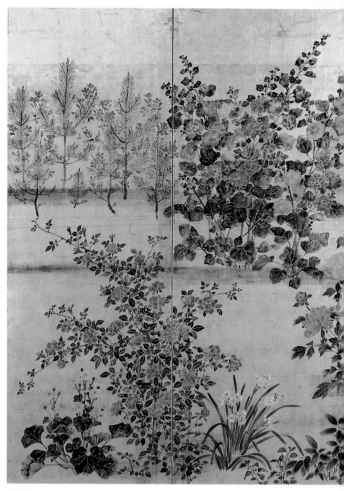

16 (right)

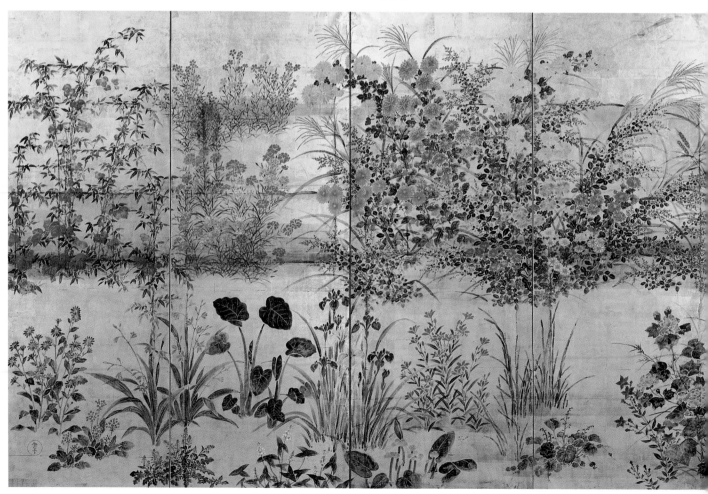

16 (left)

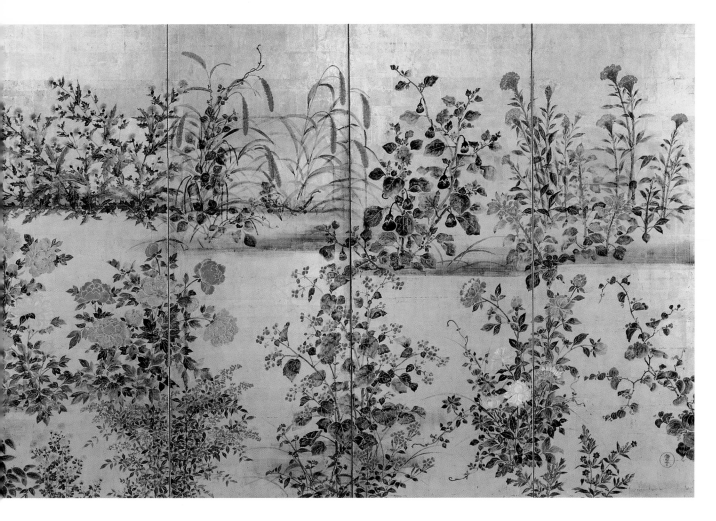

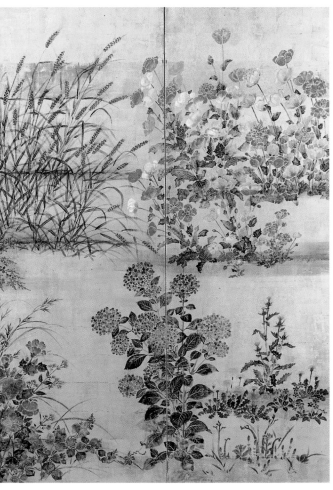

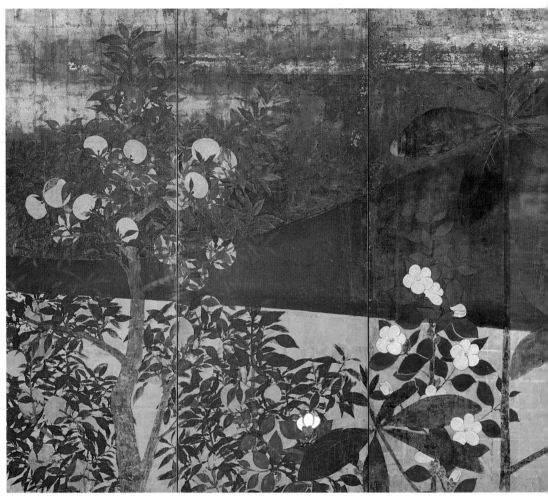

17

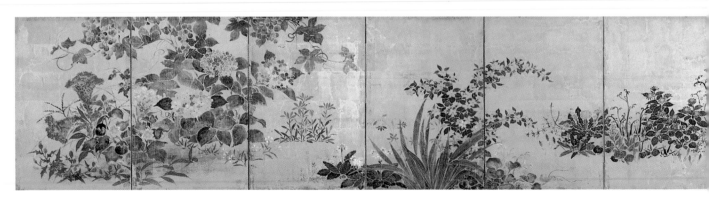

18

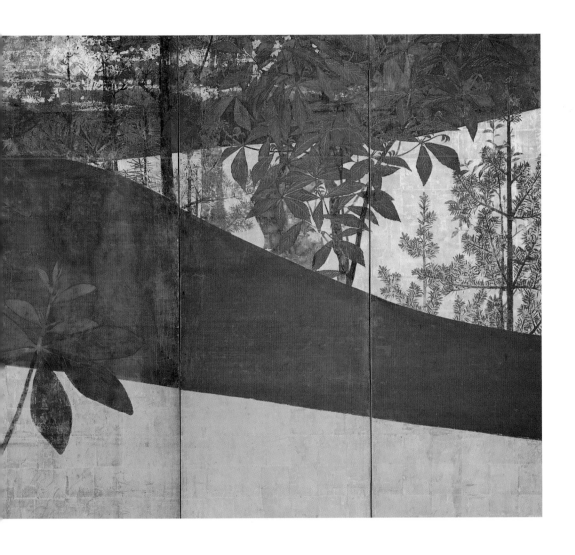
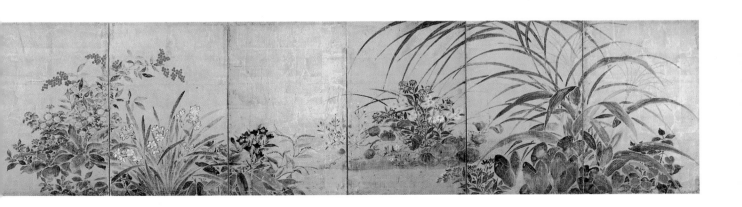

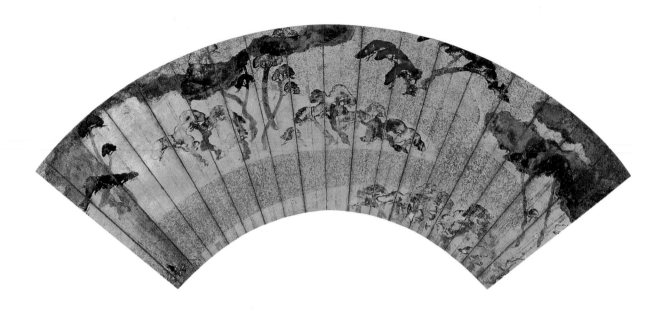

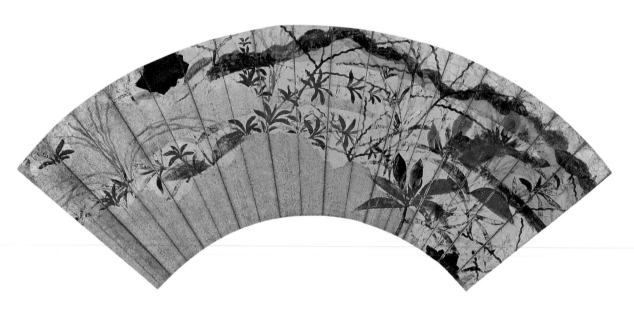

19

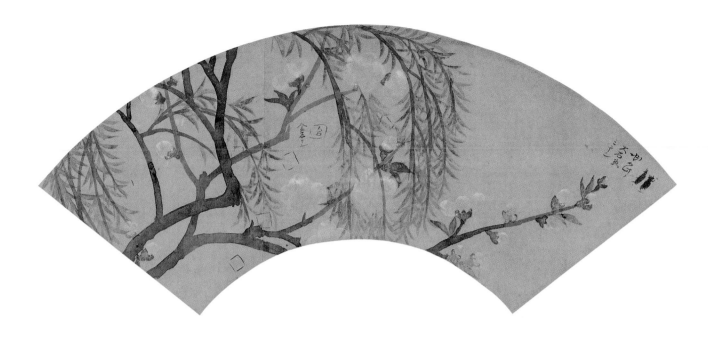

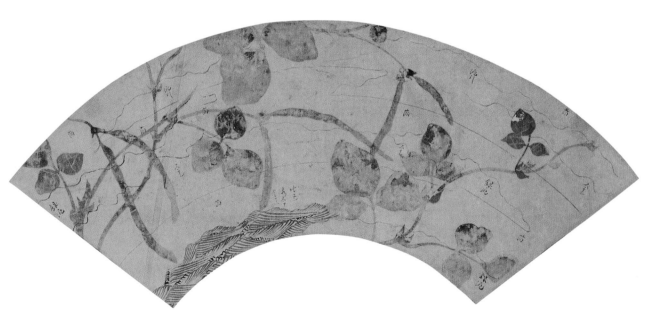

20

傳曰仁者我帝之為君也神化
宜民愛立醫道養人之大端大法
皆弦裁成天地之所未備由是樂和
之休豈果不眼其至統之流漕達
也邈乎歆哉善哉

君軍亮閣頼角謹書

21

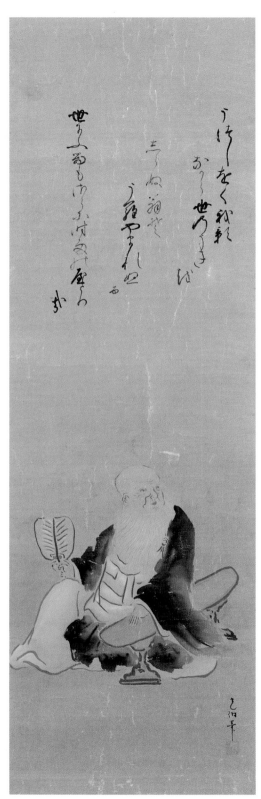

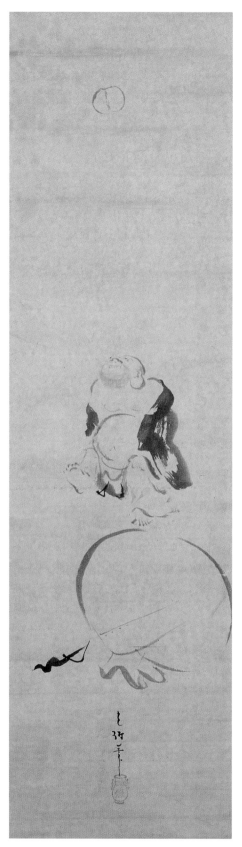

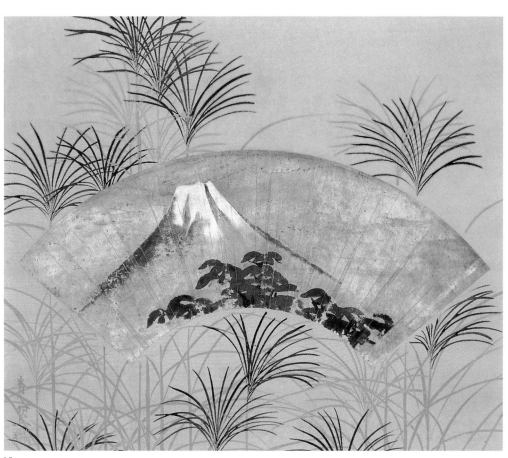

25

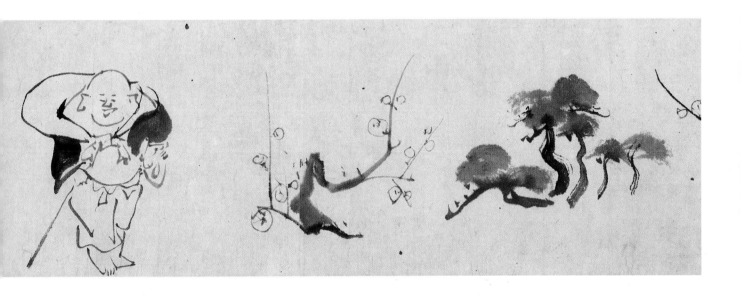

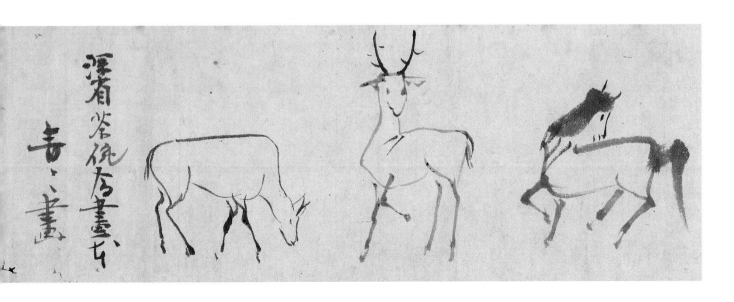

27 (right)

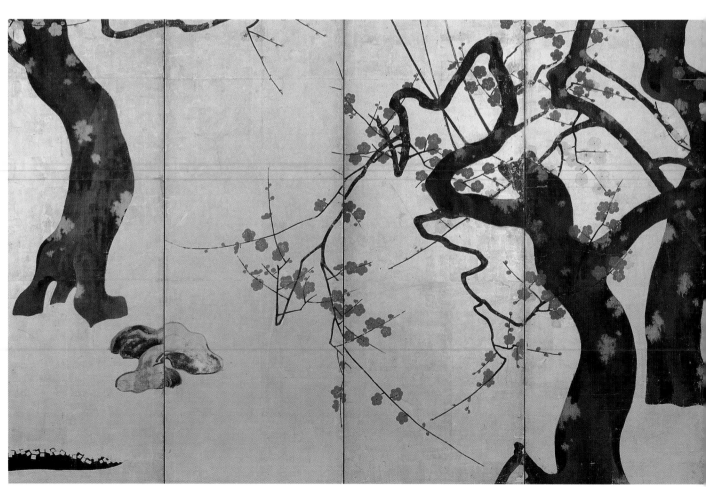

27 (left)

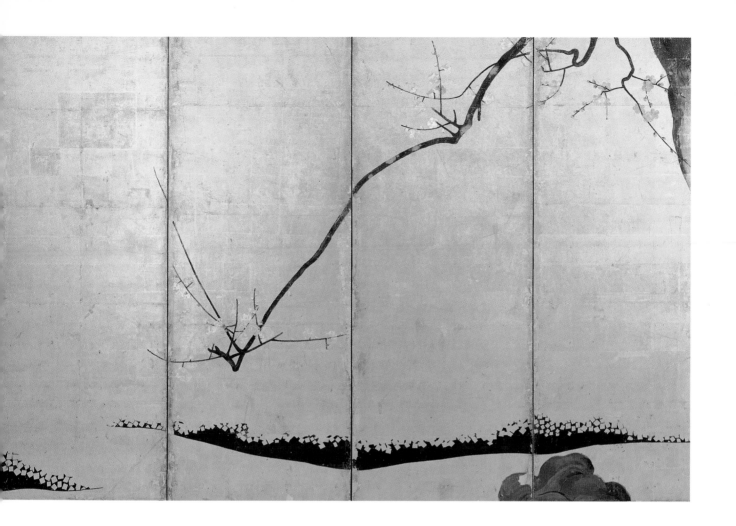
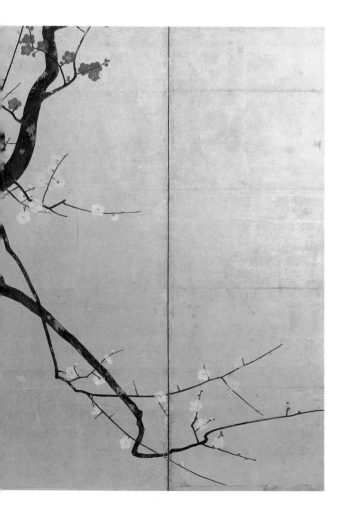

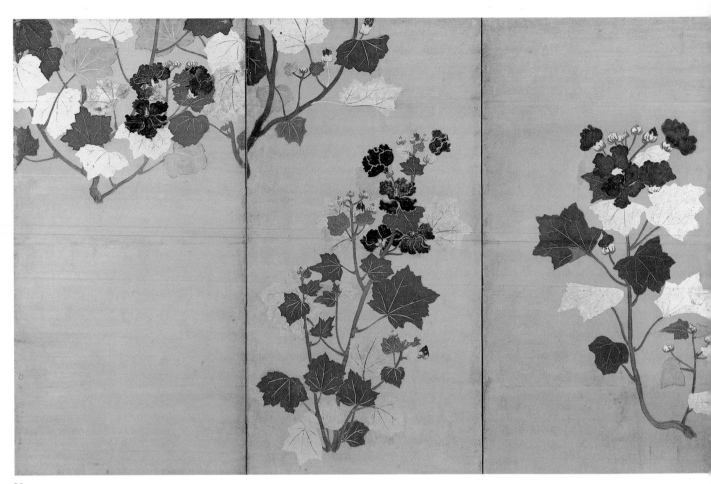

28

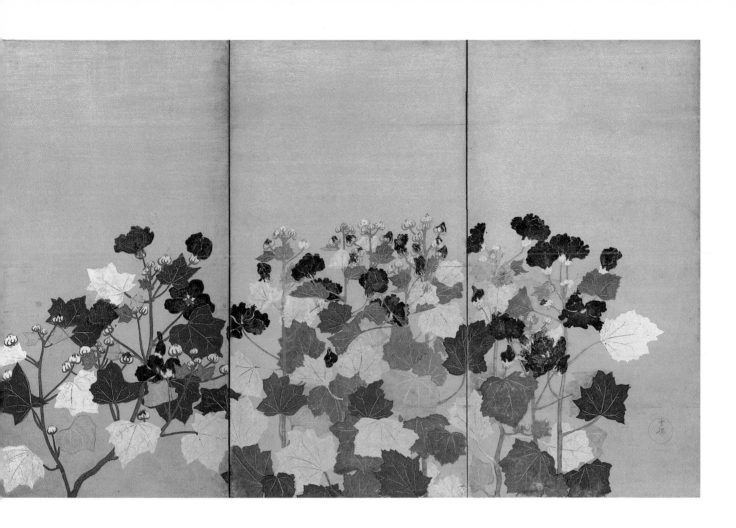

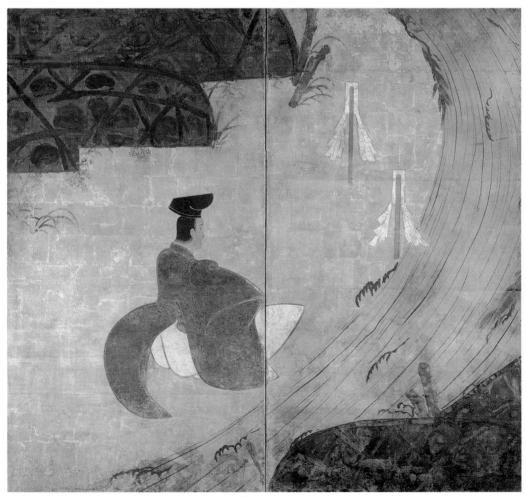

29

衰樹飄零秋雨
裡子般爛熳夕
陽中

紫翠溪道

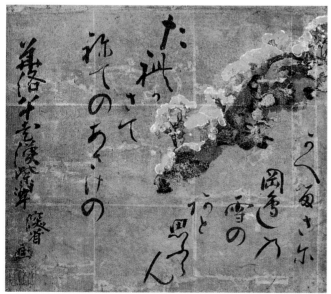

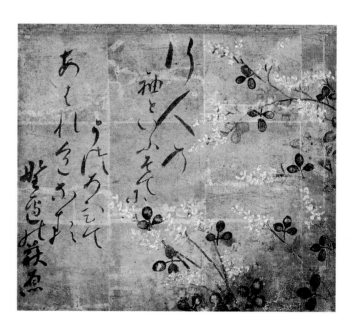

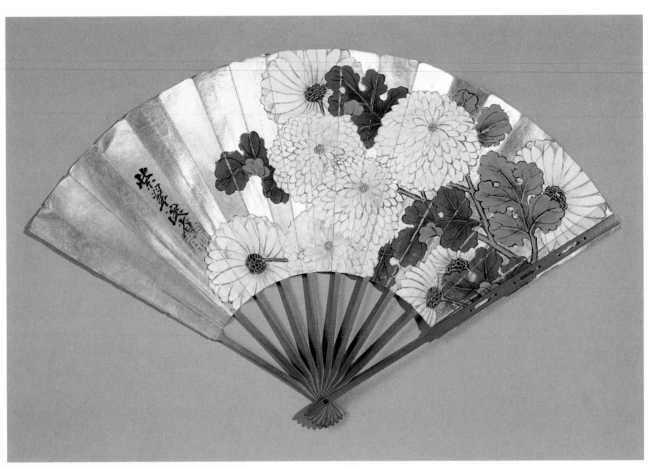

32 (back)

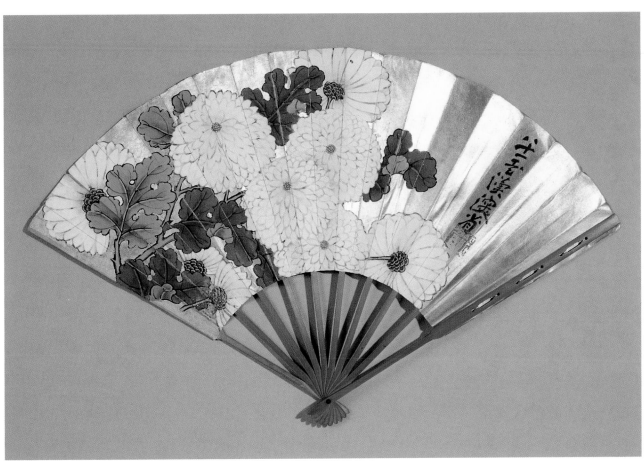

32 (front)

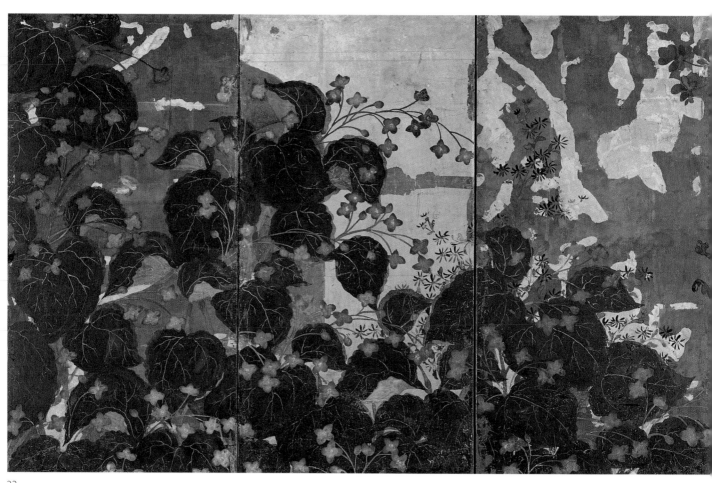

33

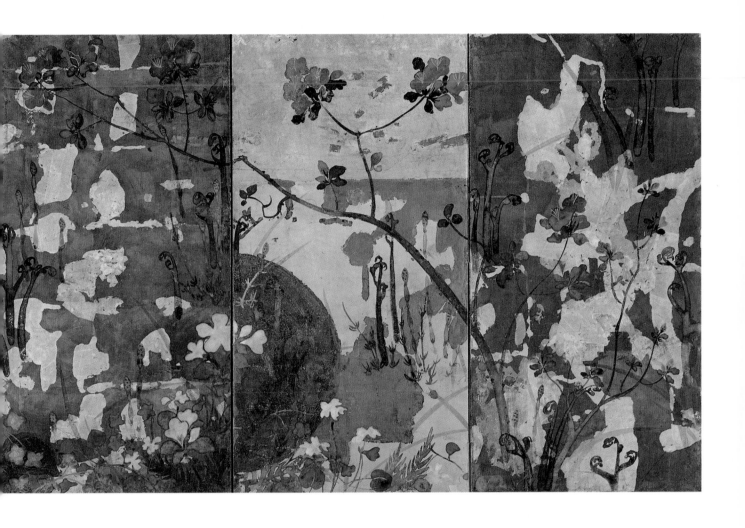

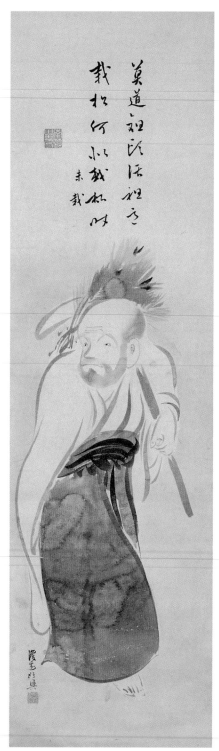

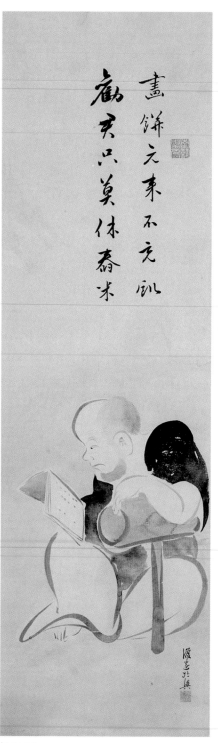

34 (left)　　　　　　34 (right)

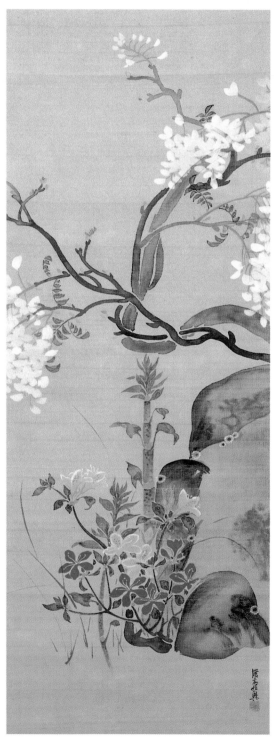

36

37

38 (left)

38 (right)

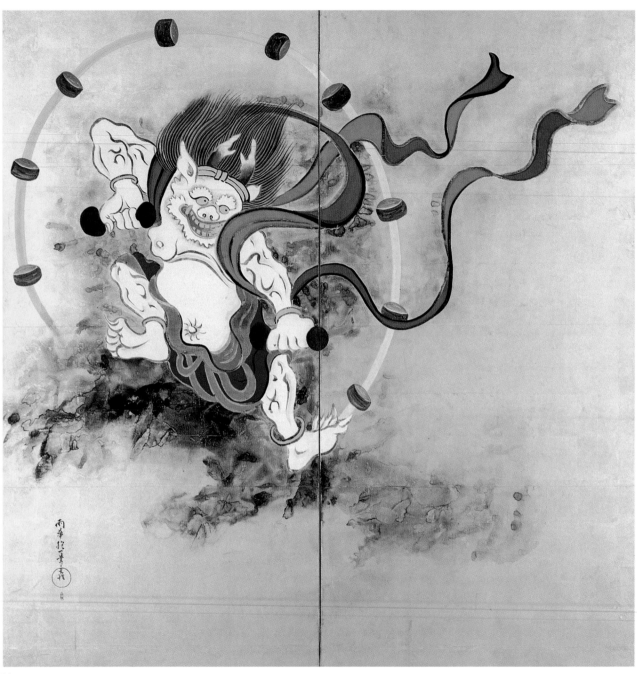

39

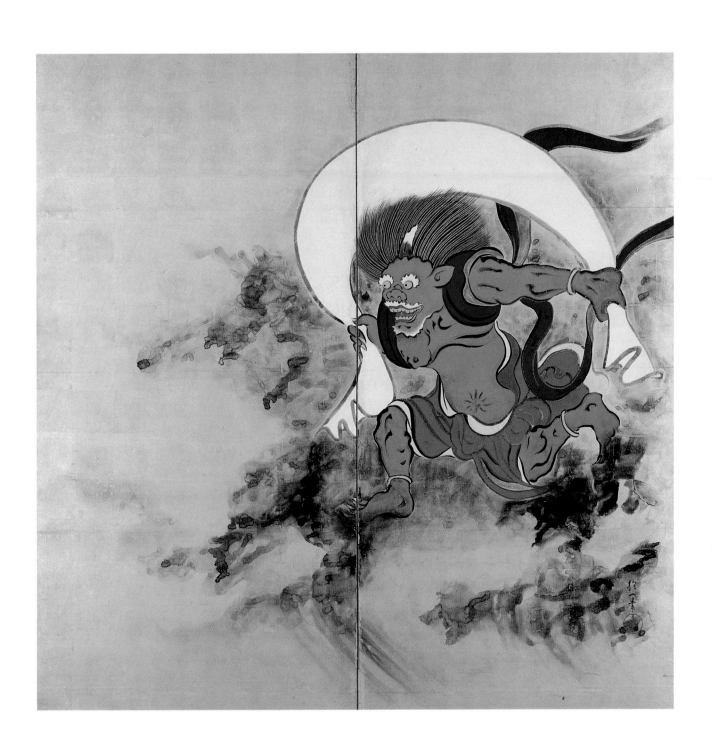

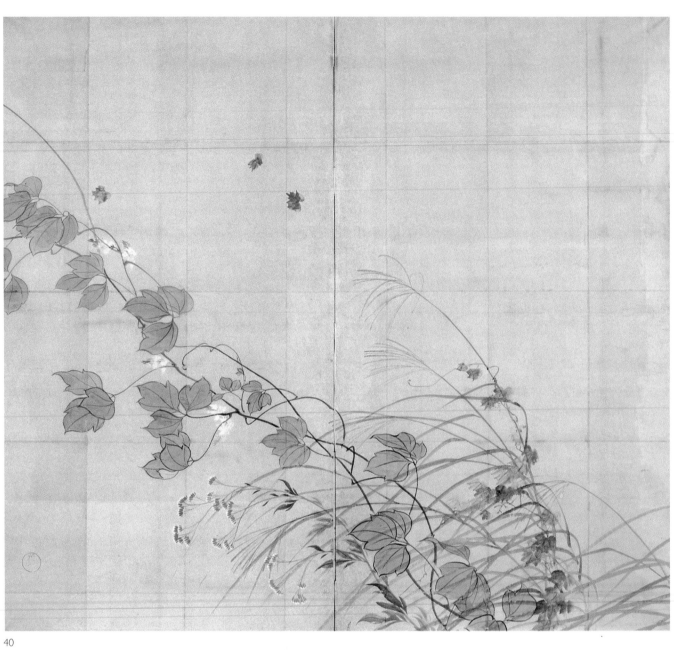

40

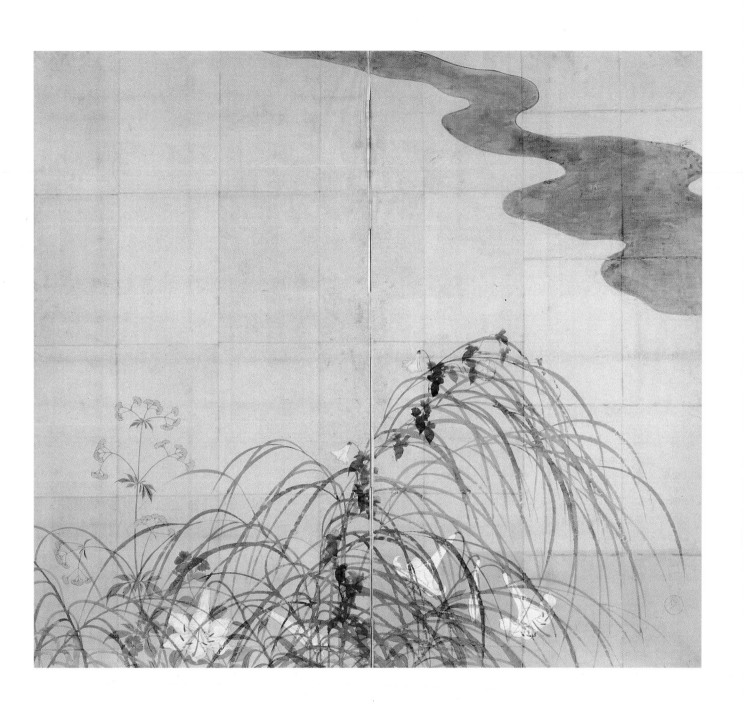

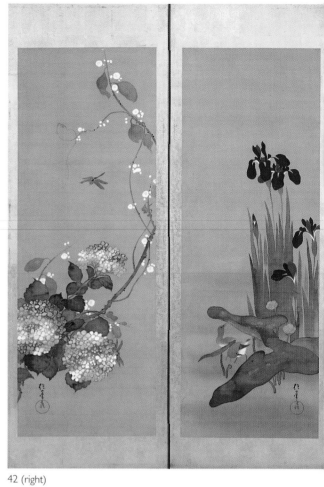

42 (right)

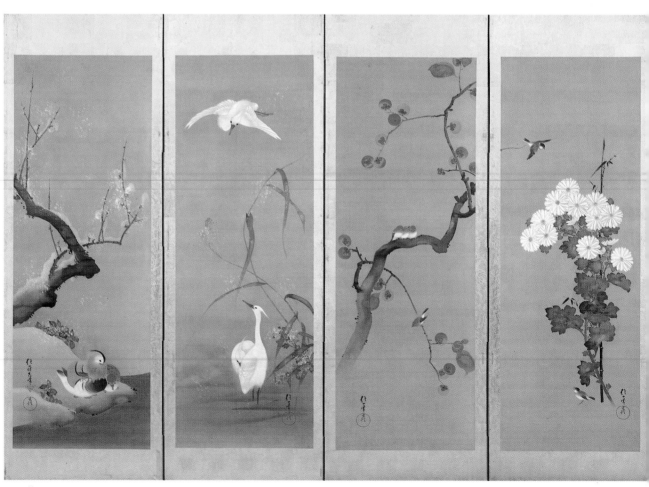

42 (left)

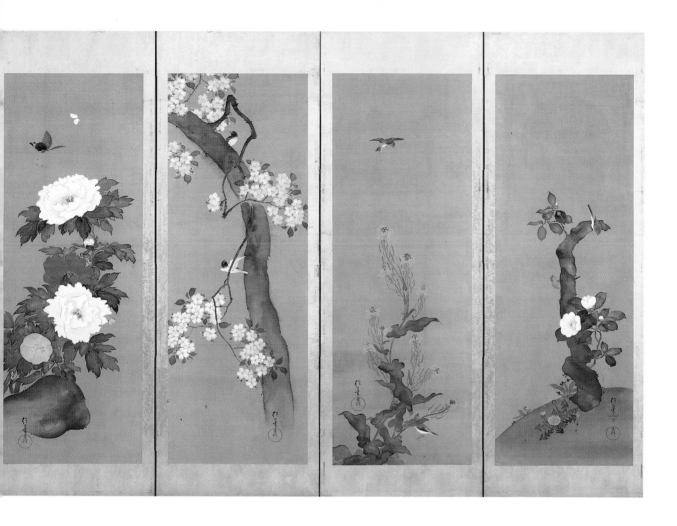
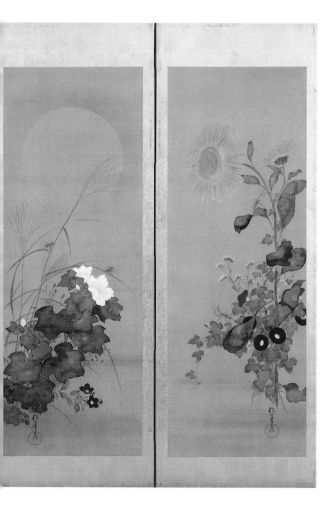

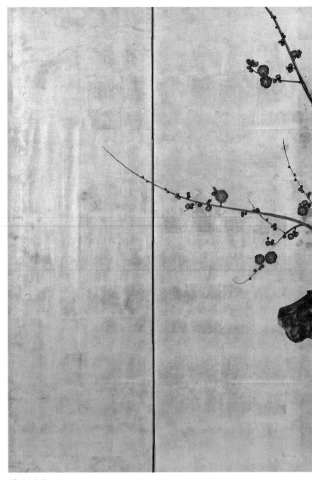

43 (right)

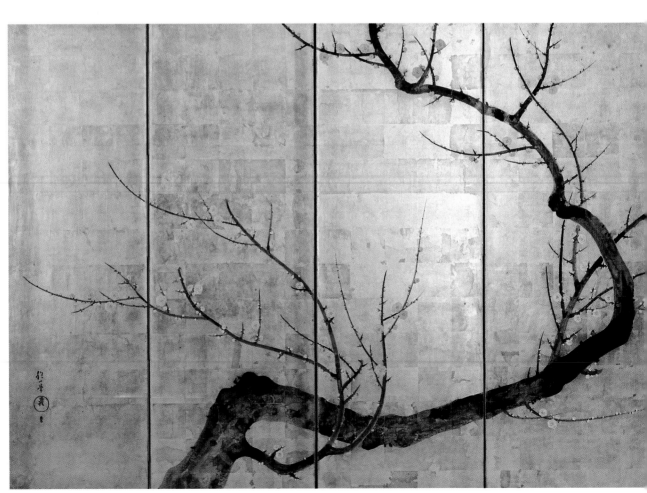

43 (left)

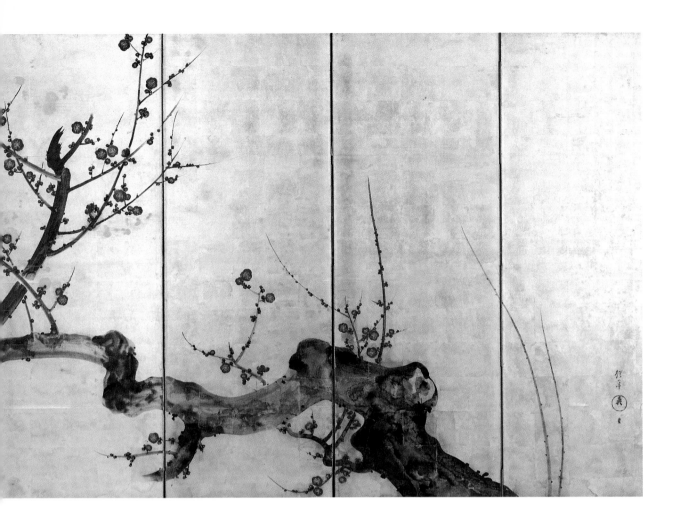

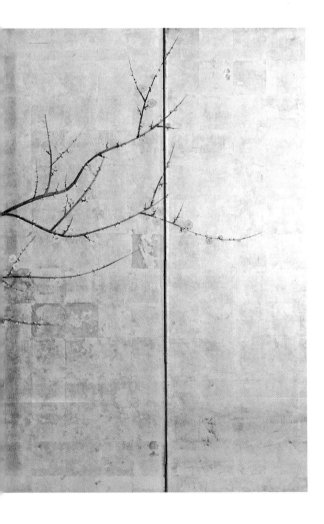

44

45

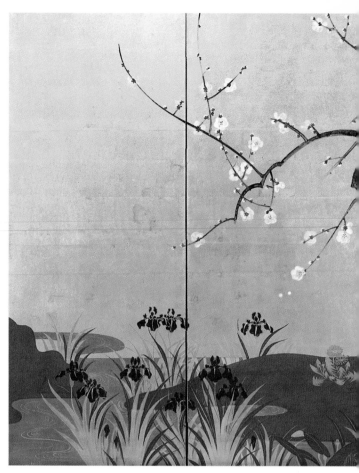

46 (right)

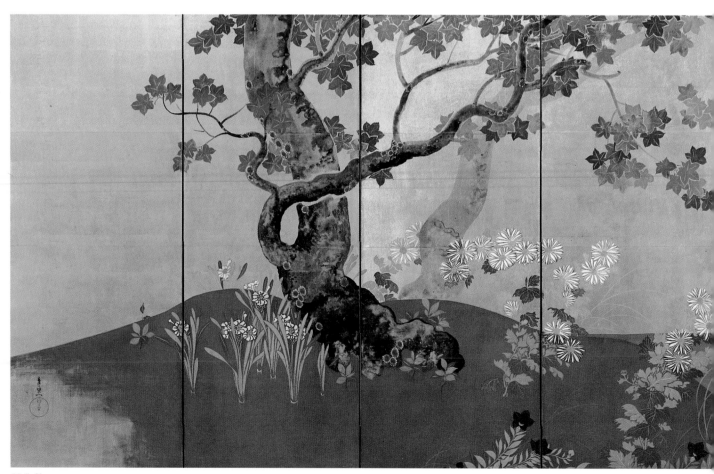

46 (left)

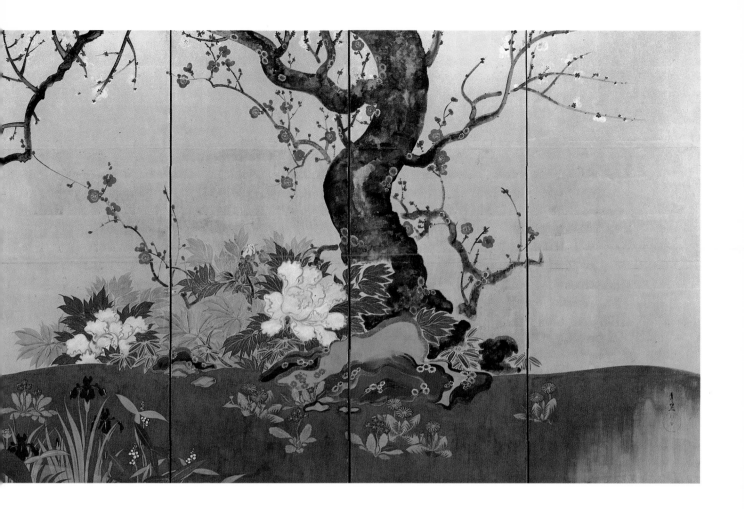

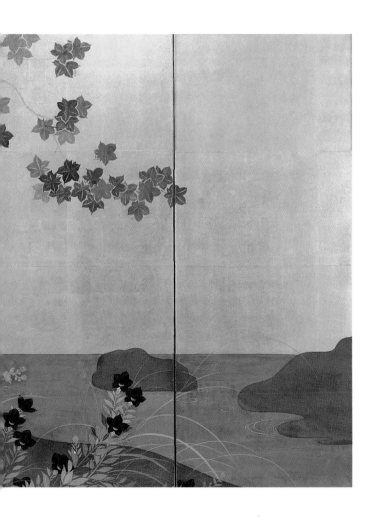

47

48

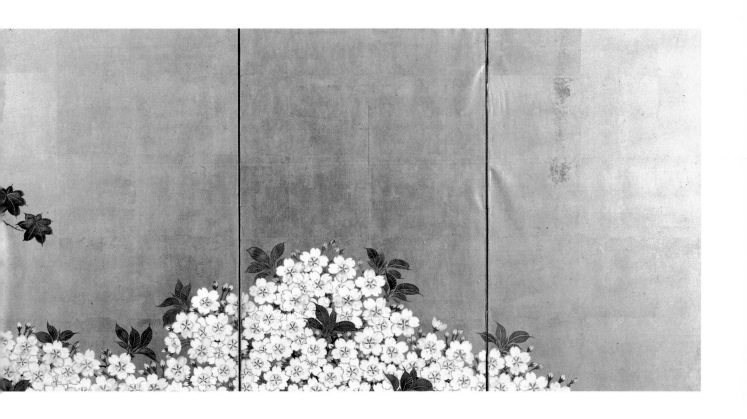

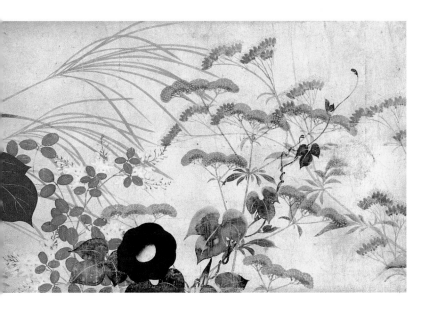

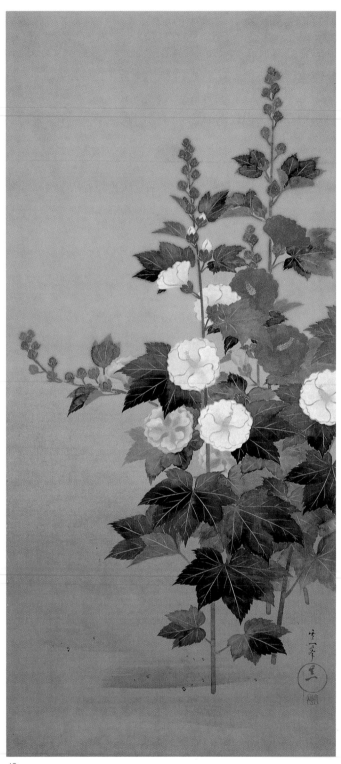

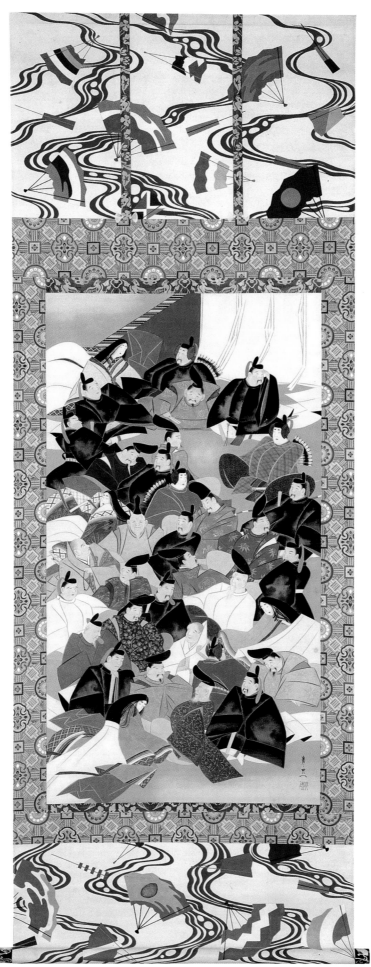

52

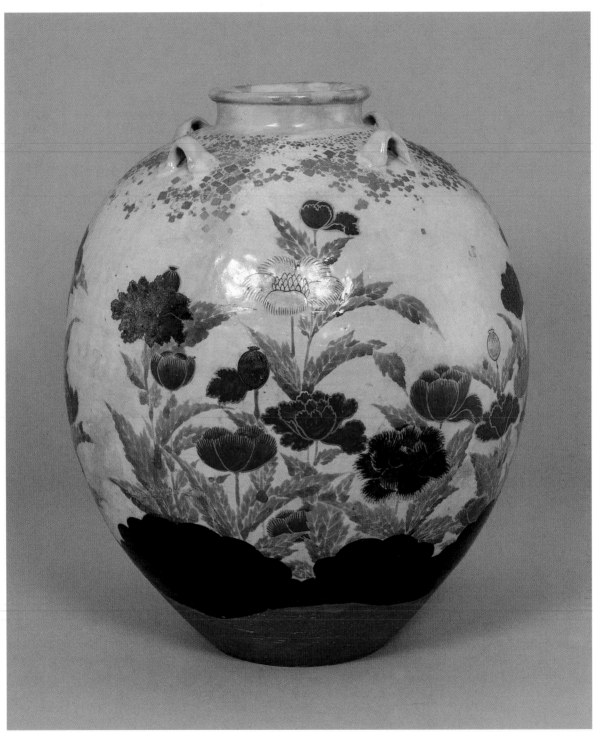

53

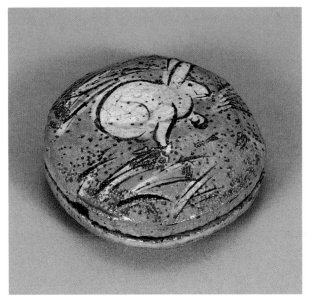

54

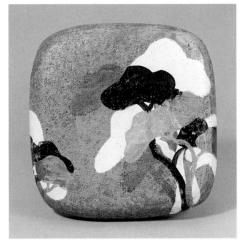

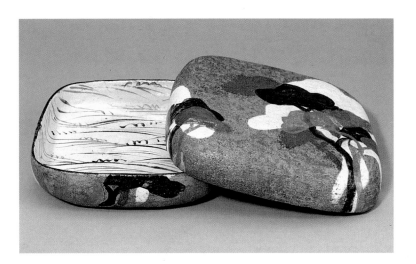

55

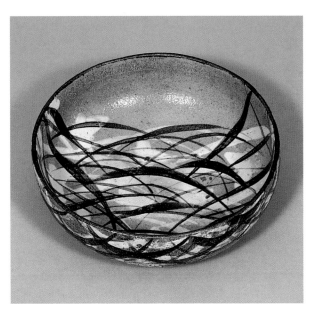

56

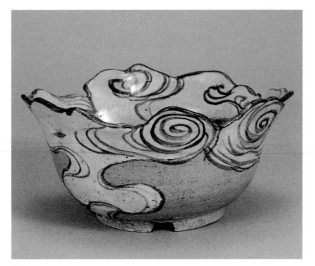

57

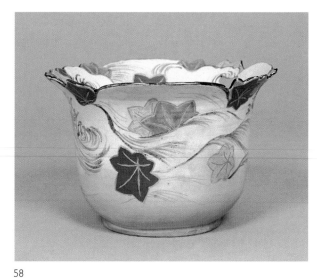

58

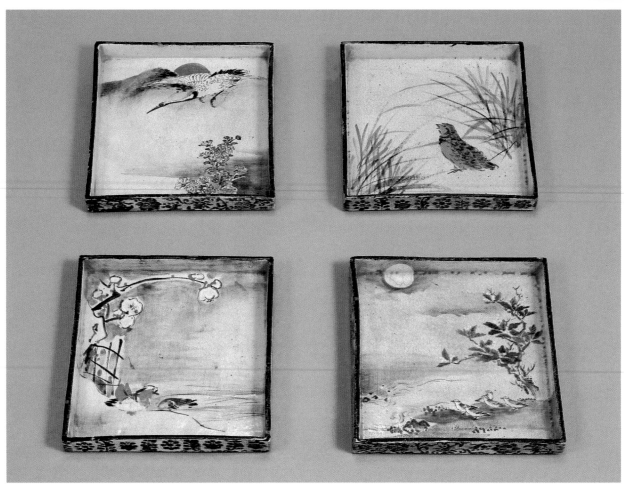

59 (9th to 12th month)

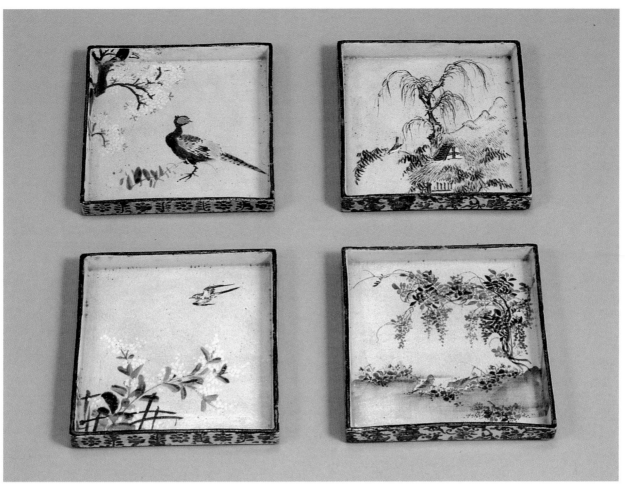

59 (1st to 4th month)

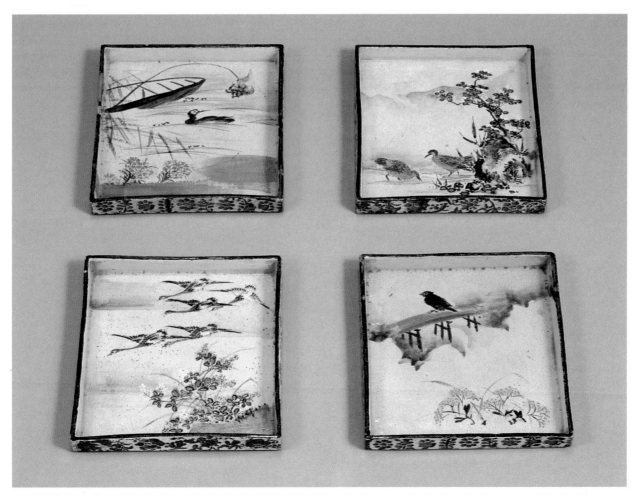

59 (5th to 8th month)

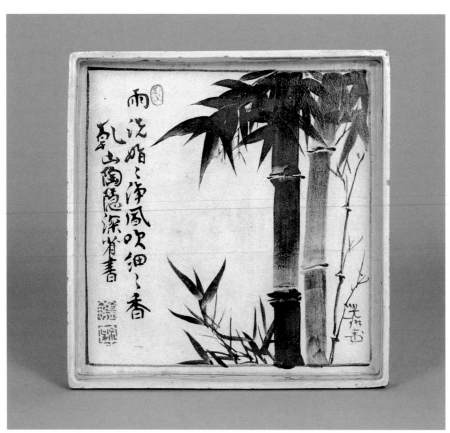

60

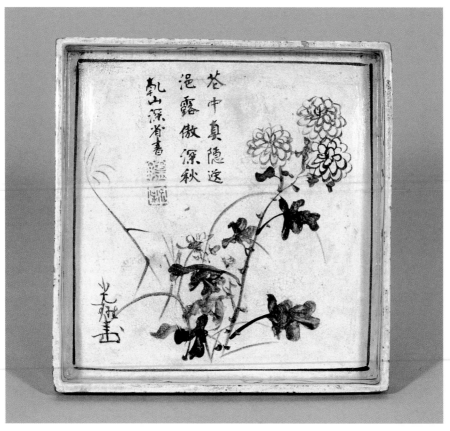

61

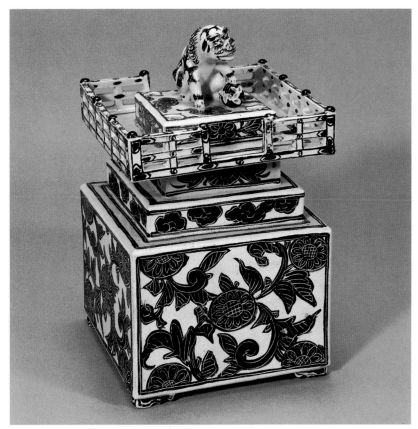

62

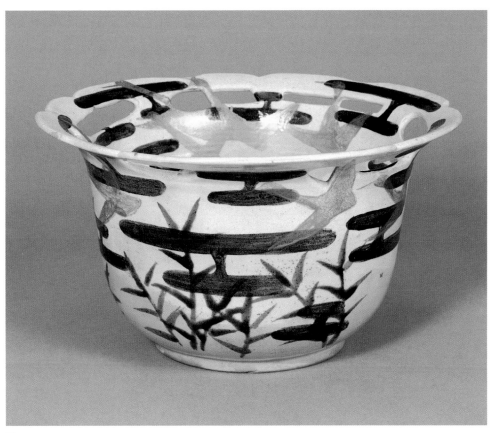

63

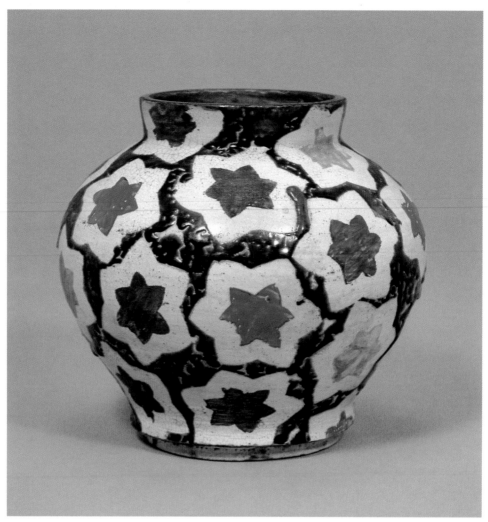

64

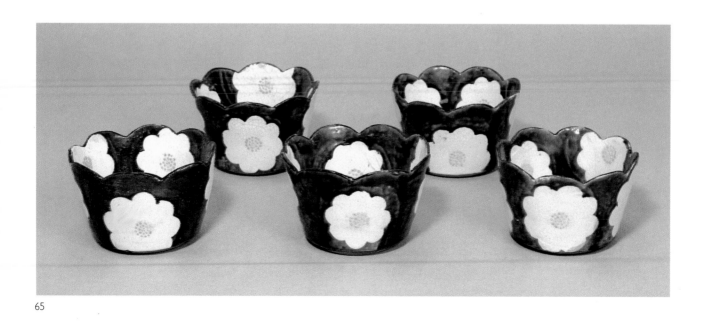

65

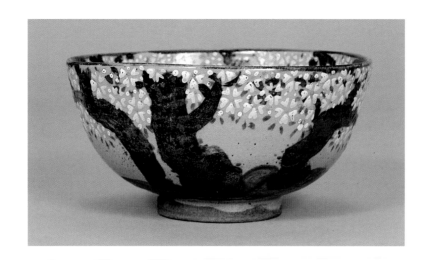

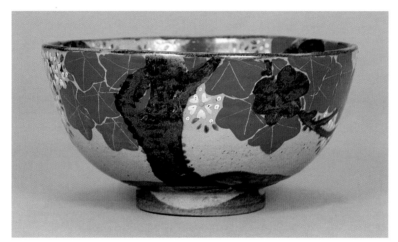

66

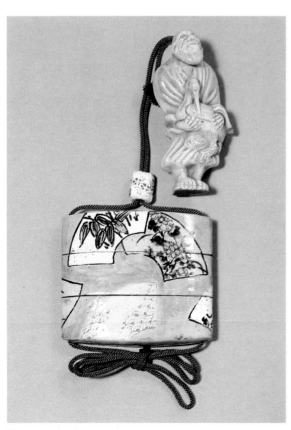

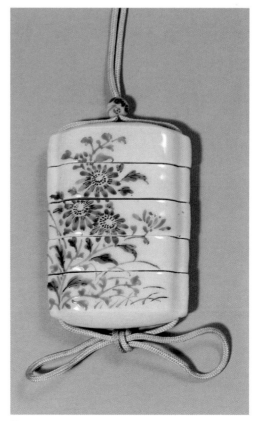

67 68

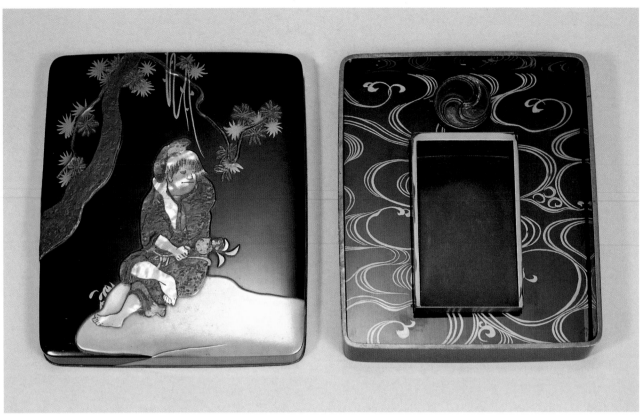

69

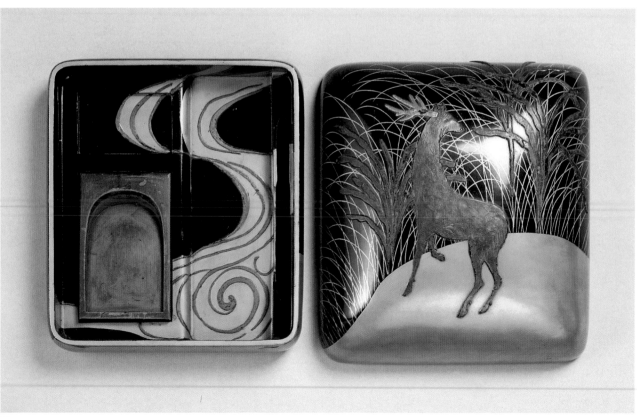

70

Artists' Biographies

Masato NAITŌ and Masaaki ARAKAWA

Hon'ami Kōetsu (1558–1637)

Born into a branch of the Hon'ami family, sword appraisers and polishers who had originally served the Muromachi Shogunate. Art-names (*gō*): Taikyoan, Jitokusai.

As a calligrapher working in collaboration with Sōtatsu, he produced many examples of handscrolls of *waka* poetry inscribed over beautiful underpaintings in gold and silver pigments. Also famous are the preparatory drawings he did for the woodblock-printed books of the so-called 'Saga' editions, published together with Suminokura Ryōi. After a grant of land at Takagamine by Tokugawa Ieyasu in 1615 and the founding of an artistic colony there, he concentrated mainly on the production of ceramics, producing fine examples in Raku and other wares. He also excelled at new and innovative designs for *maki-e* lacquer.

Tawaraya Sōtatsu (worked about 1600–40)

The founder of the Rimpa school. Details of his biography are unclear, but it can be surmised that he was originally the manager of a 'picture shop' (*eya*) in Kyoto called the Tawaraya, which specialised in the production and sale of fan paintings and decorated papers.

From the time of his association with Kōetsu onwards, Sōtatsu had many contacts with cultivated men of his period such as the courtier Karasumaru Mitsuhiro and the tea master Sen no Shōan. He is known to have been awarded the title *Hokkyō* ('bridge of the law') in 1630, upon completion of a copy of the *Illustrated handscroll of legends of Saigyō* (*Saigyō monogatari emaki*) in the Imperial Collection. He was master of the *tarashikomi* technique (see note on p. 12), perfected after personal study of the Yamato-e and ink painting traditions, developing a style that was uniquely simple and broad. He leaves many masterpieces in the genres of paintings of flowers and grasses, illustrations to courtly tales (*monogatari-e*) and portraits of Daoist and Buddhist worthies. He is known to have used seals reading 'Inen' and 'Taiseiken'.

Tawaraya Sōsetsu (dates unknown)

A painter said to have been the younger brother or son of Sōtatsu. He is thought to have inherited the Tawaraya shop name and leadership of the Sōtatsu workshop and to have applied the 'Inen' seal, previously used by Sōtatsu, to his own works. Like Sōtatsu before him, he was granted the *Hokkyō* title (by 1642), and just after this became painter in the service of the Maeda family of Kaga. There are many surviving examples by him of the screen paintings of flowers and grasses that were the speciality of the Sōtatsu school.

Kitagawa Sōsetsu* (dates unknown)

A painter thought to have been the successor to the above Sōsetsu (but the name is written with different characters and indicated in the present catalogue as Sōsetsu*). He also inherited the 'Inen' seal and worked mainly in the Kaga area. The majority of his surviving works take the form of *oshie-bari* screens (screens in which there are separate paintings mounted on each panel), with compositions of flowers and grasses on plain paper backgrounds.

Ogata Kōrin (1658–1716)

The painter who most epitomises the Rimpa school. Common name (*tsūshō*): Ichinojō. Formal adult names (*na*): Koretomi, Koresuke. Art-names (*gō*): Kansei, Dōsū, Jakumei, Seisei.

The second son of the Kariganeya drapery business in Kyoto. He first studied calligraphy and painting with his father Ogata Sōken, also Yamamoto Soken. The impact of the works of Kōetsu and Sōtatsu, coupled with his own innately brilliant design sense, enabled him to establish an independent painting lineage with a style characterised by its daring decorative qualities. As a leading painter in Kyoto he received patronage from such individuals as Nakamura Kuranosuke, an official at the mint. After being granted the title *Hokkyō*, he spent the years 1704–9 in Edo, where he was in service to the Sakai family, among others. In addition to painting, he was very active in creating designs for the applied arts, producing collaborative works with his younger brother, the potter Kenzan.

Ogata Kenzan (1663–1743)

Younger brother of Kōrin. Common name (*tsūshō*): Gompei. Formal adult name (*na*): Korechika. Art-names (*gō*): Tōzen, Shōkosai, Reikai, Shisui.

The third son of the Kariganeya drapery business in Kyoto. As a potter, he first studied the Kyoto ceramic style of Nonomura Ninsei, opening a kiln at Narutaki on the north-west outskirts of the city and calling himself Kenzan. His career as a ceramist developed through various stages as he subsequently moved to Nijō Chōjiya-chō in the centre of Kyoto, and later to the Iriya district of Edo. He requested his brother Kōrin to decorate his ceramics, most notably on square dishes. In later years he became increasingly active as a painter, producing works which combined painting, poetry and calligraphy in the literati manner.

Fukae Roshū (1699–1757)

Pupil of Kōrin. Son of Fukae Shōzaemon, an official at the Kyoto mint. Thought to have studied with Kōrin in the latter's later years, but his style has archaic elements which hark back, if anything, to Sōtatsu and others a generation earlier. His surviving works are mainly in the genre of paintings of flowers and grasses, but also include scenes from courtly tales and figure subjects.

Watanabe Shikō (1683–1755)

Pupil of Kōrin. Native of Kyoto, in the service of the Konoe, the leading court family which historically served as regents and principal advisers to the imperial family. Studied first with the Kanō school and later with Kōrin, and practised the two painting styles in parallel for the remainder of his career. He was a forerunner in the depiction of minutely detailed life studies of birds, animals and plants.

Tatebayashi Kagei (dates unknown)

Pupil of Kenzan. Formal adult name (na): Rittoku. Art-names (gō): Taisei, Kiusai.

Studied with Kenzan during Kenzan's later years in Edo, painting works in Kōrin style in the middle of the eighteenth century. Some of his works bear the 'Hōshuku' seal previously used by Kōrin.

Nakamura Hōchū (d. 1819)

Born in Kyoto. After personal study of the works of Kōrin and others, he was active mainly in Osaka, painting in an unconventional and highly individualistic manner. Around the end of the Kansei (1789–1801) era he went to Edo, where he introduced the works of Kōrin to the public by means of colour woodblock-printed albums.

Sakai Hōitsu (1761–1828)

Founder of the Edo Rimpa school. Formal adult name (na): Tadanao. Formal scholar's name (azana): Kishin. Art- and pen-names (betsugō): Toryō, Ugean, Ōson, Shiriyake no Sarundo.

Younger brother of Sakai Tadazane, Lord of the Himeji fief. Born in Edo, he enjoyed elegant literary pursuits such as haikai and kyōka poetry from his early years. He began painting by studying Kanō, Ukiyo-e and the Nagasaki school, then, deeply impressed by the works of Kōrin, he made a study of the Rimpa painting style. He was also responsible for staging a Kōrin memorial exhibition and arranging for publication of his works in woodblock printed albums. Hōitsu revived the Rimpa school in Edo, adding naturalistic elements from the new Maruyama-Shijō school of Kyoto to the existing styles of Sōtatsu and Kōrin. He was particularly innovative in his paintings of bird and flower subjects.

Suzuki Kiitsu (1796–1858)

The principal pupil of Hōitsu's school. Formal adult name (na): Motonaga. Formal scholar's name (azana): Shien. Art-names (gō): Hitsuan, Shukurinsai, Kaikai, Seisei.

Born in the Kanda district of Edo, the son of a dyer. He became a live-in pupil of Hōitsu and was adopted through marriage into the Suzuki family, retainers of the Sakai family, Lords of Himeji. From early on he painted works in Hōitsu's name. While faithfully preserving the style of his teacher in bird and flower compositions, he also developed in parallel a wide variety of other painting styles imbued with a uniquely personal and extravagant sense of form.

Nonomura Ninsei (worked second half of the seventeenth century)

Ninsei perfected overglaze enamel techniques for decorating Kyoto wares and is regarded as the first true ceramic artist in Japan. According to tradition he was born in the village of Nonomura in Tamba Province and, following an apprenticeship in the Awataguchi district of Kyoto, moved to Seto, where he learned the production of tea wares. At the time of the rebuilding of Ninna-ji Temple, Kyoto, during the Shōhō (1644–8) era, he established his Omuro kiln in the neighbourhood in front of the temple's main gateway. Ninsei received instruction from the tea master Kanemori Sōwa (1584–1656) and produced extremely elegant tea wares in courtly taste – mainly for the new daimyō (feudal lord) class. His particular innovation was the application of design ideas from the painting of his time to ceramics. Ninsei's connection with the Rimpa school is demonstrated by works which use similar motifs to those favoured by Sōtatsu and his followers and a decorative technique similar to tarashikomi in painting. Other works have designs which show the influence of the Kanō and Hasegawa schools of painting. Those of his painted designs that include gold and silver, seen mainly on tea jars, achieve decorative effects similar to those of the magnificent sliding-door and screen paintings of the earlier Momoyama Period (1568–1600).

Nin'ami Dōhachi (1783–1855)

Nin'ami Dōhachi (Takahashi Dōhachi II) was a pupil of Okuda Eisen and is considered one of the outstanding talents of the Kyoto ceramic world, along with Aoki Mokubei and Kinkodō Kisuke. At the time of his father, Dōhachi I, the Takahashi family came to Kyoto from Ise and established their own kiln in the Awataguchi district. After his father's death, Dōhachi II moved the kiln to Gojōzaka in 1811. Subsequently (in 1822?) he took priestly vows, receiving the character 'Nin' from the prince-priest of Ninna-ji Temple and the religious sobriquet '-ami' from the prince-priest of Daigo Sambō-in Temple to form the art-name Nin'ami. In contrast to the Chinese styles of Aoki Mokubei, which had their basis in the world of steeped tea (sencha), Nin'ami preserved the pure native taste of traditional Kyoto wares. Learning from the earlier examples of Hon'ami Kōetsu, Nonomura Ninsei and Ogata Kenzan, he was particularly innovative in the creation of Rimpa-style decorative designs. He also worked hard to revive various kilns and wares such as the Kairakuen ware of Kii Province, the San kiln at Takamatsu in Sanuki Province and Ippōdō ware in Kyoto.

Select Bibliography

Divided into sections on general topics and individual artists (in historical order), and arranged chronologically within each section, this is a translation, with additions, of a bibliography originally prepared by Takeuchi Misako for the catalogue of the exhibition Rimpa: *Bi no keishō – Sōtatsu, Kōrin, Hōitsu, Kiitsu* held at the Nagoya City Museum in 1994. For a more detailed, comprehensive bibliography of Rimpa studies in Japanese, compiled by Matsuo Tomoko, see Murashige Yasushi and Kobayashi Tadashi, eds, *Rimpa*, vol. 5: *Sōgō (bessatsu)*, Kyoto, Shikōsha, 1992, pp. 68–85.

General (books and catalogues)

Tajima Shiichi, ed. *Masterpieces selected from the Kōrin School (Kōrin-ha gashū)*, 4 vols, Tokyo, Shimbi Shoin, 1903–5

Mizuo Hiroshi. *Sōtatsu to Kōrin (Nihon no bijutsu 18)*, Tokyo, Heibonsha, 1965

Leach, Bernard. *Kenzan and his Tradition: The Lives and Times of Kōetsu, Sōtatsu, Kōrin and Kenzan*, London, Faber & Faber, 1966

Tokugawa Bijutsukan. *Rimpa mehin ten – Kōetsu, Sōtatsu, Kōrin, Kenzan, Hōitsu*, exh. cat., 1966

Ishikawa Kenritsu Bijutsukan. *Rimpa no geijutsu*, exh. cat., 1969

Shimada Shūjirō, ed. *Zaigai hihō: Shōhei-ga, Rimpa, bunjin-ga*, Tokyo, Gakushū Kenkyūsha, 1969

Japan House Gallery. *Rimpa: Masterworks of the Japanese Decorative School*, exh. cat., 1971

Yamane Yūzō. *Sōtatsu to Kōrin (Book of Books 18)*, Tokyo, Shōgakkan, 1971

Mizuo Hiroshi. *Edo Painting: Sotatsu and Korin (Heibonsha Survey of Japanese Art, vol. 18)*, New York, Weatherhill and Tokyo, Heibonsha, 1972

Tokyo Kokuritsu Hakubutsukan. *Rimpa*, exh. cat., 1972

Yamane Yūzō, Joe D. Price *et al. Beikoku Shin'enkan korekushon (Kinsei Nihon kaiga shūsei)*, Kyoto, Kyoto Shoin, 1972

Yamane Yūzō. *Suiboku bijutsu taikei*, vol. 10: *Kōetsu, Sōtatsu, Kōrin*, Tokyo, Kōdansha, 1975

Yamane Yūzō, ed. *Zaigai nihon no shihō*, vol. 5: *Rimpa*, Tokyo, Mainichi Shimbunsha, 1979

Honolulu Academy of Arts & Japan House Gallery. *Exquisite Visions: Rimpa Paintings from Japan*, exh. cat., 1980

Nakamachi Keiko. *Meihō Nihon no bijutsu*, vol. 19: *Kōetsu to Sōtatsu*, Tokyo, Shōgakkan, 1983

Seikadō Bunko. *Rimpa*, exh. cat., 1984

Idemitsu Bijutsukan. *Rimpa sakuhin*, exh. cat., 1985

Manno Bijutsukan. *Manno Bijutsukan korekushon: Rimpa ten*, exh. cat., 1988

Fukuoka Shiritsu Bijutsukan. *Nihon no bi 'Rimpa' – Sōtatsu, Kōrin, Hōitsu kara gendai made*, exh. cat., 1989

Murashige Yasushi, ed. *Rimpa*, vol. 1: *Kachō I*, Kyoto, Shikōsha, 1989

Kobayashi Tadashi, ed. *Rimpa*, vol. 2: *Kachō II*, Kyoto, Shikōsha, 1990

Kobayashi Tadashi *et al.*, eds. *Nihon bijutsu zenshū*, vol. 18: *Sōtatsu to Kōrin*, Tokyo, Kōdansha, 1990

Murashige Yasushi, ed. *Rimpa*, vol. 3: *Fūgetsu, chōjū*, Kyoto, Shikōsha, 1991

Kobayashi Tadashi, ed. *Rimpa*, vol. 4: *Jimbutsu*, Kyoto, Shikōsha, 1991

Machida Shiritsu Kokusai Hanga Bijutsukan. *Rimpa – han to kata no tenkai*, exh. cat., 1992

Murashige Yasushi & Kobayashi Tadashi, eds. *Rimpa*, vol. 5: *Sōgō*, Kyoto, Shikōsha, 1992

Kanō Hiroyuki *et al. Rimpa bijutsukan*, vol. 1: *Sōtatsu to Rimpa no genryū*, Tokyo, Shūeisha, 1993

Okudaira Shunroku *et al. Rimpa bijutsukan*, vol. 2: *Kōrin to Kamigata Rimpa*, Tokyo, Shūeisha, 1993

Yasumura Toshinobu *et al. Rimpa bijutsukan*, vol. 3: *Hōitsu to Edo Rimpa*, Tokyo, Shūeisha, 1993

Yasumura Toshinobu, *et al. Rimpa bijutsukan*, vol. 4: *Kōgei to Rimpa kankaku no tenkai*, Tokyo, Shūeisha, 1993

Idemitsu Bijutsukan. *Rimpa*, exh. cat., 1993

Murashige Yasushi, ed. *Edo meisaku gajō zenshū*, vol. 6: *Sōtatsu, Kōrin, Hōitsu*, Tokyo, Shinshindō, 1993

Nagoya-shi Hakubutsukan, *Rimpa: Bi no keishō – Sōtatsu, Kōrin, Hōitsu, Kiitsu*, exh. cat., 1994

Demura Kōichi & Suzuki Noriyoshi, eds. *Rimpa no hōga – Kōetsu-mura saigen*, Tokyo, Inax Shuppan, 1995

Fukuoka Daimaru. *Nihon no bi, Rimpa ten*, exh. cat., 1996

Yamane Yūzō. *Rimpa meihin hyakusen*, Tokyo, Nihon Keizai Shimbunsha, 1996

General (articles)

Kōno Motoaki. 'Rimpa-kei kaboku zu byōbu no nagare', *Nihon byōbu-e shūsei*, vol. 6, Tokyo, Kōdansha, 1980

Murashige Yasushi. 'Rimpa no kaboku sōka zu no tenkai', *Kachō-ga no sekai*, vol. 5, Tokyo, Gakushū Kenkyūsha, 1981

Wakisaka Atsushi. 'Fūjin, raijin no zuzō-teki keifu to Sōtatsu hitsu *Fūjin raijin zu*', *Ōsaka Shiritsu Bijutsukan kiyō* 4 (1984)

Nakamachi Keiko. 'Fūjin raijin zu byōbu to Sōtatsu, Kōrin', *Jissen Joshi Daigaku bigaku bijutsu-shi kiyō* 1 (1986)

Murashige Yasushi. 'Rimpa no shiki kachō zu – jikansei to tsui no ishiki', *Rimpa*, vol. 1, Kyoto, Shikōsha, 1989

Tsuzuki Etsuko. 'Sōtatsu, Kōrin, Hōitsu ni miru dentō no keishō to kakushin', *Kobijutsu* 92 (1989)

Wakisaka Atsushi. 'Rimpa ni okeru fūjin raijin zu', *Nihon no bijutsu – Ima nani ga koten kara manaberu ka*, Tokyo, Shōwadō Insatsu, 1989

Murashige Yasushi. 'Rimpa no sōshoku-ga', *Nihon bijutsu zenshū*, vol. 18, Tokyo, Kōdansha, 1990

Tamamushi Satoko. 'Sōtatsu, Kōrin no daihyō-saku to shukō no bigaku', *Nihon bijutsu zenshū*, vol. 18, Tokyo, Kōdansha, 1990

Yasumura Toshinobu. 'Byōbu no katachi to kōzu', *Nihon bijutsu zenshū*, vol. 18, Tokyo, Kōdansha, 1990

Nishimoto Shūko. '*Kōrin hyakuzu* to Rimpa no keifu', *Rimpa – han to kata no tenkai*, 1992

Yasumura Toshinobu. 'Rimpa kankaku no tenkai', *Rimpa bijutsukan*, vol. 4: *Kōgei to Rimpa kankaku no tenkai*, Tokyo, Shūeisha, 1993

Kobayashi Tadashi. 'Rimpa no iki-iki ryūten [Rimpa's vivid renaissance]', Nagoya-shi Hakubutsukan, *Rimpa: Bi no keishō – Sōtatsu, Kōrin, Hōitsu, Kiitsu*, exh. cat., 1994

Yamane Yūzō. 'Sōtatsu, Kōrin, Hōitsu kenkyū no omoide [Memories of my research on Sōtatsu, Kōrin and Hōitsu]', Nagoya-shi Hakubutsukan, *Rimpa: Bi no keishō – Sōtatsu, Kōrin, Hōitsu, Kiitsu*, exh. cat., 1994

Sōtatsu (books and catalogues)

Yamane Yūzō. *Sōtatsu*, Tokyo, Nihon Keizai Shimbunsha, 1962

Minamoto Toyomune and Hashimoto Ayako. *Nihon bijutsu kaiga zenshū*, vol. 14: *Tawaraya Sōtatsu*, Tokyo, Shūeisha, 1976

Yamane Yūzō, ed. *Rimpa kaiga zenshū: Sōtatsu-ha I*, Tokyo, Nihon Keizai Shimbunsha, 1977

Croissant, Doris. *Sōtatsu und der Sōtatsu-Stil: Untersuchungen zu Repertoire, Ikonographie und Ästhetik der Malerei des Tawaraya Sōtatsu (um 1600–1640)*, Wiesbaden, Franz Steiner Verlag, 1978

Kokka Co., eds. *Kōetsu sho Sōtatsu kingin-dei e*, Tokyo, Asahi Shimbunsha, 1978

Tsuji Nobuo, ed. *Rimpa kaiga zenshū: Sōtatsu-ha II*, Tokyo, Nihon Keizai Shimbunsha, 1978

Yamato Bunkakan. *Tawaraya Sōtatsu*, exh. cat., 1990

Sōtatsu (articles)

Tanaka Kisaku. 'Tawaraya Sōtatsu hitsu shinkai zu', *Bijutsu kenkyū* 2 (1930)

Aimi Kōu. 'Sōtatsu no sembutsu-ga to sembutsu kisō', *Yamato bunka* 8 (1952)

Yamane Yūzō. 'Sōtatsu hitsu roō zu', *Kokka* 793 (1958)

Yamane Yūzō. 'Sōtatsu to Daigo-ji – Roō zu tsuitate o chūshin ni', *Yamato bunka* 29 (1958)

Yamane Yūzō. 'Den Tawaraya Sōtatsu no Hōgen, Heiji monogatari-e semmen ni tsuite', *Yamato bunka* 30 (1959)

Kobayashi Tadashi. 'Tawaraya Sōtatsu shita-e, Hon'ami Kōetsu sho tsuru zu shita-e waka shokan', *Kobijutsu* 39 (1972)

Mizuo Hiroshi. 'Fujibakama zu byōbu', *Kokka* 955 (1973)

Mizuo Hiroshi. 'Tawaraya Sōtatsu kara Hokkyō Sōtatsu e – shinkai zu byōbu o megutte', *Kokka* 958 (1973)

Mizuo Hiroshi. 'Shimpū zu byōbu', *Kokka* 960 (1973)

Itō Keiko. 'Den Sōtatsu hitsu Ise monogatari zu shikishi no kotobagaki ni tsuite', *Yamato bunka* 59 (1974)

Kōno Motoaki. 'Sōtatsu kankei shiryō to kenkyū-shi', *Rimpa kaiga zenshū: Sōtatsu-ha I*, Tokyo, Nihon Keizai Shimbunsha, 1977

Yamane Yūzō. '*Shūkongō-jin engi-e* yori shuzai shita mono', *Rimpa kaiga zenshū: Sōtatsu-ha I*, Tokyo, Nihon Keizai Shimbunsha, 1977

Yamane Yūzō. 'Den Sōtatsu Ise monogatari zu no semmen, byōbu, shikishi', *Rimpa kaiga zenshū: Sōtatsu-ha I*, Tokyo, Nihon Keizai Shimbunsha, 1977

Kōno Motoaki. 'Tawaraya Sōtatsu no rakkan', *Rimpa kaiga zenshū: Sōtatsu-ha II*, Tokyo, Nihon Keizai Shimbunsha, 1978

Murashige Yasushi. 'Sōtatsu-ha ni okeru kingin-dei e to sōka zu no tenkai', *Rimpa kaiga zenshū: Sōtatsu-ha II*, Tokyo, Nihon Keizai Shimbunsha, 1978

Tsuji Nobuo. 'Sōtatsu-ha no sōka zu gairon – suiboku-ga, kingin-dei e nado no mondai mo fukumete', *Rimpa kaiga zenshū: Sōtatsu-ha II*, Tokyo, Nihon Keizai Shimbunsha, 1978

Mizuo Hiroshi. 'Kōetsu sho Sōtatsu kingin-dei e shin kokin-shū shika waka kan ni tsuite', *Kokka* 1074 (1984)

Mizuo Hiroshi. 'Kōetsu sho Sōtatsu kingin-dei e sanjū-rokkasen tsuru waka kan ni tsuite', *Kokka* 1090 (1986)

Nakabe Yoshitaka. 'Den Sōtatsu hitsu Ise monogatari zu shikishi kenkyū josetsu', *Rimpa*, vol. 4: *Jimbutsu*, Kyoto, Shikōsha, 1991

Kōno Motoaki. 'Sōtatsu kingin-dei e josetsu', *Rimpa – han to kata no tenkai*, exh. cat., 1992

Nakabe Yoshitaka. 'Den Tawaraya Sōtatsu hitsu sōka zu semmen-chirashi haritsuke byōbu o megutte', *Yamato bunka* 87 (1992)

Murashige Yasushi. 'Sōtatsu to *Fūjin raijin zu* no keifu [Sōtatsu and the Wind and Thunder God painting lineage]',

Nagoya-shi Hakubutsukan, *Rimpa: Bi no keishō – Sōtatsu, Kōrin, Hōitsu, Kiitsu*, exh. cat., 1994

Kōrin (books and catalogues)

Kōno Motoaki. *Nihon bijutsu kaiga zenshū*, vol. 17: *Ogata Kōrin*, Tokyo, Shūeisha, 1976

Yamane Yūzō, ed. *Rimpa kaiga zenshū: Kōrin-ha I*, Tokyo, Nihon Keizai Shimbunsha, 1979

Yamane Yūzō, ed. *Rimpa kaiga zenshū: Kōrin-ha II*, Tokyo, Nihon Keizai Shimbunsha, 1980

Nishimoto Shūko. *Meihō Nihon no bijutsu*, vol. 20: *Kōrin, Kenzan*, Tokyo, Shōgakkan, 1981

MOA Bijutsukan. *Kōrin*, exh. cat., 1985

Kōrin (articles)

Anon. 'Ogata Kōrin hitsu sanjū-rokkasen zu byōbu', *Kokka* 177 (1905)

Taki Seiichi. 'Ogata Kōrin hitsu shimpū zu byōbu', *Kokka* 518 (1934)

Kosugi Kazuo. 'Kakitsubata zu byōbu ni mirareru kata no shiyō', *Sansai* 138 (1960)

Yamane Yūzō. 'Kōrin to Nakamura Kuranosuke – Nakamura Kuranosuke o chūshin ni', *Kokka* 1023 (1979)

Nakamachi Keiko. 'Ogata Kōrin no zōkei-sei ni tsuite no hito-kōsatsu – Hyakunin isshu karuta o chūshin ni', *Kokka* 1024 (1979)

Kōno Motoaki. 'Kōrin ni dai-kessaku no gensen to tokushitsu', *Rimpa kaiga zenshū: Kōrin-ha I*, Tokyo, Nihon Keizai Shimbunsha, 1979

Kōno Motoaki. 'Kōrin hitsu hatō zu byōbu ni tsuite', *Zaigai nihon no shihō*, vol. 5: *Rimpa*, Tokyo, Mainichi Shimbunsha, 1979

Yamane Yūzō. 'Kōrin no gafū tenkai ni tsuite', *Rimpa kaiga zenshū: Kōrin-ha I*, Tokyo, Nihon Keizai Shimbunsha, 1979

Nakamachi Keiko. 'Kasen-e byōbu ni tsuite', *Nihon byōbu-e shūsei*, vol. 5, Tokyo, Kōdansha, 1984

Kawanobe Yasunao. 'Nezu Bijutsukan-zō Ogata Kōrin hitsu *Hakuraku-ten zu byōbu* ni tsuite', *Geisō* 3 (1985)

Nakamachi Keiko. 'Ogata Kōrin no byōbu o meguru mondai ni tsuite', *Kobijutsu* 76 (1985)

Nakamachi Keiko. 'Ogata Kōrin no gafū taisei ni tsuite no hito-kōsatsu – *Kakitsubata zu byōbu* kara *Yatsuhashi zu byōbu* e', *Jissen Joshi Daigaku bungaku-bu kiyō* 28 (1986)

Yamane Yūzō. 'Zoku Kōrin to Nakamura Kuranosuke – Kōrin no kōhansei, Hōei Shōtoku nenkan o chūshin ni', *Kokka* 1167 (1993)

Kōno Motoaki. 'Kōrin suiha shiron [Thoughts on Kōrin's waves]', Nagoya-shi Hakubutsukan, *Rimpa: Bi no keishō – Sōtatsu, Kōrin, Hōitsu, Kiitsu*, exh. cat., 1994

Kenzan

Mizuo Hiroshi. 'Ogata Kenzan hitsu nami chidori jakago susuki e midare-bako', *Kokka* 978 (1975)

Kawahara Masahiko. *Nihon no bijutsu*, no. 154: *Kenzan*, Tokyo, Shibundō, 1979

Kōno Motoaki. 'Kenzan no denki to kaiga', *Rimpa kaiga zenshū: Kōrin-ha II*, Tokyo, Nihon Keizai Shimbunsha, 1980

Gotō Bijutsukan. *Kenzan no kaiga*, exh. cat., 1982

Nishimoto Shūko. 'Kenzan no tachi-aoi zu', *Museum* 429 (1986)

Wilson, Richard. *The Art of Ogata Kenzan: Persona and Production in Japanese Ceramics*, New York, Weatherhill, 1991

Shikō

Aimi Kōu. 'Watanabe Shikō to Kenzan', *Yamato bunka* 23 (1957)

Yamakawa Takeshi. 'Daikaku-ji to Watanabe Shikō', *Shōheki-ga zenshū: Daikaku-ji*, Tokyo, Bijutsu Shuppansha, 1967

Doi Tsugiyoshi. *Watanabe Shikō shōheki-ga*, Tokyo, Mitsumura Suiko Shoin, 1972

Kobayashi Tadashi. 'Watanabe Shikō Yoshinoyama zu byōbu', *Kokka* 951 (1972)

Kyoto-shi Bijutsukan. *Watanabe Shikō ten – Daikaku-ji shōheki-ga o chūshin ni*, exh. cat., 1973

Kobayashi Tadashi. 'Watanabe Shikō shiron', *Rimpa kaiga zenshū: Kōrin-ha II*, Tokyo, Nihon Keizai Shimbunsha, 1980

Kobayashi Tadashi. 'Watanabe Shikō no senku-teki gyōseki', *Edo kaiga-shi ron*, Tokyo, Ruri Shobō, 1983

Mori Kumiko. 'Watanabe Shikō no shasei-teki kaiga e no kanshin ni tsuite', *Kinko sōsho shigaku bijutsu-shi rombun shū* 16 (1989)

Sōri

Kobayashi Tadashi. 'Tawaraya Sōri ni tsuite', *Museum* 260 (1972)

Nagata Seiji. 'Sōri kō – Hokusai kenkyū ni kanren shite', *Kokka* 1062 (1983)

Hōitsu (books and catalogues)

Yamane Yūzō, ed. *Rimpa kaiga zenshū: Hōitsu-ha*, Tokyo, Nihon Keizai Shimbunsha, 1978

Suntory Bijutsukan. *Sakai Hōitsu to Edo Rimpa*, exh. cat., 1982

Himeji Shiritsu Bijutsukan. *Sakai Hōitsu ten*, exh. cat., 1983

Tamamushi Satoko. *E wa kataru 13: Sakai Hōitsu hitsu natsu aki kusa zu byōbu*, Tokyo, Heibonsha, 1993

Hōitsu (articles)

Aimi Kōu. 'Hōitsu Shōnin nempu kō', *Nihon bijutsu kyōkai hōkoku* 8 (1927)

Aimi Kōu. 'Hōitsu no zen-hansei ni tsuite', *Shoga kottō zasshi* 298 (1933)

Mizuo Hiroshi. 'Sakai Hōitsu hitsu sanjū-rokkasen zu', *Kokka* 802 (1959)

Kitakōji Ken. 'Sakai Hōitsu jihitsu kushū *Keikyokan kusō* ni tsuite', *Museum* 261 (1972)

Kobayashi Tadashi. 'Hōitsu to Edo Rimpa', *Rimpa kaiga zenshū: Hōitsu-ha*, Tokyo, Nihon Keizai Shimbunsha, 1978

Kōno Motoaki. 'Hōitsu no denki', *Rimpa kaiga zenshū: Hōitsu-ha*, Tokyo, Nihon Keizai Shimbunsha, 1978

Kōno Motoaki. 'Hōitsu no yūnenki sakuhin', *Rimpa kaiga zenshū: Hōitsu-ha*, Tokyo, Nihon Keizai Shimbunsha, 1978

Nakamachi Keiko. 'Hōitsu no koten jimbutsu-zu, monogatari-zu ni tsuite', *Rimpa kaiga zenshū: Hōitsu-ha*, Tokyo, Nihon Keizai Shimbunsha, 1978

Nishimoto Shūko. 'Hōitsu no Kōrin kenshō', *Rimpa kaiga zenshū: Hōitsu-ha*, Tokyo, Nihon Keizai Shimbunsha, 1978

Tamamushi Satoko. 'Hōitsu-ga no teihen – Hōitsu geijutsu seiritsu no dojō ni tsuite', *Rimpa kaiga zenshū: Hōitsu-ha*, Tokyo, Nihon Keizai Shimbunsha, 1978

Kōno Motoaki. 'Sakai Hōitsu *Toryō no gi* honkoku', *Nagoya Daigaku bigaku bijutsu-shi kenkyū ronshū* 2 (1983)

Tamamushi Satoko. 'Sakai Hōitsu to *Nami zu byōbu* – Kōrin hitsu *Hatō zu byōbu* no sōzō-teki hensō' (jō, ge), *Kokka* 1109 (1987), 1110 (1988)

Ōno Tomoko. 'Sakai Hōitsu no gafū tenkai to sono tokushoku', *Bijutsu-shi* 126 (1989)

Kōno Motoaki. 'Kōrin hyakuzu no kitei', *Kinsei Nihon kaiga to gafu, e-dehon II*, Machida Shiritsu Kokusai Hanga Bijutsukan, exh. cat., 1990

Hayashi Susumu. 'Rimpa no e-awase – Kōrin no *Hatō zu byōbu* to Hōitsu no *Nami zu byōbu*', *Rimpa*, vol. 3: *Fūgetsu, chōjū*, Kyoto, Shikōsha, 1991

Ōno Tomoko. 'Sakai Hōitsu hitsu *Natsu aki kusa zu byōbu* no seiritsu to sono haikei', *Museum* 493 (1992)

Yamane Yūzō. 'Sakai Hōitsu hitsu natsu kusa ame, aki kusa kaze zu byōbu shita-e', *Kokka* 1154 (1992)

Yamane Yūzō. 'Sakai Hōitsu hitsu shiki kachō zu, hatō zu byōbu', *Kokka* 1171 (1993)

Kōno Motoaki. 'Sakai Hōitsu hitsu jūnikagetsu kachō zu kō', *Kokka* 1175 (1993)

Naitō Masato. 'Hōitsu kanwa [Tales of Hōitsu]', Nagoya-shi Hakubutsukan, *Rimpa: Bi no keishō – Sōtatsu, Kōrin, Hōitsu, Kiitsu*, exh. cat., 1994

Yamane Yūzō. 'Sakai Hōitsu hitsu seifū shufū zu byōbu ni tsuite', *Kokka* 1211 (1996)

Kiitsu

Chizawa Teiji & Yamaji Shōzō. 'Kiitsu-ga no tembō', *Museum* 261 (1972)

Tsuji Nobuo. 'Suzuki Kiitsu hitsu natsu aki keiryū zu', *Kokka* 997 (1977)

Tsuji Nobuo. 'Suzuki Kiitsu shiron', *Rimpa kaiga zenshū: Hōitsu-ha*, Tokyo, Nihon Keizai Shimbunsha, 1978

Tamamushi Satoko. 'Edo kōki no *Saiyū kikō* ni tsuite – Suzuki Kiitsu cho *Kishi saiyū nikki* o chūshin ni' (jō, ge), *Museum* 361, 362 (1981)

Kobayashi Tadashi. 'Suzuki Kiitsu gunkaku zu', *Kokka* 1055 (1983)

Kobayashi Tadashi. 'Suzuki Kiitsu sanjū-rokkasen zu', *Kokka* 1065 (1983)

Kōno Motoaki. 'Suzuki Kiitsu no gagyō', *Kokka* 1067 (1983)

Kitano Tayuru & Takeya Chōjirō. *Suzuki Kiitsu shojō*, Tokyo, Seishōdō Shoten, 1984

Kōno Motoaki. 'Suzuki Kiitsu hitsu shiki kachō zu byōbu', *Kokka* 1144 (1991)

Murashige Yasushi. 'Meihin kaisetsu 10', *Tokyo Fuji Bijutsukan Myūzu* 1 (1991)

Itabashi Kuritsu Bijutsukan. *Edo bunka shiriizu 12: Suzuki Kiitsu ten*, exh. cat., 1993

Yasumura Toshinobu. 'Suzuki Kiitsu – shiteki shikō no hyōshutsu', *Edo bunka shiriizu 12: Suzuki Kiitsu ten*, Itabashi Kuritsu Bijutsukan, exh. cat., 1993

Takeuchi Misako. 'Kiitsu shiron – rakkan hennen to Rimpa kaiki [Thoughts on Kiitsu's signature chronology]', Nagoya-shi Hakubutsukan, *Rimpa: Bi no keishō – Sōtatsu, Kōrin, Hōitsu, Kiitsu*, exh. cat., 1994

Index